For May and Edward

Contents

List of Illustrations

Preface

It is a sad fact: art history lags behind the study of the other arts. Whether this unfortunate state of affairs is to be attributed to the lethargy of the custodians of art, too caught up in administration and the preparation of exhibitions and catalogues to channel their remaining energies into analytic writing, and too preoccupied with the archive to think long and hard about what painting actually is, or to the peculiar history of the institutions devoted in this century to the study of art, a history which from the beginning has tended to isolate that study from the other humanities, or to some less elaborate reason, such as the plain stasis, conservatism and inertia fostered by the sociology of the profession of art history, I cannot say. Nor can I determine to what degree, if at all, this state of inertia may be nudged toward growth and change by the appearance of a book criticising the prevailing stasis from the outside: it may well be that the only changes deep enough to be effective must come from within the institutions of art history, and must directly alter the way those institutions function. What is certain is that while the last three or so decades have witnessed extraordinary and fertile change in the study of literature, of history, of anthropology, in the discipline of art history there has reigned a stagnant peace; a peace in which – certainly – a profession of art history has continued to exist, in which monographs have been written, and more and more catalogues produced: but produced at an increasingly remote margin of the humanities, and almost in the leisure sector of intellectual life.

What is equally certain is that little can change without radical re-examination of the methods art history uses – the tacit assumptions that guide the normal activity of the art historian. Here, perhaps, something can be done – and action is as urgent as it is belated. There are now fewer and fewer art historians who venture outside their speciality to ask the basic questions: what is a painting? what is its relation to perception? to power? to tradition? And in the absence of writing which does ask those ques-

tions, both the student of art history and the general public have either to rely on answers inherited from a previous generation, or to hand the questions over to the professional philosophers. The gap between philosophy and art history is now so wide that in practical terms it is filled almost by a single work: Gombrich's *Art and Illusion*. There can be no doubt that *Art and Illusion* is a milestone in the development of art history, or that its answers to those questions are, still, enormously influential. But this is itself a difficulty. The arguments stated by *Art and Illusion* have become so ingrained, and in the absence of a continuous tradition of asking those questions in each generation have become so familiar and so widely accepted, that the problems tackled by Gombrich may be thought once and for all to have been solved.

But solved they are not. To the question, what is a painting? Gombrich gives the answer, that it is the record of a perception. I am certain that this answer is *fundamentally* wrong, and in the first three chapters of this book I try to show why. Because the error is fundamental, I have gone back to the beginning, to the origin of Gombrich's ideas in the aesthetics of antiquity: I begin with what is perhaps the most succinct expression of a theory of painting, the story of the grapes of Zeuxis. It is a natural enough attitude to think of painting as a copy of the world, and given the importance of realism in Western painting it is perhaps inevitable that eventually this attitude would be elevated to a doctrine, as it has been by Gombrich – a doctrine of Perceptualism in which the problems of art are in the end subsumed into the psychology of the perceiving subject. But the doctrine remains incoherent, and by the end of Chapter 3 the reader will see that what is suppressed by the account of painting as the record of a perception is the social character of the image, and its reality as *sign*.

Once we approach painting as an art of signs, rather than percepts, we enter terrain unexplored by the present discipline of art history, terrain with as many hazards, traps and pitfalls as the former theory of Perceptualism. If it is to Gombrich that we owe the theory of painting as a mode of cognition, our ideas of what signs are and how they operate are the legacy of the founder of the 'discipline of signs', Saussure. This, too, is a problematic inheritance. Saussure's conception of the sign is exactly the instrument we need to cut the knots of Perceptualism, but if we accept Saussure uncritically we end up with a perspective as rigid and unhelpful as the old one, a perspective in which the meaning of the sign is defined entirely by formal means, as the product of oppositions among signs within an enclosed system. Chapter 4 ('The Image from Within and With-

out') accepts the conclusion that painting is a matter of signs, but works out ways to avoid the kind of formalist trap that 'semiology' or the study of signs, springs on the unwary. The element lacking in Saussure's conception of the systematic nature of signs, I maintain, is description of how signs interact with the world *outside* their internal system. Painting is an art of the sign, but the particular signs it uses, and above all its representations of the body, mean that it is an art in constant touch with signifying forces outside painting, forces that cannot be accounted for by 'structuralist' explanations.

What emerges from the set of arguments against the structuralist or Saussurian conception of the sign is the recognition that painting in the West manipulates the sign in such a way as to conceal its status *as* sign. It is this self-effacement that is explored in Chapter 5 ('The Gaze and the Glance'), and explored in terms of the actual techniques of European painting: traditions of brushwork, colour, composition, and above all, of the mechanisms determining what kind of viewer the painting proposes and assumes. We cannot, with Gombrich, take for granted that the viewer is a 'given': his role, and the kind of work he is called on to perform, are constructed by the image itself, and the viewer implied by medieval Church art is quite different from the viewer implied by Raphael, and different again from the viewer implied by Vermeer. In the Perceptualist account of art, the viewer is as changeless as the anatomy of vision, and my argument here is that the stress, in Gombrich and elsewhere, on perceptual psychology has in effect dehistoricised the relation of the viewer to the painting: history is the term that has been bracketed out (hence the impossibility, under present conditions, of a truly *historical* discipline of art history).

But to introduce history into description of the viewing subject is to run the risk of producing a determinist art history in which a social base is said to generate a superstructure of art, as its impress or ideological reflection. Indeed, it is in these causal terms that sociological art history is usually carried out. The problem here is essentially this: to which zone do we ascribe the sign? to which side does painting belong – to the base? to the superstructure? I do not believe an answer to the question of the relation of art to power can be answered in this chicken-or-egg way, and in Chapter 6 ('Image, Discourse, Power') I outline a rather more complex model of interaction between political, economic and signifying practices. What we have to understand is that the act of recognition that painting galvanises is a production, rather than a perception, of meaning. Viewing is an activity

of transforming the material of the painting into meanings, and that trans-
formation is perpetual: nothing can arrest it. Codes of recognition circulate
through painting incessantly, and art history must face that fact. The view-
er is an interpreter, and the point is that since interpretation changes as
the world changes, art history cannot lay claim to final or absolute know-
ledge of its object. While this may from one point of view be a limitation, it
is also a condition enabling growth: once vision is realigned with interpre-
tation rather than perception, and once art history concedes the provi-
sional character or necessary incompleteness of its enterprise, then the
foundations for a new discipline may, perhaps, be laid.

N.B.

Acknowledgements

I would like to thank Stephen Heath, Colin MacCabe, Anne-Lucie Norton, Tony Tanner and John Barrell, who read through the whole manuscript of this book at various stages, and whose valuable comments I have tried to reflect in the present version. I would like to record here a large additional debt to my students at the University of California at Los Angeles, and especially to Melanie Eckford-Prossor, Laura Ferguson and Howard Davies; I could not have hoped for a better teaching forum in which to present the arguments traced here. The book is practically indebted to two institutions without whose support it simply could not have been written: to King's College, Cambridge, which awarded the Fellowship enabling me to carry out the research project of which this study is the second part; and to the British Academy, whose generosity has allowed the text to be illustrated.

Author and publisher gratefully acknowledge the permission of the following to reproduce their photographs: the Trustees of the British Museum (4); the Trustees of the National Gallery, London (16, 26, 30, 34, 35, 36, 37); the University Library, Cambridge (5); Trinity College, Dublin (6); Josephine Powell (9, 10, 17); the Mansell Collection (2, 3, 12, 13, 19, 20, 21); Service de documentation photographique de la Réunion des musées nationaux (31, 32, 39); Mauritshuis, The Hague (22); Museum voor Schone Kunster (33); Alte Pinakothek, Munich (29); Kunsthistorisches Museum, Vienna (23, 24); Himler-Verlag (7); Civico Museo dell'Eta Cristiana, Brescia (1); Museo Poldi Pezzoli, Milan (27); Archivi Alinari (11, 25); National Gallery of Art, Washington, Samuel H. Kress Collection (18) and Ailsa Mellon Bruce Fund (28); Metropolitan Museum of Art, New York (8); Cleveland Museum of Art, gift of Katherine Holden (15); Honolulu Academy of Arts, gift of Mrs Carter Galt (14); the Petersburg Press, *Larry S., Fire Island*, Pen and Ink 14 × 17 ins, © David Hockney 1975 (Private Collection USA), and a Private Collection in Great Britain

which kindly gave permission to reproduce the Ingres *Study for L'Odalisque à l'esclave*.

King's College, Cambridge
November 1982

Chapter One
The Natural Attitude

It is hard to imagine a more revealing story about painting in the West than
this, from Pliny:

> The contemporaries and rivals of Zeuxis were Timanthes, Androcydes,
> Eupompus, Parrhasius. This last, it is recorded, entered into a competi-
> tion with Zeuxis. Zeuxis produced a picture of grapes so dexterously
> represented that birds began to fly down to eat from the painted vine.
> Whereupon Parrhasius designed so lifelike a picture of a curtain that
> Zeuxis, proud of the verdict of the birds, requested that the curtain
> should now be drawn back and the picture displayed. When he realised
> his mistake, with a modesty that did him honour, he yielded up the
> palm, saying that whereas he had managed to deceive only birds, Par-
> rhasius had deceived an artist.[1]

The enduring relevance of Pliny's anecdote is remarkable: indeed, unless
art history finds the strength to modify itself as a discipline, the anecdote
will continue to sum up the essence of working assumptions still largely
unquestioned. The Plinian tradition is a long one. When the Italian human-
ists came to describe the evolution of painting in their own epoch, it was to
the *Natural History* that they turned, updating Pliny by substituting the
names of contemporary painters for those of antiquity. Painting is once
again thought of as a rivalry between technicians for the production of a
replica so perfect that art will take the palm from nature. That the goal of
the painter is to outstrip his competitors was already enshrined in Dante:

> Credette Cimabue ne la pinture
> tener lo campo, e ora ha Giotto il grido,
> sí che la fama di colui è scura.[2]

1

Once, Cimabue was thought to hold the field
In painting; now it is Giotto's turn;
The other's fame lies buried in the dust.

To the humanists, the recent rivalry vividly recalls antiquity. Villani, in the history of painting he includes in his encyclopedic *De Origine Civitatis Florentiae*, models his account of Giotto's surpassing of Cimabue directly on Plinian precedent:

First among the painters was John, whose surname was Cimabue, who summoned back with skill and talent the decayed art of painting, wantonly straying from the likeness of nature as this was, since for many centuries previously Greek and Latin painting had been subject to the ministration of but clumsy skills After John, the road to new things lying open, Giotto – who is not only by virtue of his great fame to be compared with the ancient painters, but is even to be preferred to them for skill and talent – restored painting to its former worth and great reputation.[3]

It was Apollodorus who first gave his figures the appearance of reality (Pliny: *hic primus species instituit*): so in the modern age Cimabue summoned back the art of painting and restored it by his skill and talent to the stature it had known in antiquity. It was through the gate opened by Apollodorus (Pliny: *ab hoc artis fores apertas*) that Zeuxis entered, so excelling his predecessor in skilful replication that even the birds were deceived: in just this way, Giotto entered the road opened by Cimabue (*strata iam in novis via*) and cast his predecessor's memory into eclipse, as Dante observes.[4] Vasari expands the Plinian tale and multiplies its *dramatis personae* into a whole saga of triumph and obsolescence, beginning with the obligatory references to Cimabue and Giotto and culminating in Michelangelo, hero, genius, saint.

In the nineteenth century, as positivism takes hold of the discussion of art, this innocent tale will no longer suffice: scholarship, and the market, demand an analysis that will do justice to work seen more and more in terms of formal technique. Yet no sooner has Morelli expounded the principles of morphological analysis that will enable an exact science of attribution to develop, than Berenson pulls the Morellian technology back into the service of the Plinian account: just as it was Cimabue who first questioned the bi-dimensionality of the Byzantine image, so it was Giotto who

set Renaissance painting firmly on the road to discovery of tactile values.[5] Even more recently, when Francastel stands before one of the most firmly imprinted of Renaissance images, Masaccio's *Tribute Money*, it is still in terms of the ancient formula that he portrays his reaction.

> Placed at the edge of the space and of the fresco, his calves tense, his bearing insolent, this magnificent *sabreur* bears no relation to the figures of gothic cathedrals: he is drawn from universal visual experience. He does not owe his imposing presence to the weight and volume of robes: his tunic moulds itself on his body. Henceforth man will be defined not by the rules of narrative, but by an immediate physical apprehension. The goal of representation will be appearance, and no longer meaning.[6]

What Francastel voices here is not only the view of the illustrious ancestors, but of received opinion: the generally held, vague, common-sense conception of the image as the resurrection of Life. Life does not mean, Life is; and the degree to which the image, aspiring to a realm of pure Being, is mixed with meaning, with narrative, with discourse, is the degree to which it has been adulterated, sophisticated, as one 'sophisticates' wine. In its perfect state, painting approaches a point where it sheds everything that interferes with its reduplicative mission: what painting depicts is what everyone with two eyes in his head already knows: 'universal visual experience'.

The ancient tale, repeated across the generations from Pliny to Francastel, might seem capable of engendering a historical discipline. Its emphasis is, after all, on change, and the rapidity of change, within the evolution of the image. Apollodorus appears: Zeuxis outstrips him. Cimabue appears: Giotto surpasses him. Painting is seen as a constant mutation within history. Yet although the study of mutations may possess a historically changing object of enquiry, morphology by itself is not art history: indeed, history is the dimension it exactly negates. The ancient tale sees painting as faced with a task of enormous magnitude: it is to depict everything – gods, men, beasts, things; 'groves, woods, forests, hills, fish-pools, conduits, and drains, riverets, with their banks, and whatsoever a man would wish to see'.[7] The problem lies in the task – its performance, its infinity of possible subject-matter, its manual difficulty – but not in the means by which the task is to be performed.[8] Painting itself has no problematic. The difficulties confronted by the painter are executive and concern the fidelity of his registration of the world before him. The

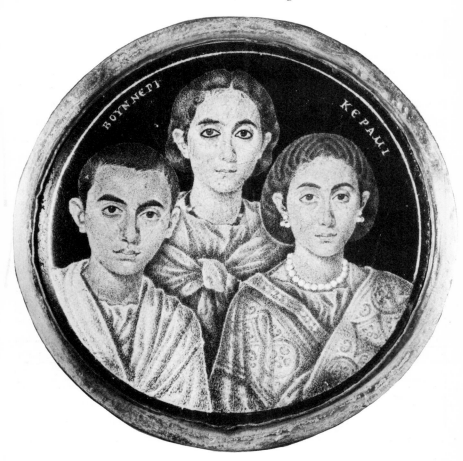

1 *Family of Vunnerius Keramus*

world painting is to resurrect exists *out there*, already, in the plenitude of its Being; and all the image is required to do is approximate as closely as possible the appearances of that plenary origin. Painting corresponds here closely to what Husserl describes as the 'natural attitude'.

> I find ever present and confronting me a single spatio-temporal reality of which I myself am a part, as do all other men found in it and who relate to it in the same way. This 'reality', as the word already indicates, I find existing out there and as I receive it just as it presents itself to me as something existing out there (*als daseiende vor und nehme sie, wie sie sich*

mir gibt, auch als daseiende hin). 'The' world as reality is always there: at most it is here and there 'other' than I supposed it and should it be necessary to exclude this or that under the title 'figment of the imagination', 'hallucination', etc., I exclude it from this world which in the attitude of the general thesis is always the world existing out there. It is the aim of the *sciences issuing from the natural attitude* to attain a knowledge of the world more comprehensive, more reliable, and in every respect more perfect than that offered by the information received by experience, and to resolve all the problems of scientific knowledge that offer themselves upon its ground.[9]

Husserl's remarks concerning the sciences developed out of the natural attitude invite direct application to painting, at least as theorised in the account that stretches back in time from Francastel to Pliny. The world is pictured as unchanging in its foundation, however much its local appearance may modify through history; history is conceived here as an affair of the surface, and, so to speak, skin-deep. It will be inevitable, therefore, that painting, whose function it is to attend to the surface and to record in minute detail its local manifestations, will give the impression of constant change at the level of content: costume, architecture, and the immediate physical neighbourhood around the human body, are in continual flux, and painting will record that flux with devoted attention. There will be no immediate question, however, that the reality painting records belongs to any category other than that of nature: it is as the natural that the substratum underlying superficial cultural rearrangement is apprehended.

The major term suppressed by the natural attitude is that of history; and the first objection that must be raised against the Plinian account is that the real ought to be understood not as a transcendent and immutable given, but as a production brought about by human activity working within specific cultural constraints. Cultural production and reproduction concern not only the shifting cosmetic surface, but the underlying foundation which any given society proposes and assumes as its Reality. While the image of a Roman family such as that of Vunnerius Keramus (Illus. 1) seems to state the timelessness of the human body, and would appear to confine the province of change to the limited margin of costume, the historical reality to which the figures in the image belong is precisely that which the image brackets out. The power of the image in this way to evoke an ahistorical sense of human reality, and in particular a sense of the culturally transcendent status of the body, is extreme. Under certain conditions,

such as those exemplified by the Keramus portrait, the image seems to have sublimed the historical dimension altogether.

Within the natural attitude, which is that of Pliny, Villani, Vasari, Berenson, and Francastel, the image is thought of as self-effacing in the representation or reduplication of things. The goal towards which it moves is the perfect replication of a reality found existing 'out there' already, and all its effort is consumed in the elimination of those obstacles which impede the reproduction of that prior reality: the intransigence of the physical medium; inadequacy of manual technique; the inertia of formulae that impede, through their rigidity, accuracy of registration. The history of the image is accordingly written in negative terms. Each 'advance' consists of the removal of a further obstacle between painting and the Essential Copy: which final state is known in advance, through the prefiguration of Universal Visual Experience.

The painter, in this project, is passive before experience and his existence can be described as an arc extending between two, and only two, points: the retina, and the brush. A binary epistemology defines the world as anterior and masterful, and the painter's function before it as the secondary instrument of its stenographic transcription. His work is carried out in a social void: society may provide him with subject-matter, but his relation to that subject-matter is essentially optical. In so far as the task he is to perform involves any other human agents, the involvement is not with other members of the society but with other painters, whose existence is reduced to the same narrow and optical scope. Moreover, the interaction between the individual painter and the community of painters is once again negative: his aim is to outstrip them, to shed their formulaic legacy, to break whatever limited bond exists between that community and himself, as Zeuxis outstripped Apollodorus, and as Giotto discarded and rendered obsolete the work of Cimabue.

The domain to which painting is said to belong is that of *perception*. The painter who perceives the world insensitively or inaccurately falls below the standards of his craft; he will be unable to advance towards the Essential Copy. Advance is known to have taken place when the viewer is able to detect the reproduction of an item from Universal Visual Experience that has not before appeared in the image. There will be no doubt concerning the presence of such an advance: everyone will see it in the same way: since each human being universally experiences the same visual field, consensus will be absolute. All men are agreed that Giotto's registration of the visual field is subtler, more attentive, and in every way superior to that

of Cimabue (Illus. 2 and 3).

Such consensus is matched by a definition of style as personal deviation. The struggle towards perfection is recognised as long and arduous: the Essential Copy, if it were ever achieved, would possess no stylistic features, since the simulacrum would at last have purged away all traces of the productive process. The natural attitude has no way to legitimate style except by way of the limited tolerance it extends to inevitable human weakness. With a ruthless optimism that never fails it, the natural attitude turns all its attention towards the Essential Copy, or at least towards the niche where eventually it will be installed. The modes of failure to achieve the desired and perfect replication are therefore of no more interest to it than are random and extinct mutations to the evolutionary process. Style is a concept that is juridically absent from the scene. Idiosyncrasies of the palette, habitual deformations of the figures, the characteristic signature of brushwork, these reflexes that spring from the body and from the past history of the painter are therefore consigned to an underside of the official ideology.[10] Style, serving no apparent purpose within the project of transcription, except here and there to impede its progress, is given no clear argument with which to justify its existence. Lacking in purpose, and the result of no clear intention, it appears as an inert and functionless deposit encrusting the apparatus of communication. Indifferent to the exalted mission with which the image has been entrusted, style emanates from the residue of the body which its optical theorisation had thought to exclude; what had been pictured as an ideal arc extending from retina to brush is discovered to cross another zone, and almost a separate organism, whose secrets, habits, and obsessions distort perception's impersonal luminosity. The Morellian method, with its focus on the tell-tale details of drapery, hands, and hair, is entirely forensic: style *betrays* itself, in the manner of crime. And the agency with an active interest in such detective-work will be a market hungry for precise attribution in order to maximise the worth of the authentic commodity, and to introduce into its transactions the stability of standard measurement.

Apart from the tax of style that must be paid to human fallibility, the dominant aim of the image, in the natural attitude, is thought of as the communication of perception from a source replete in perceptual material (the painter) to a site of reception eager for perceptual satisfaction (the viewer). Setting aside the informational 'noise' caused by style, by the resistance of the medium, and by the vicissitudes of material decay, the communication of the image is ideally pure and involves only these

2 Cimabue, *Madonna and Child Enthroned with Angels and Prophets*

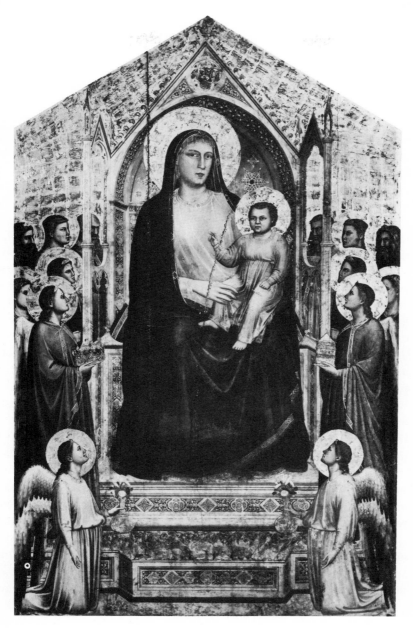

3 Giotto, *Madonna and Child Enthroned with Saints and Angels*

termini: transmitter and receiver. The rest of the social formation is omitted.
The family of Vunnerius Keramus looks much as a comparable family in
Rome might look today: the visual essence has been captured.

The global outlook of the natural attitude amounts, then, to a commit-
ment to these five principles:

1. *Absence of the dimension of history.* The production of the image is a
 steady-state process where variation in the image is accounted for
 either in terms of changing emphases on different aspects of the
 anterior and unchanging reality, or in terms of fluctuation in the execu-
 tive competence of the painter. History has a place in the account, but
 only as a superficially changing spectacle whose alteration does not
 affect the underlying and immutable substrate. The basic visual field
 remains the same across the generations, and corresponds to the fixed
 nature of the optical body. Visual experience being universal and
 transhistorical, it is therefore given to every viewer to judge, along a
 sliding scale, how closely a particular image approximates the truth of
 perception. The scale itself is outside historical process. No-one has
 ever doubted and no-one ever will doubt that Zeuxis outstripped Apol-
 lodorus, or that Giotto's *Madonna Enthroned* marks an objective advance
 over Cimabue's version of the same subject.

2. *Dualism.* Between the world of mind and the world of extension there is
 a barrier: the retinal membrane. On the outside, a pre-existent and
 plenary reality, flooded with light, surrounds the self on all sides;
 within, a reflection of that luminous scene is apprehended by a passive
 and specular consciousness. The self is not responsible for constructing
 the content of its consciousness: it can do nothing to stem or modify the
 incoming stream of information stimuli: the visual field it experiences is
 there by virtue of anatomical and neurological structures that lie
 beyond its influence. From the material and muscular body, continu-
 ous with physical reality and capable of performance within physical
 reality, a reduced and simplified body is abstracted. In its classical and
 Albertian formulation, this body of perception is monocular, a single
 eye removed from the rest of the body and suspended in diagrammatic
 space.[11] Having no direct access to experience of spatial depth, the
 visual field before it is already two-dimensional, is already a screen or
 canvas. The suspended eye witnesses but does not interpret. It has no
 need to process the stimuli as these arrive, since they possess an intel-
 ligibility fully formed and theirs by virtue of the inherent intelligibility

of the outer world. The barrier is not, therefore, in any sense opaque, nor does it perform tasks of scansion or censorship on the incoming data: it is a limpid and window-like transparency, without qualities. Once the image comes to recreate the passive translucence of the retinal interval, the Essential Copy will be achieved.

3. *The centrality of perception*. The natural attitude is unable easily to account for images that depart from universal visual experience except in negative terms: the painter has misperceived the optical truth, or has been unable, through lack of skill, or through excess of 'style', to match optical truth on canvas. The appearance on canvas of a wholly imaginary object which nevertheless cannot be characterised as the result of misperception or of executive incompetence is explained either as the combination of disparate segments of the visual field into a new synthesis, or as a personal 'vision' manifesting within the consciousness of the painter and repeated on canvas in the same manner as any other content of consciousness. In all these cases, departure from optical truth is recuperated by restating the departure again as perception, perception that has undergone only minor modification: the project of the painter is still the transmission of the content of his visual field, whether actual (the scene before him) or imaginary (a scene manifesting in consciousness but not in perception). The material to be transmitted exists prior to the work of transmission: it stands before the painter fully formed, before the descent into material transcription begins.

4. *Style as limitation.* The Essential Copy would be immediately and entirely consumed by the viewer's gaze. The same gaze applied to an image that falls short of perfect replication consumes as much of the image as corresponds to universal vision, but will then discover a residue indicating the degree of the image's failure, and running counter to its whole purpose. Where success consists in the perfect preservation of the original precept, style indicates its decay: where communication in its ideal form follows a single direction from transmitter to receiver, style *lacks destination*: where the visual field is the shared property of all, style indicates a withdrawal into privacy and solitude. Style attests to the existence of a physiology that is not at all the decorous and abstract outline sketched in the diagrams of perceptual psychology, but a carnal structure that cannot be subsumed into the official project. If the success of an image and its degree of approximation to universal vision is characterised by the speed of its consump-

tion by the viewing gaze, style is something dense, non-flammable, inert. Ontogenetically, the individual painter is unable to subdue the inclinations and habits of creatural clay; phylogenetically, a generation of painters is unable to see and to overcome the dead weight of inherited formulae.

5. *The model of communication.* The content of the image is alleged to antedate its physical exteriorisation. The present case is posited as the echo or repetition, more or less distorted, of a prior instance for whose existence, nevertheless, there is no evidence; or rather, the present instance is itself viewed evidentially, as product and proof of an earlier and more perfect incarnation. The location of the earlier image is a mental space within the psyche of the painter. The present image does what it can to transport intact the event within that space into the corresponding mental space in the consciousness of the viewer. A physical entity – the material image – is required if the interchange between non-physical mental spaces is to take place: yet in so far as the material image interposes its own physicality between the communicating fields, it constitutes an impediment to their union. Success can occur only when the image manages to minimise or to conceal its independent material existence.

My aim in this book is the analysis of painting from a perspective very much opposed to that of the Natural Attitude, a perspective that is, or attempts to be, fully materialist. Where it falls short of that aim, on its own terms it fails, and the degree of its failure is for the reader to judge. The topics on which the book touches could be discussed at far greater length, and in choosing to limit discussion to its present brevity, I hope I am not subjecting my reader to undue strain. In reading the text, he or she may well sense a difficulty of topology or affiliation which I myself have been unable to resolve. Where the discussion stands in relation to the work of Gombrich, Wittgenstein, and Saussure, is clear, at least to me. Where it stands in relation to the work of N. Y. Marr and V. N. Vološinov, and to the Soviet materialist tradition in general, is harder to estimate. The intellectual quality I find most to admire in materialist thinking is its firm grasp of a tangible world. My approach to the subject is historical, and it is materialist; yet my argument finds itself in the end in conflict with Historical Materialism. Throughout the writing of this book, I have felt the difficulty of mapping the political implications of its intellectual position on any right-to-left spectrum. It is quite possible that all I understand by 'materialism' is clear-sightedness.

Chapter Two

The Essential Copy

Perhaps the most powerful arguments against the Natural Attitude have come from the sociology of knowledge. The doctrine of technical progress towards an Essential Copy proposes that at a utopian extreme the image will transcend the limitations imposed by history, and will reproduce in perfect form the reality of the natural world: history is the condition from which it seeks escape. Against this utopia the sociology of knowledge argues that such an escape is impossible, since the reality experienced by human beings is always historically produced: there is no transcendent and naturally given Reality. The implication of this general proposition of most concern to the image is that the natural attitude is mistaken in thinking of the image as ideally self-effacing in the re-presentation of things: the image must be understood instead as the milieu of the articulation of the reality known by a given visual community. The term 'realism' cannot therefore refer to an absolute conception of 'the real', because that conception cannot account for the historical and changing character of 'the real' within different periods and cultures. The validity of the term needs to be made relative, and it is more accurate to say that 'realism' lies rather in a coincidence between a representation and that which a particular society proposes and assumes as its reality; a reality involving the complex formation of codes of behaviour, law, psychology, social manners, dress, gesture, posture – all those practical norms which govern the stance of human beings toward their particular historical environment. It is in relation to this socially determined body of codes, and not in relation to an immutable 'universal visual experience', that the realism of an image should be understood.

This second and more subtle description of realism, which begins to emerge once the anti-historicism of the natural attitude is called into question, touches on a phenomenon familiar to social anthropology. For example, in their work *The Social Construction of Reality*, Peter Berger and

Thomas Luckmann comment extensively on the drive inherent in all societies to 'naturalise' the reality they have constructed and to transform a world produced by a specific socio-historical activity, into a World given from the beginning, a Creation, natural and unchanging. While 'social order is not part of the nature of things and . . . cannot be derived from the "laws of nature", social order being only a product of human activity', nevertheless the social world is typically and habitually experienced by its inhabitants 'in the sense of a comprehensive and given reality confronting the individual in a manner analogous to the natural world'.[1] In connection with the image, realism may be defined as the expression of the idea of the *vraisemblable* which any society chooses as the vehicle through which to express its existence to itself in visual form.[2] Clearly the historically determined nature of that *vraisemblable* must be concealed if the image is to be accepted as a reflection of a pre-existing real: its success lies in the degree to which the specificity of its historical location remains hidden; which is to say that the success of the image in naturalising the visual beliefs of a given community depends on the degree to which the image remains unknown as an *independent* form.

Naturalisation is not, then, the goal of the image alone: it is a generalised process affecting the whole social formation and influencing all of its activities, including among many others the production of images. Culture produces around itself a 'habitus' which though discontinuous with the natural world, merges into it as an order whose join with Nature is nowhere visible.[3] If the context of animal species is the habitat, the habitus of the human species consists not only of the physical environment, but of a whole assemblage of maxims, morals, proverbial lore, values, beliefs, and myths which will ensure for the members of a given social formation the coherence of their experience, and will secure for them the permanent reproduction of the regularities of their cultural process.[4] The habitus may involve explicit cultural knowledge, such as codes of justice or articles of faith, as well as the patently enculturated domain of art, where this is socially institutionalised; it may equally involve implicit cultural knowledge that exists nowhere in codified form, but remains at a tacit level. Either way, the internal absorption of such knowledge becomes, through habituation, the natural attitude of the human agent towards his surrounding world.

This argument for cultural relativity might at first seem to overturn the confident refusal, within the natural attitude, of the dimension of history. Essential to the work of naturalisation and of the habitus is the mobility of

the place at which the 'join' between cultural and natural worlds lies hidden, as a kind of blind spot or blank stain within social consciousness: travelling through time and across the shifting cultural spaces, its invisible accompaniment and participation is vital to the process of cultural reproduction. Its migratory existence might never be known if it were not for the traces it leaves behind: the outline, in ochre and black, found in a cave; the painted canvases of the West. It is within this blind spot of culture's vision that the image is fashioned, and in the strangeness of the traces left behind by the natural attitude, the relativity of experience within differing social formations stands out in stark relief: no single Essential Copy can ever be made, for each strange trace left behind by the habitus was, relative to its social formation, itself an Essential Copy already. And a sense of the impossibility of a final Essential Copy would seem to bring about, as an immediate consequence, an end to the doctrine of progress that dominates the traditional account of painting from Pliny to Francastel.

Yet the concession made to historical *relativity* does not substantially alter the traditional account: it merely forces the account into epicycles from which it emerges with rather greater sophistication and force. Insistence on the fluctuating character of the social construction of reality by itself leads readily to a position in which the stylistic variety of the image through history is attributed to the variability of the real, leaving no room for variation in the 'technical' means whereby the changing nature of the real is 'registered'; leaving no room, in fact, for a history of art, but only of society. The problem is this: critical analysis of the natural attitude, whether conducted by way of the sociology of Berger and Luckmann or the anthropology of Mauss, still leaves open the utopian option of the Essential Copy, since within each fluctuating phase of the social formation, an image is capable of being fabricated that will correspond exactly, if things go well, to the collective beliefs of its members, equally, the obstacles whose gradual conquest is chronicled in the traditional account may, if things go badly, prevent the fabrication of such an image: the intransigence of the medium, the inadequacy of technique, the detritus of inherited formulae, and the rest, are free to reappear. All that 'relativisation' of the real accomplishes, as a concept operating in isolation, is a reduction in the scale of the ancient Plinian fable: the Essential Copy may no longer exist at the end of the historical rainbow, but instead of disappearing it on the contrary multiplies, as a possibility open to each stage of social evolution. Even within a relativised cultural history, a Giotto may still outstrip a Cimabue.

What is required, if the doctrine of progress towards the Essential Copy is to be successfully overcome, is something much more subtle than an all-encompassing sociology, for besides the history of the montage of notions, behavioural norms, myths, values and beliefs from which a society constructs its particular reality, another history must be supplied, which is that of painting as a *material practice*. It is obviously absurd to suppose that a social agent, however fully enculturated by the codes of his community, and supplied with brush and pigments, will be able to produce, from scratch, a fully fledged image adequate to the society's standards of accomplishment. Besides the codes of the real, there are codes specific to the material signifying practice of painting; codes which cannot be mastered, so to speak, simply by inhaling the atmosphere of a given culture. To approach the image from the sociology or anthropology of *knowledge* is to risk ignoring the image as the product of *technique*. If the concrete nature of technique is overlooked, analysis of the image falls into immediate simplification: only its semantic or iconological side is noted, and then linked to a corresponding structure of knowledge within the habitus. For example, a local change at the level of content, let us say a change in the representation of poverty, is linked directly to a fluctuation in the economic base. Yet even if we admit the model of base and superstructure, nonetheless between changes in the economic sphere and change in the representation of poverty there stretches a long, long road that crosses many separate domains.[5] In the case of painting, there exists the vast corpus of technical problems and their solutions, of studio practices, of prescriptions, models, familiar and unfamiliar formats, long-discovered pitfalls, together with the means to avoid them; a whole tradition of previous courses taken and of options not fully explored, of systems of perspective, modelling, shading, composition, colour; in sum, everything the apprentice must learn in the atelier. While this corpus of skills within the domain of painting stands in decisive relation to the ideological, political, and economic domains within the social formation, it is in no sense derivable from them directly. As the painter takes up his position before the canvas and begins his work, there is an encounter between this complex of practical knowledge and the new situation; under the pressure of the novel demands of the encounter, the complex itself is modified, and its tradition extended.

Here the situation of painting contrasts strongly with that of language. The word possesses a social ubiquity which the image entirely lacks: indeed, whereas a society that banned the use of imagery could continue

functioning, a society that banned the word would instantly grind to a halt.[6] The word is involved in every social domain and in every contact between people: present in every labour process, in every political exchange, in the home, in the school, the word responds instantly to each change in its surrounding world. For this reason it acts as a supremely sensitive index of change within the social formation: painting must filter social change through the elaborate density of its technical practices. While painting may indeed perform important functions in the naturalisation of events and beliefs at work in the social formation, an adequate account of painting cannot reduce its object to those functions alone, or assume that in the enumeration of the ways in which painting confirms and supports the work of the habitus its description will be exhausted. In the Plinian account, the unchanging nature of the real established and highlighted variation within painting as the result either of shifting emphases on and selections from different segments of the real, or of the autonomous work of painting practice. Historical relativisation of the real renders such ascription uncertain, and from one point of view that is its advantage; yet unless combined with further analytic concepts, it risks crudifying the account, in which variation in painting practice is attributed directly to the fluctuation of collective experience.

The theory of the image produced by cultural 'relativisation' is focused too much on undemonstrable social experience to possess objective criteria that will determine the *degree* of naturalisation, or indeed establish with certainty that naturalisation is actually occurring. It has no means of testing whether the image in fact represents that which the theory of naturalisation claims it does, a *view* of the habitus from the inside: to prove that, it would first have to demonstrate the 'view' in abstraction from the image, in order to claim identity (or non-identity) between naturalised 'view' and image. Yet the image is the only evidence for that view which can be adduced; the image cannot, then, be accorded the status of reflector to a 'view' allegedly prior to this reflection, and accurately or inaccurately repeated within it (yet undemonstrable outside it). The contradiction here puts the whole concept of naturalisation in jeopardy. The methodological limitations are extreme: there is no way to discriminate between what might indeed be a perfect registration of the view of the habitus 'from inside', and an imperfect registration, or to distinguish either of these from parody, or hallucination. The practical consequences of this debilitated theory can make for some grim reading. At worst, there is reversion to an untenable sociology of art where events within the social formation in one column are

'read off' against their corresponding artistic consequences in another. Those familiar with the depressing stultifications of this approach will not need to be reminded of the names of its adherents and practitioners.

Despite its promise, historical relativisation does not, therefore, dislodge the Essential Copy or significantly modify the doctrine of artistic progress towards it. The stronger challenge to the Essential Copy comes in fact from another direction: its most complete expression is found in the work of Sir Ernst Gombrich. Gombrich's view of representation marks a major break with the anti-historicism of the natural attitude. Indeed, the centrality of the problem of historical change within representational art is asserted on the first page of *Art and Illusion*.

> Why is it that different ages and different nations have represented the visible world in such different ways? Will the paintings we accept as true to life look as unconvincing to future generations as Egyptian paintings look to us? Is everything concerned with art entirely subjective . . . ?[7]

The renunciation of the Essential Copy, or rather the claim to such renunciation, is explicit in Gombrich in a way it is not in the aesthetics of the image derived from the sociology and anthropology of knowledge. Its disappearance is brought about from another direction altogether: from the philosophy of science, and in particular through the application by Gombrich of certain aspects of the theory of scientific discovery developed by Sir Karl Popper. The connection between Gombrich and Popper merits the closest attention. Rarely – perhaps not since the alliance between LeBrun and Descartes – have artistic and scientific theorisation followed in such close formation and conformation as here. To understand exactly why in Gombrich the Essential Copy is precluded, or seems to be precluded, there is no better place to begin than with Popper's arguments concerning the status and validity of scientific propositions. 'I should be proud if Professor Popper's influence were to be felt everywhere in this book'[8]

The aspect of Popper's work of most direct interest to Gombrich concerns his contribution towards a solution of the problems raised for scientific method by the principle of *induction*. Induction's general features can be sketched roughly as follows. The scientist carries out controlled experiments that yield precisely measurable observations: he records his find-

ings and in due course builds up a corpus of exact and reliable data. As the corpus grows, certain recurrences within the data begin to appear, certain regularities within the body of information, which the scientist then abstracts from the data and restates as propositions of a general nature. The inductively derived proposition is based, that is, on the accumulated data arising from observation of specific instances. Science is the name given to the overall structure of such propositions: its development consists in the addition of new propositions of a general and lawlike character to the existing stock of propositional knowledge.

This classical doctrine of induction has long been open to objection.[9] No matter how large the number of observed instances, mere observation does not entail that the proposition derived from the data observation yields will be generally true. Even when it is the case that in every recorded instance, event y has always followed another event x, observation does not guarantee that in any future case the same sequence will occur: observation has no bearing on prediction. Of course, when in the experience of all men it is found that y invariably follows x, there will be *expectation* that the sequence will continue to recur in the same way. Yet that is a fact of human psychology and not of logic. The principle of induction is incapable of being inferred here either from experience or from logical procedure. Although it may seem psychologically true that the degree of probable truth is raised by each confirming instance, especially in those situations where y has followed x through innumerable confirming instances without a single counter-example having ever been found, nevertheless the accumulation of confirming instances cannot prove the truth of a general proposition; nor does such accumulation logically, as opposed to psychologically, increase the probability that the proposition is true.

In the challenge raised against the principle of induction it is the whole status of scientific knowledge that is at stake. In the words of Bertrand Russell, 'If this one principle is admitted, everything else can proceed in accordance with the theory that all our knowledge is based on experience.'[10] Popper's answer to the Humeian challenge begins by drawing a crucial distinction between *verification* and *falsification*. While no number of observations of white swans enables the derivation of the universal statement that 'all swans are white', one single observation of a black swan is sufficient to produce the derived and universally valid statement that 'not all swans are white'. Empirical statements, in other words, may never be verified so as to yield propositions of a lawlike character; but such proposi-

tions *can* be derived if the path followed is that, not of verification, but of falsification.[11] Scientific propositions based upon empirical observation do not possess the status of universal laws, as induction had maintained, and the accumulation of such propositions will never yield a final or certain blueprint of the physical world. Their status must be seen instead, according to Popper, as that of hypotheses, testable in spite of being unprovable. The process of testing through systematic attempts at refutation therefore constitutes the central activity of science. The propositions will never produce a perfect map or model of the universe and can never transcend their provisional status; but this should not deter science from continually producing provisional statements about the universe, or from building on the solid foundation of the falsifiable hypothesis.

Step by step, the Popperian arguments are transported by Gombrich from science to art. To the classical view of induction corresponds the Plinian account of faithful representation. Just as the inductive scientist starts with observation and the recording of data, so the inductive painter starts with observation and simply records his findings on canvas. According to inductive principle, scientific laws are the secondary result of accumulated information: the primary encounter is between the innocent, untheorising eye of the scientist and the surfaces of the physical world, an encounter that takes place without mediation, and above all without the mediation of the hypothesis. Similarly the theorisation of painting in terms of the natural attitude posits the innocent eye of the painter in unmediated encounter with the surfaces of a luminous world it must record and register; nothing intervenes between the retina and the brush.

To Popper's rejection of induction and to his advocacy of the provisional hypothesis corresponds Gombrich's insistence on the *schema* as the painter's prime transcriptive instrument. Hypothesis and schema stand here in exact alignment. In *Objective Knowledge*, Popper characterises the work of the scientist as a continuous cycle of experimental testing. First there is the initial problem (P^1) that science is to explore. A Trial Solution (TS) is proposed, as the hypothesis most appropriate to the problem and most likely to lead to its solution. An experimental situation is devised in which the strengths and weaknesses of the hypothesis can be submitted to falsification: let us call this the stage of error elimination (EE). The resulting situation reveals new problems (P^2) whose existence or importance were not apparent at the commencement of the process.[12]

$$P^1 \rightarrow TS \rightarrow EE \rightarrow P^2$$

In *Art and Illusion* Gombrich characterises the work of the painter along identical lines: as a continuous development consisting in the 'gradual modification of the traditional schematic conventions of image-making under the pressure of novel demands'.[13] The pattern for art is the same as that for science. First there is the initial problem: Giotto, for example, sets out to record the appearance of the human face. Tradition suggests a particular formula or schema for its transcription on to canvas: let us imagine that it is an early Giotto, where the influence of Cimabue is strongly felt. Giotto tests the schema against actual observation of the face. Observation reveals that here and there the Cimabue-schema is inadequate to the empirical findings, and that the schema must be modified in accordance with the discrepant data. The modified schema in turn enters the repertoire of schemata and will in due course be subjected to similar tests and elaborations as its predecessor.

To Popper's abandonment of a perfect map or model of the universe corresponds a renunciation of the possibility of the Essential Copy. Just as universal scientific laws cannot be inferred from empirical experience, so painting can never hope to produce a true, certain, or absolute image that will correspond perfectly to optical truth. The painter does not, according to Gombrich, gaze on the world with innocent or naive vision and then set out to record with his brush what his gaze has disclosed. Between brush and eye intervenes the whole legacy of schemata forged by the painter's particular artistic tradition. What the painter does, what the scientist does, is to test these schemata against experimental observation: their production will not be an Essential Copy reflecting the universe in terms of transcendent truth; it will be a provisional and interim improvement on the existing corpus of hypotheses or schemata, improved because tested against the world, through falsification.

Gombrich's viewpoint seems to succeed, therefore, where the approach from the sociology of knowledge failed: the Essential Copy has been sacrificed, and with it, one might think, the commitment of the traditional or Plinian account to a progressive history of art. Moreover, by concentrating on the evolutionary history of the schemata, Gombrich avoids the danger inherent in the sociological approach, of denying the independent materiality of painting practice. In the end this is perhaps its most valuable feature. Yet Gombrich's account of the evolving schema bears striking resemblances to the classical Plinian version: so far from questioning the Whig optimism of that version, it in fact reinforces its evolutionary and teleological drive. Whether Gombrich actually renounces the Essential

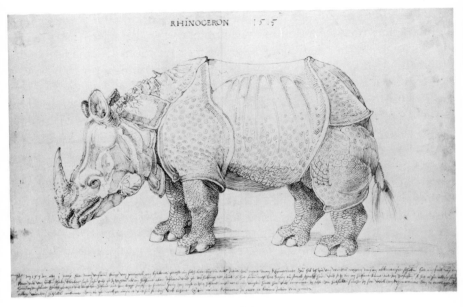

4 Dürer, *Rhinoceros*

Copy is very much in question. In general terms, the work of Gombrich amounts to a transitional aesthetics that recognises but cannot yet theorise in depth the material nature of the painterly sign. Let us take an actual example, from *Art and Illusion*.

The idea Gombrich intends by the word 'schema' is in itself straightforward. When Dürer, in his drawing of 1515, comes to deal with the problem of representing the likeness of a rhinoceros, the image he creates reveals to a striking extent his dependence on secondary accounts and descriptions of this novel and extraordinary beast; in particular, his dependence on prevailing taxonomies of the animal kingdom where the rhinoceros is categorised as a grotesque anomaly or aberration, a kind of horned dragon equipped with an armour-plated body and scaly, reptilian limbs: the result is a creature out of Borges's *Book of Imaginary Beasts* (Illus. 4).[14] When the English engraver Heath is called upon to provide illustrations to Bruce's *Travels to the Source of the Nile* (1789) the influence of the medieval bestiary has largely disappeared, yet even though Heath announces that his engravings are 'designed from life' and have been based on first-hand observation, the image he produces clearly owes as much to Dürer's drawing as to his actual encounter with 'the motif' (Illus.

5). The persistence of Dürer's chimerical beast attests to the importance, not only in this limited case but as a general rule for image practice, of inherited schemata.[15] Heath may not even have been aware of the degree of his dependence on Dürer's precedent and in the daily, practical activity of art history it is at present not considered essential, when positing image x as a source for image y, evidentially to prove that the producer of y actually saw image x at such and such a time, or to enquire into the level of conscious awareness of the source (all that need be proven is that it would have been *possible* for the producer of image y to have seen image x). The artistic schema here directly matches the scientific hypothesis in Popper's account of objective knowledge: repeated observation of the natural world enables the continuous falsification of the earlier hypothesis, and the continuous future refinement of hypotheses. At no point will the rhinoceros be perfectly represented, any more than the scientific proposition based on falsifiable observation will yield a verifiable and absolute natural law. The

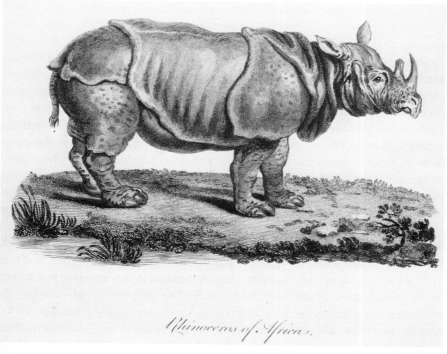

Rhinoceros of Africa.

5 Heath, *Rhinoceros*

object towards which both scientist and artist direct their attention is not simply the world 'out there', as in induction, or in Pliny's *Natural History*, but a double entity: hypothesis-in-interaction-with-the-world.

At this point we must ask of the schema a crucial question: are we to think of it as an objective structure, like a *stencil*, mediating between retina and brush, a set of received formulae operating exclusively, so to speak, in the hand and musculature of the painter, or is it a mental structure, like a *Gestalt*, responsible for configuring the perception of the artist into distinctive and historically localised form? To put this another way: is it a *manual* entity, whose existence is confined to the habitual muscular training of the painter's hand; or a *noumenal* entity, residing within the painter's field of consciousness?

It must be said that Gombrich himself oscillates, to the confusion of many of his readers, between the two positions.[16] There is, of course, no reason why the schema should not, following an Anglican compromise, be both of these things: a schema might exist partly in the form of a Gestalt filtering the content of sensory stimuli in a certain way, screening out some stimuli and giving priority to others, and constructing a distinctive image of the exterior world within the painter's perceiving consciousness. At the same time the same schema, or a second schema working in unison with the first, might then act as a further filter between the field of consciousness and the surface worked by the hand. A rough combination of the manual and noumenal senses of the word 'schema' is probably what unreflecting opinion is content to take away from the argument. Nevertheless, the two senses are diametrically opposed, and for the purposes of analysis must be kept in strict separation. While a blurred fusion of the two positions may seem satisfactorily to advance beyond the far less sophisticated account offered by the Plinian tradition, inquiry into each distinct position in turn raises serious doubts as to whether the tradition has been questioned in any significant way.

If the schema is to be understood in a manual or executive sense, then the account has not moved appreciably beyond the stage established by Morelli. The science of attribution had already isolated a complex body of typical morphologies whereby the identity of the painter could be decided on fairly objective grounds.[17] To be sure, the purpose Gombrich has in mind for the schema is far larger than mere ascription: its scope is far greater than Morelli's narrow focus on the individual painter. Where Morelli is concerned with the schema as the signature of individuality, it is exactly the schema's transpersonal nature that is of interest to Gombrich.

History is admitted as a force acting at a higher level than that of the individual biography: the schemata are seen as a general cultural legacy available to the individual artist as a total repertoire of potentialities, and then localised and adapted by the individual painter in the immediate circumstances of painting practice. We may say that whereas Morelli screens out the general legacy as the area which, because transpersonal, will be of no use to the science of attribution, and that he concentrates exclusively on individual variation of schemata, Gombrich gives equal weight to both terms. Yet neither Morelli nor the Gombrich of the manual schema breaks with the traditional emphasis on the dualistic portrayal of the encounter between the painter and the world: a third term is added – the corpus of schemata – but only as a problem of competence, of efficient performance of the transcriptive task. The Essential Copy, here, can not only be created but to within a hair's breadth can be known to have been created. The only impediment that remains concerns the *measurement of discrepancy* between the Essential Copy and the reality towards which Gombrich insists the image can only 'approximate'.

This point needs careful clarification. All systems of measurement are subject to the limitations imposed by their instruments of calibration. Let us say that a section of plastic is to be cut to a measure exactly one metre in length. An accurate result will be obtained by comparing the block, after cutting, against the original metre that serves as a standard for all metrical calculation. In order to estimate the discrepancy between that Ur-metre and the block, a scalar instrument must be employed that will gauge the discrepancy between the two lengths (in practice, only that instrument will be used to measure the block). The accuracy of the instrument's gauge may be of a high order: the divisions of the scale are, say, in fractions of a millionth of a millimetre. Yet within the margins of two divisions of the scale between which each end of the block falls, the exact termini of the block cannot be determined. It may be the case that the block is precisely the length of the Ur-metre. But that cannot be ascertained with certainty. The gauge-divisions of measuring instruments may evolve towards ever greater refinement, yet exact measurement is not a process that is ever met with in experience – even when the two objects being compared are, in fact, of identical dimensions.

In terms of the manual schema, and its relation to the Essential Copy, we can therefore say this: schemata might go on being refined until they reached a point where the resultant representation approximated the anterior reality to a very high degree; although – and it is this that Gom-

brich lays stress on, as part of his apparent renunciation of the Essential Copy – just as measurement in absolute terms can never actually be carried out, being subject at every turn to the limitations of the calibrating instrument, it would be impossible to determine whether an Essential Copy had actually been achieved. But however much the argument for the relativity of measurement is stressed, there remains a crucial, and insuperable, objection. In the same way it is possible for the block cut from plastic to be identical in length to the Ur-metre (although that identity can never be ascertained with certainty) it is possible for the copy to coincide in its dimensions *exactly* with the prior object of representation. While the matter can never be proved, nonetheless it is possible that an Essential Copy had in fact been made.

The schema considered as an executive instrument allows, therefore, for perfect illusionism; the fables of Zeuxis are reinforced and renovated. Indeed, we note here an asymmetry between Gombrich and Popper in which the domains of art and science are mutually out of phase. The crucial objection raised by Hume against the principle of induction concerned the *predictive* value of 'laws' derived from observation: that the sun has risen at the dawn of every day of which we possess records in no way entails that it will rise again tomorrow; we will never, accordingly, be able to derive from experience a body of physical laws that will be true for all time, an ultimate blueprint of the universe's structure. Yet however much the predictive aspect of scientific propositions is threatened by the Humeian objection, there is no reason to suppose that the vicissitudes of induction here, within science, will have their immediate counterpart within art. In fact the sense of a painting's having *predictive* value is obscure. A camera reproduces the phenomena in front of its lens without meditation on the laws governing those phenomena: to rule out the ultimate blueprint of scientific law does not rule out the Essential Copy at one and the same stroke. Popper's concern is with the status of scientific propositions, and were we to imagine a scale for the status of propositions, it would be a scale of *validity*. Predictive propositions would not be accorded absolute validity, being always provisional; nor would statements of measurement, since measurement is always subject to the limitations of calibration. The scale along which the artistic representation moves is one of *accuracy*: 'tomorrow' does not feature in its calculations, since everything turns on the degree of approximation between the original reality and its copy *now*, in this instant of time when the two can be seen together, as the copy is completed. There may be no future occasion when the two can be

compared. And while accurate measurement of discrepancy between the two is incalculable (a limitation on the validity of statements of measurement), it may nevertheless be the case that the two terms, original and copy, are dimensionally identical and that the Essential Copy has in fact been actualised. The asymmetry is therefore total: the Ultimate Blueprint can never, the Essential Copy can certainly come into being.

If the schema is to be understood in a noumenal sense (Gestalt rather than stencil), the situation of Gombrich's account changes; it must be said that the account becomes among other things much more interesting. The claim now made for the schema is that it lodges within the perceptual rather than the performative apparatus of the painter: in the nervous system, so to speak, rather than in the musculature. The world reflected by the painting exists within the consciousness of the painter, which however is no longer to be equated with the retinal surface or image but with the mental image processed by the brain out of the neural messages arriving from the retinal membrane. Although the word 'Gestalt' is probably the best shorthand term for designating the structures intervening between the stimuli and the noumenal field, the term does not do justice to the historicism of Gombrich's description. A perceptual Gestalt, in its classical definition and exposition, is a physiological datum – the workings of a Gestalt will be the same for all members of the species and are not constructed in the first place by cultural experience and cultural work, although these may be able to some extent to modify the Gestalt.[18] What is interesting about Gombrich's schema, noumenally defined, is its immanence in history. Giotto *perceives* the subject before him through the grid inherited from Cimabue, until by focused attention he discovers the grid to be inadequate to the complexity of the observed material. Giotto's modification of the schema is then recorded on the pictorial surface, and this will in turn serve to provide the grid through which those who follow may organise their own perceptual material. The claim is that perception follows the same route as the Popperian hypothesis:

$$P^1 \rightarrow TS \rightarrow EE \rightarrow P^2$$

Let us imagine that a painter comes across a phenomenon in the physical world which he is unable, given the limited schemata at his disposal, to register on canvas or even to hold clearly before his eyes: it is a subtle, elusive detail he has not remarked before in the visual field; certainly he has never seen it represented within the image. Even attending to it and

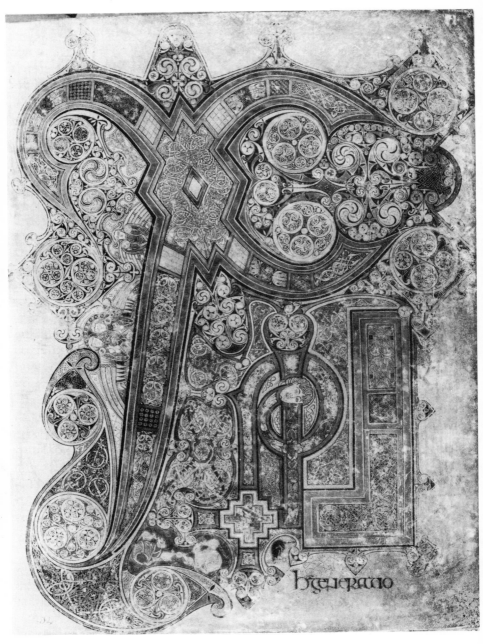

6 Chi-Rho Page, *The Book of Kells*

fixing his mind upon it requires a tenacious effort: he has noticed that some of the shadows cast by the objects before him are faintly, yet distinctly, blue in coloration – even though he can find neither a blue-looking source of light nor any actually blue objects in the visual field; it is a sort of nebulous haze, reminiscent of an aerial perspective yet affecting objects that are physically near (P^1). He attributes the shadow to a slight deviation of the atmosphere from normal conditions: the air here, he supposes, is somewhat smoky; and he registers the supposition on canvas by casting over his image a glaze of almost imperceptible milkiness (TS). Yet turning again to the phenomenon, after completing the glaze, he recognises that there is a discrepancy between the image and what he now, more clearly, perceives: not all of the objects are evenly saturated with the bluish cast (EE); and he cannot work out why this should be so (P^2). Perhaps there is a slight redness in one of the scene's sources of light: where the light from the source is obstructed by one of the objects, the residual light seems blue by contrast (TS). Yet even this will not do; the distribution of colour varies from place to place (EE $\rightarrow P^3$); and he constructs a further hypothesis, that shadows vary in colour according to the colour of objects near the shadows, objects reflecting their own colour into the shaded areas (TS).

This stress on the hypothetical character of perception is backed by now-famous diagrammatic examples. The hoariest of these chestnuts is the drawing which looked at one way seems to represent a duck, and another way a rabbit; a further diagram, rather more strained, shows an attractive young girl who shortly transforms into a withered crone (the 'Wife/Mother-in-law').[19] The point is that the drawings do not change, only the perceptual configurations we bring to them; configurations that may relate to the neurological Gestalten of perceptual psychology, but also depend on taxonomies and categories which the perceiver brings to the drawings as part of his general experience of enculturation. The moral is that all artistic creation follows these lines: the painter, working with (of course) infinitely more sophisticated visual hypotheses, activates these structures in his painting practice; where the structures prove inadequate, he devises new ones; and so on.

A conspicuous merit of the hypothesis-theory of perception, though its advantages took some time to emerge fully, is its ability to account for non-representational art: for many years readers of *Art and Illusion* had supposed that the weakness of Gombrich's arguments lay in their fixation on representationalism and that Western twentieth-century painting, for example, lay beyond their scope. Yet by the simple substitution of the

viewer for the painter, the hypothesis-theory is able to advance into the territory of abstraction with ease.[20] Illustration 6 shows a page from the Book of Kells. It is recognisable at once as a representation of the Greek letters *chi* and *rho*; and whatever may subsequently happen to vision as it probes the interior of the letters and the intervening spaces between them, the overriding shape of the characters stakes out the fundamental boundaries and resting-places for the adventures and vagaries of a glance soon driven to perpetual mobility. The eye may come to welcome the hospitality of these enclosures as much for relief as for orientation, for once vision has left their confines and has plunged away from their sides it is caught in mazes so intricate and so devoid of termini that before long only two options seem to exist: either to follow the labyrinths faithfully to their exits and entrances (where these exist), or to derail the glance and to create visual trajectories that refuse the complex *entrelacements* mapped out definitively by the design. Only the former course does justice to the planning behind the Chi-Rho page. The presence of symmetry, of privileged areas that are variously cross-overs, entrances, exits, and pivots of rotation, all these promise that vision will be able to resolve the tangled surface into separate strands and to apprehend the hidden logic behind their apparent confusion. The eye needs only to forge *hypotheses*: if this band is taken to be 'above' the band it crosses, what is its resultant fate? The task of keeping track is countered by a suite of playful obstacles: here the band seems to cross both above and below, there it meets a clover-leaf junction where its re-routing overturns expectation, there again it seems to falter under the impact of a design clearly separate before but now encroaching into it, capturing it and carrying it away as plunder. Combining the strengths of meticulousness and of anarchy, the lines know in advance the pleasures they can yield by playing into the speculative gaze. When it is safe to assume that the viewer is myopically detained by the plaiting of minute abstract forms or is fully taken up in pursuit of a complex pattern back to its lair, it is then that the lines release their wild anthropomorphic and zoomorphic repertory, of domestic animals and fabulous beasts, disembodied heads and chimerical angels. When an obvious symmetry, coloured highlight, or other distraction can be relied on to draw the first tentative explorations of the probing eye, the lines at first clear before it the smoothest of paths and supply unequivocal signpostings; but a moment later the signposts are pointing in opposite directions at once, the band has narrowed to a filament, and a competition has begun between the rival skills of viewer and craftsman – between the eye of the needle and its

thread. The mind, fascinated with fascination itself, discovers in the pleasures of abstraction all the happiness of Binet's lathe, in *Madame Bovary*; hypothesis and counter-example interlocking in a satisfaction where all aspiration ends.[21]

There is little point in dwelling on the drastic reductivism of this description of non-figurative art; except perhaps to observe that a theory which ends by reducing the achievement of Klee, of Mondrian, of Jackson Pollock, to the level of a visual *puzzle*, cannot do much to further our understanding of non-representational art in this or in any other century: it is difficult to conceive of a theory of 'abstract' art more committed to its banalisation and trivialisation. More to the point, for our present purpose, is the theory's confirmation of the exclusive stress placed by Gombrich on *cognition* as the motor of artistic production, and on the all-embracing claim made for the perceptual hypothesis; it is this claim we will continue to examine. Fully elaborated, the claim comes close to producing a kind of phenomological *épochè*.[22] The picture of the world constructed within the painter's perceptual consciousness is posited as the source of the image, subject to possible and further filtration by the schema's performative intervention. This picture is not in any sense absolute, is not itself an Essential Copy of the world existing 'out there' beyond the retinal bar, and for this reason the images made from the picture can never themselves be regarded as Essential Copies of the world in the style of the natural attitude. What the painter perceives is a construct derived from, but not identical to, the retinal stimuli arriving from the outer reality, and the construct varies according to the degree of development within the schemata: Cimabue perceives in a manner that is less differentiated than that of Giotto. Perception is therefore an historically determined process, never yielding direct access between consciousness and the outer world but instead disclosing the limited version of that outer reality which the given stage of evolution in the schemata permits. To the extent that the theory includes the dimension of history, and indeed extends 'history' into the innermost recesses of the perceiving brain, it marks a radical break with the traditional account of what painting is and what it represents. It converges with and amplifies the cultural relativism where the terms 'naturalisation' and 'habitus' have important tasks to perform. Perhaps this is to be over-generous towards the kind of implicit anti-historicism revealed in what the theory has to say about non-figurative art, as it is revealed also in the duck–rabbit and related diagrams, where the hypotheses activated by the viewer are so primitive ('is the band "above"

or "below"') as to be almost indistinguishable from the rudimentary neurological Gestalten of Köhler and Koffka: but let us stay with schemata of a more sophisticated order, of the kind we might suppose activated by Giotto or Dürer or Constable. Is it actually the case that the mental field they 'construct' is of a historically fluctuating nature?

The following is a passage from Popper's *Conjectures and Refutations*.

> The belief that science proceeds from observation to theory is still so widely and so firmly held that my denial of it often met with incredulity Twenty-five years ago I tried to bring home (this) point to a group of physics students in Vienna by beginning a lecture with the following instructions: 'Take pencil and paper; carefully observe, and write down what you have observed!' They asked, of course, *what* I wanted them to observe. Clearly the instruction, 'Observe!' is absurd Observation is always selective. It needs a chosen object, a definite task, an interest, a point of view, a problem . . . it presupposes similarity and classification, which in its turn presupposes interests, points of view, and problems.[23]

The painter, in Gombrich's view, is in the same position as Popper's students. Without the instructions that indicate *what* is to be observed, observation cannot begin, and it is just this needed set of instructions that the schema supplies. Indeed a minor problem emerges here concerning the origin of the schema, for if observation is *always* selective and dependent upon schemata and if the schemata are constructed by the active work of the perceiver (unlike the biologically given Gestalten of Köhler and Koffka) then it is difficult to see how the first observation – the first perception – could have arisen. Popper, who with the words 'a definite task, an interest, a point of view' links observation to a material reality where necessary labour is to be performed, is able to resolve the problem by going *outside* the circle of perception into the realm of physical necessity: the hunter who is hungry is going to start looking for food. Gombrich's attempted resolution of the problem of the first schema is, significantly, divorced from such pressing concerns: the first artistic schemata, he speculates, were formed within the orbit of perception in an encounter between the eye and visual *randomness*; unable to make sense of the randomness, vision formed a randomly chosen schema (no external or material pressures at this point recommended one schema over another). Once begun, the process of schema-building gradually increased the extent and

sophistication of its repertoire, eventually yielding a coherent visual field. [24]
It might seem, if we are unwary, that Gombrich's account is now identical
to the sociology of knowledge's 'construction of reality' since the perceiver
starts off with a *tabula rasa* and his perception of outer reality is formed
entirely on the stage of history. But it is still true that in Gombrich's view
the participation of others only aids and accelerates (as Cimabue aided
Giotto) a process of reality-building which the individual could carry out,
at an admittedly much slower rate, even if he existed in Adamic solitude.
To conflate Gombrich with Berger, Luckmann, or Alfred Schutz would be
a mistake. Let us see what happens if we try to do so. The painter con-
structs a world out of noumenally existent schemata: the society constructs
a world out of social codes.

But the symmetry of the diagram is false. The structures proposed by the
sociology of knowledge construct reality *in toto*: there is no other Reality to
be experienced beyond the reality the social process constructs. But in
Gombrich's account there is always an ulterior and veridical world which
exceeds the limited, provisional world-picture built from schema and
hypothesis.

 Let us return to the painter at work. His instruments include not only
brush, pigment, and canvas but a whole repertoire of visual hypotheses
that come to him from his artistic tradition. The hypotheses are found to
work until observation discloses a counter-example; at that moment they
cease to perform efficiently.

$$P^I \rightarrow TS \rightarrow EE \rightarrow P^2$$

Point P^I, the emergence of the problem, is created at the instant when the
schemata no longer function, when an ulterior world breaks through the
reticulated layers of perception and filtration with stimuli too powerful for
the schemata to censor or screen out. In order to cope with P^I, the painter

constructs a hypothesis that will, he hopes, restore the systems of filtration to order; yet invariably it proves, in time, inadequate to the task in that certain stimuli continue to stream in as anomaly, aberration. This is exactly what happens at EE: the painter/scientist discovers what errors are yet to be accounted for. In the course of examining these, he uncovers further problems; that is, observations which formerly had failed either to be observed or to be recorded generate a new cycle of hypotheses. At each point of movement in the linear diagram there is access from the observer to the external world; at each transitional stage in the process the schemata or hypotheses are rendered inoperative as raw and disorderly stimuli press past them from the outside.

The account is in open contradiction with itself. It posits a separation between the stream of information coming into the mind so to speak at the gate, and the structures – hypotheses or schemata – which *then*, at a subsequent stage, intervene to 'order' the information. It demands, in other words, that we envisage a first state in which the sensations or stimuli are exterior to the structures that are fated to intervene; and in so far as it makes that demand it establishes that we can know that first state *eo ipso*, by-passing the structure of filtration. This insistence on a separate first stage belongs to the expository order of the account and might, perhaps, be regarded in wholly abstract terms as a component of the theory necessary to its intelligibility but not empirically discoverable without manifestation in the world. Yet it is then *re*-stated as a crucial phase in actual perceptual work. The stage when the schemata/hypotheses cease to 'work' is not a momentary embarrassment to the account, a split-second anomaly which it is best to leave to others to sort out, while the history of science and of art pursue the more serious question of the important 'intervening' structures. That moment recurs again and again. It is when theories break down in the light of observations that contradict them that falsification occurs: it is *the* crucial moment; and at that moment the screens of speculation are broken open in a dyadic encounter between self and world with all the qualities of directness and absence of mediation familiar from innocent or Plinian vision. The only significant difference between Pliny and Gombrich here is that whereas for Pliny the encounter is continuous, for Gombrich it is intermittent: grey and monotonous periods of rule by aberrant schemata, interrupted by the brilliant restorative flash of falsification.

Infrequent though its occurrence may be, polluted by the inert residue of erroneous schemata though it may become, access to a world beyond the

schema, a world against which the schema is constantly to be tested, is therefore central to Gombrich's account. Where unmediated contact between consciousness and world is able to take place, the only difficulties that remain for the production of the Essential Copy are on the executive or manual side of the schema. Progress towards that Copy will be slow but inevitable since the 'falsification test' will constantly triangulate the schema's position in relation to the world beyond it.

Yet how inevitable is that progress? Both Popper and Gombrich would seem to subscribe to the very error of 'accretionism' they had criticised in inductive method. Their argument appears to work by subtraction. Just as the withdrawal of psychic projections from the world is supposed, by certain psychologists, to result in clear and mature perception of its real nature, so the elimination of error is alleged to constitute of itself advance towards knowledge. In the case of the linear diagram $P^1 \rightarrow TS \rightarrow EE \rightarrow P^2$, the possibility of its *cyclical* nature is denied. Even complete failure to solve P^I is believed to teach at least this, that the particular trial solution applied was wrong; its falsification may be reckoned to mark a decrease in the total sum of our ignorance.[25] Before, we did not know TS to be absurd: now we do. But inability to start the car can hardly be counted as part of the journey. Suppose that a second, a third, a million such trial solutions are tried and abandoned: are we any nearer our destination? Indeed, it seems quite possible to argue that the creation of the second, third and millionth erroneous trial solution amounts to an increase in the total sum of our ignorance, rather than the reverse. Access to a world beyond the schema is essential if the false start is to be distinguished from advance, and both of these distinguished from regression: the difference between *progress* and *change* depends on our knowing in advance the conclusion of the process, so that degrees of distance towards and away from the conclusion may be measured.[26] Between Cimabue and Giotto there is certainly change, but our decision to call it advance rather than to categorise Cimabue and Giotto as two equally invalid 'false starts' will depend on their degree of approximation to the Essential Copy: the latter is essential to the doctrine of progress, even when Giotto's advance beyond Cimabue is alleged to consist in the elimination of Cimabue's errors. And for as long as the Essential Copy remains a necessary component in the theorisation of painting, analysis of the image will continue to preclude the dimension of history.

Chapter Three
Perceptualism

Stylistics and iconology enjoy a prestige in art historical writing without precedent before the present century. The perfection of the stylistic analysis inaugurated by Morelli and Berenson, together with the refinement of the iconological analysis pioneered by Warburg, Saxl, Wind, and Panofsky, continue to occupy the operational centre of the modern discipline of art history. Few would contest that the double focus on stylistics and on iconology has produced remarkable results. At the same time many observers, and particularly those looking in on art history from the outside, are aware that in comparison with the other disciplines within the humanities, art history presents a spectacle of conspicuously 'uneven' development.[1] While the past three decades have witnessed extraordinary transformation in disciplines as diverse as anthropology, linguistics, literary criticism, sociology, historiography, and psychoanalysis, the discipline known as the History of Art has over the same period come to seem less and less capable of growth, static where it is not stagnant, and increasingly out of touch with developments in what once had been its intellectual vicinity. While elsewhere innovations have occurred which might have provided art history with an infusion of fresh ideas and techniques, art historical scholarship in general, and the study of painting in particular, has remained largely isolated, or unresponsive. Although an impressive table of factors responsible for the present situation is not difficult to draw up, a table which would almost certainly include the distortions which prevailing art history owes to a market interested in the pursuit of attribution, in the use of documentary sources as confirmation of provenance, in the exploitation of journals for the purposes of trade, in the construction of expertise capable of direct insertion into market transactions, and in the cultivation of a general climate of positivism in keeping with the status of the art-work as commodity, alongside these should be included a state of intellectual *impasse* which, given the poverty of methodological discussion

37

increasingly evident in the discipline, effectively binds art history to a prior historical and cultural context; a theoretical paralysis which, once the assumptions of prevailing or official art history are openly investigated, must strike the observer from any other subject within the humanities as, simply, inevitable. An underlying configuration of ideas as distressed by contradiction as that which currently prevails, is unlikely to convince or to energise; and where it fails to convince, it will tend under present circumstances to drive a community of scholars already discouraged from 'speculation' still deeper into the proceduralism and protocol of 'normal science', or normalised professionalism.

Less pessimistically, it must be said that the present *impasse* displays all the characteristics of transition. The two traditions of stylistics and of iconology, developed in conditions of mutual separation (which in England find concrete expression in the institutional separation of 'the Warburg' from 'the Courtauld'), imminently converge upon the entity each has been forced to ignore: the painting *as sign*. The weakness here is symmetrical. Stylistics on its own is committed to a morphological approach that denies or brackets out the semantic dimension of the image: iconology on its own tends to disregard the materiality of painting practice; only in a 'combined analysis' giving equal consideration to 'signifier' and 'signified' within the painterly sign can this structural and self-paralysing weakness be overcome.[2]

At the level of theory, the concept which suppresses the emergence of the sign as object of art historical knowledge is *mimesis*. The doctrine of mimesis may be said to consist in a description of representation as a process of perceptual *correspondence* where the image is said to match ('making and matching'), with varying degrees of success, a full established and anterior reality. The model is one of *communication* from a site of origin, replete with perceptual material, across a channel troubled by various (and perhaps diminishing) levels of 'noise', towards a site of reception which will, in ideal conditions, reproduce and re-experience the prior material of perception. The model itself is untroubled by the question whether that prior material is constituted from unequivocally empirical sensory data or from a non-empirical 'vision' without counterpart in the objective world: for as long as the original vision, of whatever nature, is *imparted*, the conditions of mimesis have been fulfilled. The mimetic doctrine can therefore be summed up in a single word: *recognition*; and it is the logic of the word 'recognition' we must now consider.

Its sense is far from simple. In such statements as 'I know that face',

'Now I see where we are', recognition involves a direct comparison between two terms, the anterior and the posterior occurrence. An act of recollection is performed: the new or present datum is referred to and placed alongside an earlier datum retrieved from memory. We can designate this as recognition in its most fundamental and rudimentary form; yet in such statements as 'Now I understand, looking at the *View of Toledo*, what El Greco meant by divine retribution', or 'Now I see what Grünewald understood by humiliation', a quite different process is at work: in these statements, as with all propositions that concern recognition of intentions said to exist 'behind' a particular image, and all acts of apprehension where the viewer grasps a gerundive content to-be-expressed by way of the image, cross-reference and comparison between present and prior data does not occur. While it might be possible for the painter to know that his image corresponds to his original perception or intention, no such knowledge is available to the viewer: the latter can only see what the painter has set down on canvas. In order to provide an equivalent to the test where, in recollective recognition, two similar or identical data are placed in adjacency for comparative evaluation, recognition in this more complex and clearly non-recollective case must resort to the concept, propounded earlier in the statement from Francastel, of universal visual experience, as the only guarantee that the viewer will perceive *the same entity* as the painter, that the mental field of origin matches the mental field of reception. Because we are all human and thereby share a neurological apparatus of vision which we can take, save for cases of obvious malfunction, as behaving in the same way for everyone, there seems no reason to doubt that what a painter understands by, say, a hand is exactly what everyone understands by it.[3] Yet how can we be sure that visual experience is universally similar? What guarantees the guarantee?

Does our 'belief' that other people have minds belong to the noumenal or to the phenomenal world?[4] Is it a mental state without manifestation beyond the field of consciousness, or should we rather call this belief an *attitude*, where the latter word includes not only an unvisible and unmanifested dimension of faith, but concrete expression outside the noumenal field? If called upon to account for my feeling of pity towards a man in pain, I may justify my feeling by pointing to his pain-behaviour. In such a response am I justifying a belief, or an attitude?[5] From one point of view, belief would seem the correct description: the emotion of pity is a form of *conviction* that someone else is in pain.[6] Yet what I am justifying is not only a conviction which may or may not have manifested outside the

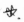

noumenal field: in so far as the conviction has been questioned by the person calling upon me to justify it, it has manifested beyond the noumenal, and the word 'attitude' is accordingly indicated. In turn, my experience of the emotion of pity does not entail reference to an inaccessible and undemonstrable state of pain internal to the man whose pain-behaviour I witness. Rather, my belief in his pain involves a readiness to act in certain ways, for instance to go to his aid, action which itself involves reference beyond the noumenal boundary of belief to the outward orientation of attitude. My belief in his pain is known to others only in so far as it becomes embodied in attitude; as a result of their reflection upon my evident response, others may come to 'share' my belief in his pain. We thus have three possible noumenal fields interactively present in the scene of pain: the man in pain; a sympathetic observer, 'myself'; and others who come to share my sympathy, whether as a consequence of contact with myself (the hospital answering my emergency call), or as a consequence of contact only with the man in pain (others arriving as I telephone), or both together. Yet none of these potential noumenal fields has actually participated in the drama. At no point (at none of the three points of agency in the scene) has 'belief' depended upon knowledge of, *or even inference towards*, inward mental events separable from the behaviour of pain or sympathy: it has throughout taken as its object the attitude of others, just as it has been known to others itself as attitude.[7] Again, an individual might always use the sentence 'I am in pain' correctly, in that he groans and complains of pain whenever the hammer strikes his finger instead of the nail; or might always use correctly the word 'red', in that he is always able to pick out red objects when called upon to do so, and consistently passes all the tests designed to detect colour-blindness: yet 'in fact', in the private realm of his sensations, he may have *only* experiences that others would identify as 'pleasure', or 'blue'. The point does not concern this multiplicity of private worlds contingently linked to linguistic expression, this colourful possibility of subjectivities infinitely diverse; rather it concerns the undemonstrability of such rainbow variation, and the aspect of redundancy which would characterise evidence of variation even if it could be presented.

The immediate application of these remarks is to the act of recognition as understood by the mimetic theory of the image. In so far as the theory refers to an original set of perceptions occurring within the mind of the painter and transferred by him on to canvas, it anchors itself in the noumenal field in the way associated with belief; anchors itself in what is

in the first place undemonstrable, and in the second in what, even if successfully demonstrated, would not affect (either by addition or by contradiction) the viewer's ability to recognise the marks on canvas. In viewing-recognition there is neither knowledge of, nor inference towards, an Ur-event in the painter's mind which the viewer compares with the image before him. To transpose the terms: is our belief that someone else has recognised the content of an image a belief, or an attitude? I may be convinced that an individual looking at an image and identifying the same content which I myself find in it, is (noumenally considered) in the same state-of-having-recognised-the-image as myself. Yet my belief in the successful act of recognition does not entail a journey into the hinterland of the other's subjectivity, but rather observation of the viewer's recognition-behaviour, and indeed both his and my observation (in the sense of 'obedience') have reference only to the socially constructed codes of recognition. Recalling the earlier example of the man who 'experienced' as blue what others would call red, it is clear that the same *contingency, undemonstrability, and redundancy* evident there, obtain also in the case of recognising the image. And just as recognising the content of the image does not of itself entail reference to an Ur-reality existing within the painter's mental field and anterior to the marks on canvas, neither does it involve, in observing the reactions of recognition in another individual, cross-reference or comparison between the mental field of 'myself' and events in that other individual's corresponding mental field, in separation from his or her behaviour of recognition. When I look at an image, there may well occur in my mind a set of sensations which I can obtain only when I look at *this* image, and no other; sensations which need not only be, so to say, retinal, but may involve the most private recesses of sensibility ('it makes me think of Michelozzo, of a certain afternoon in Florence, when the silhouette of the Uffizi seemed cut out of card, and a cat leapt from the guttering . . .'). Yet the occurrence of mental events supplies neither a necessary nor a sufficient criterion for recognition. Even if a transcendental probe or speculum enabled us to have access to the mental field, and there we were to discover the reminiscence of that Tuscan afternoon, what would be the bearing of the discovery on recognition of the image? 'Possibly he had a special experience . . . but for us it is the circumstances under which he had such an experience that justify him in saying in such a case that he understands, that he knows how to go on.'[8] Putting the idiosyncrasies of sensibility to one side, and staying only with what would be generally regarded as appropriate recognitive response or men-

tal events 'relevant to recognition' (though the question of relevance is precisely what is at issue), let us say that the probe discovered a mental event which does not deviate so strikingly, if at all, into private association: is then the *congruence* between image and mental event to be thought the criterion for recognition?

Certainly such a criterion would be unacceptable in the case of sign-systems other than painting. With mathematics, for example, I may indeed have a vivid picture in my mind of a certain formula, but the criterion of my knowing that the picture was a *formula* would be my awareness of its mathematical application.[9] The test of whether or not I had understood the formula would not consist in examination of my private mental spaces, or of 'Now I see how it works!' experiences, but in seeing if I can place the formula in the general context of my knowledge of mathematical techniques, in my ability to carry out related calculations; in short, in my executive use of the formula. Again, in the case of a child learning to read it is hard to determine the sense of the question, 'which was the first word he or she *read*?' The question seems to appeal to an inward accompaniment to the physical progress of the eye through the suite of letters, an accompaniment which at a particular point takes the form of 'now I can read' sensation.[10] Yet the criterion for right reading cannot be this: the child might well have such a sensation, yet be quite unable to read correctly; where reading, like the activity of mathematics, and like the recognition of an image, can be said to take place only when the subject is able to 'go on'; not to reveal to the world a secret event of the interior, but to meet the executive demands placed upon the subject from the outside.

The domain within which recognition occurs is accordingly that of society: it is a fully material and observable *action*. In our drama of pain, it is conceivable that at each of the three points of participation – the man in pain, 'myself', and the other observers – a noumenal field of 'belief' exactly matches the behavioural activity of 'attitude'. The man in pain may be experiencing sensations identical to the sensations anyone else would have 'in his place'; exploring his subjectivity, the transcendental probe would find 'pain', not 'pleasure', and 'red', not 'blue'. The pity I experience may match precisely the inward emotion of the others at the scene. Yet without their manifestation in the world, there is no way either to verify or to falsify statements concerning these invisible inwardnesses. It is equally conceivable that at each point of participation there is incommensurable discrepancy. We cannot, therefore, say that 'consciousness arises and becomes viable fact only in the material embodiment of signs'; proposi-

tions concerning the emergence, whether gradual, instantaneous, causal, or contingent, of consciousness into the sign, are neither logically nor empirically coherent. Recognition involves the activation of socially constructed and maintained codes of recognition which at no point plunge into an inner being, non-material in nature and unembodied in signs. Yet it is precisely the social and material character of recognition which the classical account of painting, from Pliny onwards, seeks to deny. The concept of *universal* visual experience is, so to speak, an amplification to the greatest magnitude of the possible identity of noumenal fields at the three points of our drama of pain: it extends that possible identity to the whole human species and across its entire history. Yet the only noumenal field with possible access exists solely at the point marked, in the drama, by 'myself'. Even if it is true that I possess a field of consciousness separable from its manifestation in the world, to generalise from one case to an entire species cannot be regarded as a valid procedure. By the same token, it is invalid to deny the possibility of congruent private experiences at the three points of agency in the pain example, or to deny the possibility of universal visual experience: what is posited is the invalidity of propositions concerning the existence and nature of that universal visual experience. It is this condition which the theorisation of painting in terms of mimesis fails to fulfil. The domain to which painting belongs, in mimetic doctrine, is that of perception, not recognition; the painting relays perceptual material from site of origin to site of reception, with, under ideal conditions, no interference from outside the channel of transmission. The sophistication of Gombrich's account certainly lies in its admission of the exterior as the provider of means through which transmission can take place: when the repertoire of schemata is sufficiently developed, perceptual material may be cycled without undue distortion, and in the final stage of development with no distortion at all. But the transaction is understood throughout as cognitive in nature; even in the case of non-representational art, perception and cognition form the basic mode in which viewer and image interact.

Perhaps the most negative consequence of perceptualism is its bracketing-out of the constitutive role of the social formation in producing the codes of recognition which the image activates. Elimination of factors external to the perceptual transaction can be illustrated by the example of the discussion, in *Art and Illusion*, of Constable's *Wivenhoe Park*.[11] Constable's effort is said to lie in removing from landscape painting the obfuscating schemata that have collected over generations within the genre; in

the name of natural science he has taken upon himself to produce what is
described as an 'art of truth'.[12] His task is that of the experimental scientist,
busy with the project of falsification: alone in nature, and occupying
within nature a position of isolated experimental observation (the names of
Galileo and of Huyghens are invoked), Constable adjusts the schemata
which tradition has supplied until the image on canvas corresponds to the
scene before his eyes. First, Constable surpasses the noumenal limitations
imposed upon his perception of Wivenhoe Park by the dead weight of
tradition – the cognitive distortions brought about by academic formulae
whose symbol is the 'Claude glass' (the polished copper reflector to which
the connoisseur of landscape had occasional recourse, as an aid in making
his perception of the scene before him conform to the admired canvases of
Claude). Second, Constable surpasses the limitations imposed upon his
capacity to transcribe the events occurring in the mental field by the crude
and stencil-like rigidity of the schemata understood in the manual sense –
schemata which introduce a second set of distortions and, unless cor-
rected, result in the mediocre landscape painting of official taste, rep-
resented here by the academism and pedantry of Constable's opponent
George Beaumont. Third, Constable surpasses the limitations imposed
by the medium itself, oil paint, which despite its density, recalcitrance,
opacity, he will handle in such a way that all the brilliance of light and shade
before him will be preserved in pigment, and preserved so perfectly that
the brilliance will survive even the fluctuating light of the gallery, where
paintings are seen one day in bright sunshine and another day in the dim
light of a rainy afternoon. Despite all the obstacles, the original luminosity
of Wivenhoe Park will *come through*, will pass across the threshold of the
canvas from the perceptual world of the painter into the perceiving mind
of the viewer, in a transaction where the element of codification, of distor-
tion, has been reduced to a minimum. No cultural training will be required
for the viewer to 'recognise' *Wivenhoe Park* – all he need do is consult his
own visual experience, which being universally true by-passes the artifice
laid over it by culture: the less enculturated the viewer is, the more accu-
rately will he perceive the accuracy of Constable's work; the more encultu-
rated he is, the likelier he will be to complain that it does not look suffi-
ciently like the views disclosed by Claude, the Claude glass, or George
Beaumont. Success here consists in the *shedding* of cultural forms, so that
nature may speak in her own accent ('the art pleases by reminding, not
deceiving').[13] And in case we have misunderstood that this has been the
goal, the account adduces its concluding piece of evidence, photographic

images of Wivenhoe Park; grown out of shape, and relayed by a medium with its own inevitable distortions, but nonetheless the true source of the communication, and its final guarantee.

Recognition of a mimesis is portrayed, in other words, as taking place in a cultural void. The less that culture (academism) intervenes, the more lifelike the image: remove 'projection' from the world, and the world will reveal its luminous essence. At the end of the process of falsification, an image will be produced that will contain no false information:[14] what is not false must be true; and true universally, since the false accretion of culture will have been discarded. Reduced to a rudimentary cognitive apparatus, both viewer and painter are abstracted from the practical and public sphere where alone the codes of recognition operate, to become in the end disembodied retinal reflectors, photosensitive machines: in the fantasy of a suddenly depopulated world where a camera is left to run, Constable's painting on this account would correspond to the camera's film.

To describe the nature and function of painting in these narrowly cognitive terms leads to the view of the interaction of social formation and schema in terms of *negativity* and *mutual exteriority*. Let us take the example of Byzantine representationalism. Illustrations 7 through 10 are images of the Nativity dispersed across an enormous geographical and temporal range.[15] Illustration 7, the earliest, is an ivory plaque from the throne of Maximian, Archbishop of Ravenna from 545 until 553. Illustration 8 is a squinch from a half-dome in the Church of El Adra at the Deir es Suryani monastery in Egypt; the wall-painting of combined Annunciation and Nativity dates from the tenth century. Illustration 9 is a mosaic from Hosias Loukas near Delphi, made around the year 1000. Illustration 10 is a decoration from the Church of the Peribleptos at Mistra in the Peloponnese, painted around 1350. Over eight centuries, and in widely diverse communities, the basic schema remains unchanged: the Virgin is always reclining and viewed from her right side, is always robed and hooded, is always placed within an irregular oval form which is at once mattress and mandorla; the Child is always to the right in a rectangular enclosure, its body diagonally swathed in cloth. Certain features are subject to local variation: the presence of angels, their number, and their disposition within the scene; the star, its beam of light; the presence of Joseph, the degree of Joseph's prominence: yet however much latitude is granted to such variation, the schema adheres faithfully to its component formulae.

To such absence of inventiveness, perceptualism must react with impatience: the artists are failing in their representational mission, and the

7 Throne of Maximian, Ravenna (detail)

8 *The Annunciation and the Nativity,* Deir es Suryani, Egypt

9 *Nativity*, Hosias Loukas, Delphi

10 *Nativity*, Church of the Peribleptos, Mistra

failure can have only two causes: either their eyes and minds are held captive to a mental schema they are unable to falsify by direct observation; or the manual schema possesses such sheer force of immobility that no craftsman is strong enough to dislodge it. The *intellectualism* of the account ascribing no role to the social formation, it cannot take into consideration the image as part of an ideology of Ecclesia:[16] ideology, a minor and remote component of the social formation, exists outside the artistic process and can at best only indicate that certain subjects be represented; its influence ends once the scene has appeared before the painter, for now the schemata intervening between the scene and the painter's mental field belong to the inside of the perceptual apparatus, to an invisible and interior domain; or to the inside of the technical process whereby the scene is exteriorised on canvas. The stasis of the image is attributed to the inertia of the perceptual apparatus, or of the painter's executive skill: analysis results in the dismal choice between stupidity and incompetence. Moreover, since the noumenal field of the craftsman is something that can never be demonstrated, this choice is itself paralysed: there is no way to distinguish between primitive mentality and primitive technique, although these are the only options available. Should the analyst feel that something is perhaps missing in the account, that possible extra-cognitive factors may share some responsibility for restraining the image from its inherent advance towards the *trecento* and beyond, the involvement of the social formation in the image will then be cast in negative terms: power, conceived as external to the image and pressing in on it from the outside, is holding the image down.

In reaction against a cognitive theory unable to explain the ubiquity and the endurance of the Byzantine schema except through appeal to primitivism, there emerges quite naturally a model of the interaction of social power and signifying practice that knows only two terms – the image robbed of its rightful independence and prevented from growth by *force majeure*, and the social formation as a separate and encroaching imperium of repressions, prohibitions, interdictions. When joined to a polemically simplified description of the distribution of power in the social formation, the resultant sociology of art can be relied on to relate its unsurprising findings: that group x produces style y, that this ruling group expresses its possession of power by means of that stylistic vehicle: the grey era of Lukács and Antal.[17]

Certainly recognition *can* occur without involvement of the social formation, as for example when an individual recognises a particular private

sensation as identical or similar to an earlier sensation; yet that kind of recognition is hardly what takes place when an individual looks at a painting. The act of purely private recognition, involving as it does the activation of personal memory, can be called recollection or reminiscence. With painting, the only individual capable of reminiscent recognition is the painter; yet even for him, in so far as the reminiscence is of a truly private nature, no test will be available to enable him to determine whether the content of memory being recognised is the same now as on the occasion of its original registration in memory, or whether the content has not in fact emerged at one stroke together with its sensation of *déjà vu*. [18] But recognition of a Nativity, or of a landscape by Constable, does not take place in this sequestered and uncertain hinterland: the codes of recognition here occupy the *interindividual* territory of the sign. The criterion of right recognition always involves *more than one observer*: it is essential that agreement exist to attach a term of recognition ('Nativity') to the image in regularised and consensual fashion; only *between* individuals does the medium of signs take shape. [19] Noumenal events may indeed accompany recognition, but in so far as recognition in any way submits to criteria of correctness it comes to operate within the world as *practical activity*, and no longer concerns the noumenal field: the latter may assume any guise we may attribute to it. Interaction between the image and the social formation cannot, therefore, be conceived as the convergence or the collision of two entities existing beforehand in mutual exteriority: sign and social formation are continuous and occupy the same 'inside' of semiotic process. The sign cannot exist outside the social formation, for only in as much as it has achieved consensual regularity does it exist as sign. It is wrong to think of the social formation as characteristically exerting *pressure* on the sign from an area beyond the sign, although this is an inevitable implication and tendency of the perceptualist account. There, the painter and the viewer commune in the privacy of noumenal fields mutually shared; the social formation remains on the outside and may be disregarded, or when the perceptualist account becomes unsatisfactory, as in the case of its description of the Byzantine image, and when 'social factors' are looked for to provide a modification or supplement to that account, again the social formation is thought of as influencing events in the perceptualist domain from outside. Yet the participation of the painterly sign in the social formation is immanent: the sign has its being in the interval *between* those who recognise it, and beyond that interindividual arc of recognition ceases to exist.

Illustrations 11 and 12 are representations of the Betrayal, by Duccio and by Giotto.[20] How are we to account for the conviction that persists – despite our awareness of the inadequacies of theories which involve the Essential Copy – that the Giotto is nevertheless decidedly more 'real' than the Duccio? for the feeling that it seems impossible not to view the distance between them in terms of progress?

Our perplexity may well increase when we recall the intense interest of the generation most immediately influenced by the work of Pierce and of Saussure in the concept of *motivation* in analysis of the sign. Pierce had postulated varying degrees of distance between symbolic systems and the world to which (as he saw it) they directly referred.[21] At one end of the spectrum he placed those systems where a natural or intrinsic relation obtained between the sign and its referential world. These he charac- terised as possessing 'motivation', in the sense that behind the sign was the backing of an ulterior phenomenal world which powered the sign directly from this prior origin: a photograph, for example, possessed high motivation, in that the meaning-bearing surface of the sign – the photo- sensitive plate – came into direct contact with the world at the moment of exposure. To the general class of sign systems where a direct link between the sign and its referent seemed to exist, Pierce gave the name of *index*. At the other end of the spectrum, under the general class-heading of *symbol*, were placed those systems where the relation between sign and referent seemed to Pierce conventional or artificial. There, no motivation is present: the connection between the sign and its meaning is formed exclusively within the intending consciousness. In language, for example, no resem- blance between a photograph and the word 'photograph' indicates that this and only this collection of syllables may act as the linguistic represen- tation. Given such a distinction, it seems therefore entirely possible to assign various positions within the spectrum to different systems of signs, in accordance with the index/symbol polarity: a photograph of a street taken at eye-level might be designated as closer to the extreme end of index than a photograph of the same street taken from a reconnaissance aircraft and requiring specialised decoding techniques; and so it might continue with many other systems – semaphore, traffic signals and codes, cinematic montage, sumptuary laws and conventions, heraldry, etiquette, cuisine, gestures: surely, on such a spectrum, the Duccio would be placed towards one end, the Giotto towards the other.

Yet the idea of spectrum, or of a sliding scale toward and away from 'natural resemblance' merely reiterates, in semiological language, the

archaic doctrine of the Essential Copy: certain sign-systems are claimed as naturally closer to the anterior reality they are said to reproduce, while others are formed at a distance from nature, as purely artificial conventions. The problem is this: to prove the validity of the sliding scale, it is necessary to appeal beyond the sign to a world disclosed to consciousness directly and without mediation, against which the different systems are then compared; and this raises the whole set of objections already levelled against the natural attitude. The idea of a sliding scale may be retained only on condition that for the concept of approximation toward and away from a reality noumenally disclosed, we substitute approximation toward and away from that which the given society agrees to call the Real. That is, in place of transcendental comparison between the sign and a world revealed within consciousness must stand the socially constructed, socially located codes of recognition, and the evident behaviour of recognition to which the individual refers in his acquisition of criteria for right recognition; and in place of the link extending from an outer world into the ideal recesses of subjectivity, must stand the link extending from individual to individual as consensual activity, in the *forum* of recognition. When Francastel remarks of the Masaccio *Tribute Money* that 'Henceforth man will be defined not by the rules of narrative, but by an immediate physical apprehension', and that 'the goal of representation will be appearance, and no longer meaning', the sliding scale invoked corresponds exactly to the formula of motivation in Pierce and in Saussure: the image moves between universal visual experience at its 'positive' end, revealed in Masaccio's 'elimination' from the *Tribute Money* of the deadening gothic accretion of convention, didacticism, stylisation; and at its 'negative' end, a force of enculturation, narrative, habitus whose field of force the image must combat and escape, and whose centre of gravity is the sign. The same opposition between Meaning and Being dominates the Gombrich account of Constable: Constable strips away from landscape the symbolic academism of Beaumont and of the Claude glass, to give us a canvas whose indicial marks are alleged to correspond exactly to, even to be in contact with, prior events within the perceptual field. The logic of recognition will not permit the notion of motivation to which Pierce and Saussure, Francastel and Gombrich, in their different ways all subscribe: we cannot say that the Giotto is more 'real' to us than the Duccio because of its comparative proximity to the index and its comparative distance from the symbol; it is no closer to and no further from these, or from the Essential Copy, than is any other image. How, then, does the Giotto still succeed in

11 Duccio, *The Betrayal*

convincing us that it has a greater value of lifelikeness, even when we have banished reference to the Essential Copy from our discussion? One can see why a *contemporary* of Giotto might agree that Giotto had surpassed Duccio: the Giotto might have more closely coincided with the definition of reality created within the culture by the contemporary consensus of recognition; yet even now, when that cultural formation has long since disappeared and when we might be tempted to consider both Duccio and Giotto as historically equidistant from ourselves, it is to Giotto that we will ascribe, without hesitation, the quality of *vraisemblance*. Placing in suspension the ontological explanations of Francastel and Gombrich, and considering *vraisemblance* only as a *rhetoric* of persuasion, how may we account for the Giotto's persistent persuasiveness?

Any adequate answer to this question will indeed be complex, and later there will emerge reasons why a formalist explanation, attending to the internal arrangement of the pictorial signs within the four sides of the canvas, is ultimately insufficient. To attempt an answer in terms of formalism, however, is very much demanded by the present condition of the discipline of art history. It is hardly an exaggeration to say that a formalist semantics of the image has not yet emerged – despite its enormous prestige and diffusion, in the 1950s and 1960s, in linguistics, in anthropology, and in the study of literary texts. A sort of formalism in art history certainly exists, and has done so at least since Morelli, but its main tendency is to examine the image in dissociation from its structure of meaning – a connoisseurship of abstraction. 'Combined analysis', taking as its object *both* the morphology and the semantics of the image, has far greater range.

A formalist description of the rhetoric of *vraisemblance* might begin with the proposition that lifelikeness or 'high mimesis' results from a *supposed exteriority of the signified to the signifier*.[22] Reading a realist novel, we quickly lose the sense that we still possess when reading, for example, poetry, of the work of signification as a process occurring *within* the text; signification seems to enter the text from an 'outside', an outer reality which the text passively mirrors. The same may be said of the image. In Gombrich's reaction to Constable's *Wivenhoe Park*, which has the virtue at least of symptomatic clarity, there is little evident awareness of the canvas as a place of and for the generation of meaning: meaning has disappeared from discussion, and the image is analysed instead as perception; meaning would actively intrude upon and impede the perceptual transmission – as it is said to do according to Francastel in Italian painting before Masaccio. The realist image disguises or conceals its status as a site of *production*; and

in the absence of any visible productive work from within, meaning is felt as penetrating the image from an imaginary space outside it. The development of codes of perspective has meant that the cultivation of this imaginary space has, in the case of European painting, been particularly intense. While the metaphor of the painting as window does not grow to maturity until the Renaissance, its existence is anticipated from the beginning, in that for as long as the signified is felt to exist in separation from and beyond the signifier, there exists a conceptual *second space* that is not identical to the picture-plane; an imaginary space which the codes of perspective, as it were, catch hold of and pull into focus, developing its articulation until a point is reached where the 'window' opens on to a perfect alternative world: behind the silhouettes which make up the figures on the picture-plane stand figures identical to the cut-outs we see, but endowed with the additional dimension of depth (in a final and hallucinatory phase, occasionally reached in Gombrich, the cut-outs will seem to be 'in the way').

The realist image, considered from a formalist standpoint, achieves part of its persuasiveness by including within itself information not directly pertinent to the task of producing meaning; information that is then read as existing 'at a distance' from the visible work of meaning, where *distance from the patent side of meaning* is interpreted as *distance towards the real*. The Giotto *Betrayal* is marked by a dramatic excess of information over and beyond that quantity required for us to recognise the scene; the Duccio *Betrayal* is not.

Let us think of an image beamed on to a screen at first as an illegible blur, which then gradually resolves into discernible shape and outline as the lens moves into focus. At a certain point we will have enough information to recognise the image as a group of figures involved in some obscure transaction; soon we are able, perhaps, to identify the scene as scriptural, and are hesitating among a small array of possible subjects; even before the image is in exact focus, a conclusive piece of evidence (the raised spears, the kiss) comes into view, and we correctly identify the image as a representation of the Betrayal. Let us call this state of the image, still out of focus, the minimal schema of recognition. It stands at the threshold between recognition and non-recognition: were it to lose more information, or to go further out of focus, recognition would become impossible; the information disclosed after this state, as the focus became clearer, would constitute an excess and would qualify as redundant. Or let us reach the minimal schema by another route. The Giotto *Betrayal* conveys far more

12 Giotto, *The Betrayal*

information than the Duccio, concerning the exact disposition in space of Christ, the disciples, and the guard, far more detail of facial expression, drapery, bodily posture, light-conditions. None of this information is *required* for the purpose of recognising the scene as a Betrayal, though it certainly reinforces and supports the activity of recognition. The Duccio tells us far less than the Giotto, but even in Duccio's *Betrayal* a marked tendency toward anecdote is to be detected: nothing in the biblical text corresponds, for example, to Duccio's portrait-like individuation of the disciples. Projecting backwards from the Giotto and the Duccio, we can easily conceive of an earlier representation of the Betrayal from which

much of the informational excess present both in Duccio and in Giotto had been omitted. If we were to describe the individuation of the disciples, the nocturnal lighting, the contingent detail of the foliage of Gethsemane, as *adjectival*, and as *adverbial* the information concerning the manner in which Simon Peter struck the High Priest's servant, the manner in which Judas kissed Christ, the minimal schema would separate out into the irreducible narrative sentence: Judas – kisses – Christ.[23]

It is this nuclear or core sentence which both Duccio and Giotto take as the foundation for their essentially *elaborative* work. All that recognition needs, and all the Byzantine image was concerned to supply (where the concept of the minimal schema is at the centre of painting practice) is a set of visual markers that will correspond point by point to the Passion text. What characterises the Byzantine image is an extreme frugality of signalling means: a single halo is sufficient to single out one of the figures as Christ, and to identify the figure closest to him as Judas; the superimposition of frontal and profile heads is enough to indicate the action of the kiss; a bristling array of spears, disconnected from their bearers and functioning as a quasi-independent schema (or sub-schema) will establish the term 'guard'; while the presence of a torch or lantern, even when no other clue is given (the sky in the Duccio is gold), efficiently and minimally evokes the night. Yet Duccio incorporates into his image far more information than the nuclear statement 'Judas –kisses –Christ' demands. Though many of the guard are glimpsed only in their attributes of helmet and spear, some are facially portrayed almost to the same degree of differentiation as the disciples. The dilation is still at an early stage and closely observes Byzantine protocol: the guard are not yet accorded the privileged visibility reserved for the apostolic group in the foreground, and remain huddled at the periphery of the image as a generalised presence. But a multiplication of epithets is clearly underway. We can see, for example, that the figure standing between Simon Peter and the High Priest's servant – impassive, immobile, unengaged – is handled as an individual narrative, and even biographical unit. The disciple to the extreme right of the group is by contrast impulsive, vigorous, spontaneous. The distance between the feet of Simon Peter marks his attack as swift and swooping: the servant, standing firmly and facing away, is clearly the victim of a surprise attack. Judas, in a robe echoing that of Christ, and with Simon Peter's sandals on his feet, is not simply designated, but dramatically realised: still in possession of full apostolic status, only gesture (surreptitious, venal) betraying his fall from grace.

What such an image is able to establish is a *distribution of priorities* in the information it contains. Certain features (the haloes, torches, trees, spears) are essential components of the minimal schema, and although some terms could be omitted without loss of recognition – the scene could in fact be inferred from a fragment consisting only of the two central profiles – Byzantine practice retains a high level of redundancy: that is a peculiarity of its procedures of recognition. Other features attach themselves to the minimal schema in the manner of adverbs and adjectives qualifying the nuclear narrative sentence: inessential to the transaction, they nonetheless support and in turn depend on it, and cannot stand or be read in separation from it. Still other features lack even the connection of adverb to verb or adjective to noun, and it is this set we find emphasised in the later example. As we move from Duccio to Giotto we witness something like an exponential expansion of the information the image furnishes. Nothing is there, in the discourse of scripture, to legitimate or claim that vast corpus of data concerning the position, in what is now an exactly articulated rotational space, of Christ, disciples, guard, nor the data concerning the individual appearance of attendant figures which the image relays through its multiple and free-standing portraits, nor the contingent detail of how, at a precise moment, the folds of cloak and tunic fell.

The image divides into three zones. In the first, that of the minimal schema, the image is entirely exhausted by textual function and ecclesiastical instruction. Analysed archaeologically even the Giotto lays bare an informational economy so insistent on the value of legibility that an extreme of redundancy is not only tolerated, but is deliberately built into the image. In a Byzantine Nativity it is quite possible for us correctly to identify the scene from a single item: from the star; from the bodily disposition of the Virgin; from the diagonal swaddling bands; from Joseph; from the cattle; from the angels. Yet the scene repeats *all* of these components, partly out of respect for the letter of holy writ, partly as a preventive counter-measure against deterioration of the image in transmission from region to region (and generation to generation) in the eternal Empire.[24] In a second zone, of semantic *neutrality* or *inference*, the nuclear sentence is embellished with material extrapolated from the text: it is here that in Giotto's image Judas becomes the embodiment of simian malice, and the features of Christ the expression of the highest Passion, compassion, dispassion; and in the Duccio the episode of Simon Peter's attack, and the diverse reactions of the disciples to the kiss, are magnified and actualised from potential dramatic nuances in the Gospel account. In a third zone, the

sway of text ends and the image begins to relay information with no prior justification or legitimation. The technical development of Renaissance painting will take place largely in this 'unmotivated' region of semantic inessentiality, as the painters learn to marshall more and more data on their canvases, information which because claimed by no textual function, and offered without ulterior motive, acquires the character of *innocence*. In just this fashion the realist novel, with its vast corpus of information concerning time-sequences and specific locations, sub-plots, half-noticed and instantly forgotten detail, will out of seeming inconsequentiality construct the lifelike appearance of real and possible worlds.

In realism, periphery counts over centre, and the preterite over the elect. The logic to which the image under realism subscribes is not that of evidence, but rather of suspicion: not in the place where it is on display will truth be found, but only where it lies hidden from view, and once found there, it will be the truth. If at the centre of the image an enthroned Madonna is encircled by angels, then it is towards the landscape at the sides that the realist gaze will tend, finding in a frozen pool, in a peasant carrying wood, in a dog scurrying across a field, more of the truth of the Middle Ages than in the triumph of its Church; not because it lacks faith or trusts only to a low-plane reality, but because the form in which it perceives truth is in the absence of bias: given sufficient 'honesties'[25] to deflect attention towards the insignificant, its credulity is without bounds.

In language, the distinction between denotation and connotation remains unsatisfactory.[26] While it may be legitimate for lexicography to accord primary status to the most recurrent sense of a particular word, and secondary or tertiary status to senses statistically less frequent, this at best crude division, based on ideas of the central, the customary, the normative value of words breaks down completely with the literary text: at what point does the literal narrative of a novel end and its generalised or symbolic sense take over? In a poetic text, where does the denotative level of language become separable from secondary or implicit levels of meaning? With the image, the line between denotation and connotation seems much more clearly demarcated: the denotative aspect of, for example, a photograph, would be simply 'what is there'; its connotative aspect would be the ideological or mythological construction adjoined to that manifest content. Indeed, in one of the most celebrated as well as one of the most misleading analyses of denotation and connotation in the image, that is exactly where the line is drawn. In *Mythologies*, Barthes cites the example of a *Paris Match* cover showing a negro soldier saluting the tricoleur: the

denotation is simply the 'factual discourse' which repeats, by means of photographic reproduction, the original physical and narrative event; the connotation is that nebula of attendant ideological mystifications which hovers over the image as its particular myth, of imperial glory, brotherhood across race, colonial co-operation, and the rest.[27] Barthes's claim for the procedure of reading such an image is that the connotation consumes the denotation, impoverishes or obliterates its physical truth, and puts in its place a myth useful to social management which is nevertheless apprehended as perception of an unmediated kind, a Nature from which history has been effectively banished.

The fault of the analysis lies in its curiously self-defeating account of the denotative phase: an innocent and Plinian eye, untroubled by the culturally produced and culturally determined codes of recognition, once more contemplates the primal truth of the visual field; *next*, culture descends and robs him of his experience, substituting in its place and as an almost perfect replica, the ideologically saturated but empirically impoverished and impoverishing myth of the image.

Enough has been said about Adamic vision, and descriptions of the image in terms of noumenal inwardness, for it to be clear why neither the account of denotation as *pure* perception, nor the description of viewing in terms of perception rather than recognition, can be accepted. Even in *La Chambre Claire*, we find Barthes continuing to propound a theory of the gaze which is completely at odds with the anti-Natural, de-mythologising analysis which his work elsewhere so brilliantly demonstrates.[28] Yet in the case of painting, the distinction between denotation and connotation is not only possible (as it is not with photography), but essential. The denotation of painting consists in its intersection with all the schemata of recognition (Nativity, Betrayal, Madonna Enthroned) codified in iconology: denotation results from those procedures of recognition which are governed by the iconographic codes. They are not absolute in character: it may certainly happen that a particular viewer activates an inappropriate iconographic code, and misidentifies the painting's subject;[29] yet the publicly sanctioned, didactically transmitted codes which control the iconographic aspect of painting are in such a case authorised to call the misidentification error, to criticise it as interpretative work incorrectly performed. It is simply wrong to identify, let us say, a *Pietà* as an old woman with a corpse; and wrong in a consensual and socially evident manner that differs absolutely from 'rightness' or 'wrongness' within the noumenal field: we can never know what form perception takes in that mysterious interior, but

whatever it may be, it is not concerned with the precise and socially sanc-
tioned criteria which govern the domain of iconology. Perhaps there is a
first and Adamic state of perception, upon which culture swoops and
preys, as Barthes believes, but concerning that state coherent propositions
cannot be constructed; and if it truly is the case that the image belongs to
the empire of signs, which Barthes would here seem only intermittently to
believe, then we must accept that recognition is through-written by social
codes, and not only in an alleged 'second phase' of apprehension.

In the case of the photograph as a general class of the image, as well as of
Barthes's *Paris Match* example, many contexts can be imagined in which
diverse acts of recognition follow on from various contextual insertions ('it
is my friend Joshua', 'it is a typical *Paris Match* cover', 'it is a notorious
semiological *lapsus*'). In the case of paintings where the iconographic codes
have achieved a regularised and official status, this diversity of textual
insertion is met and resisted by codes of recognition that serve to standar-
dise recognition of the image, and to subject it to conventions of legibility
as binding as the conventions which govern the legibility of the written
word. Whereas with photography denotation and connotation cannot be
separated or isolated, with painting a distinct threshold exists, at the point
of the minimal schema of recognition: on this side of the threshold, the
information required for construction of the schema and for eliciting cor-
rect identification; on the far side of the threshold, excess of information,
in the form of semantic neutrality (extrapolation from the denoted text),
and/or semantic irrelevance (supplementary data added to the denoted
text). We have observed that a formalist account of *vraisemblance* asserts that
distance away from the patent site of meaning is read as distance towards
the real. Formalist analysis is now in a position to say of painting, as it can
neither of the literary text nor of photography, that the 'effect of the real'
consists in a specialised relationship between denotation and connotation,
where *connotation so confirms and substantiates denotation that the latter appears
to rise to a level of truth*.

This process may be demonstrated by turning to the central episode in
the Giotto *Betrayal* (Illus. 13). If we examine the system of physiognomic
contrasts between the profiles of Judas and of Christ, we find present in
the image at least the following principles of opposition. The *linear* versus
the *curvilinear* (the straight lines of Christ's nose and forehead, as against
the convexity of Judas's nose and the concavity of Judas's forehead; the
emphasis on the line between the lips in the case of Christ, and on the
everted outer curves of the mouth in the case of Judas; the straightness and

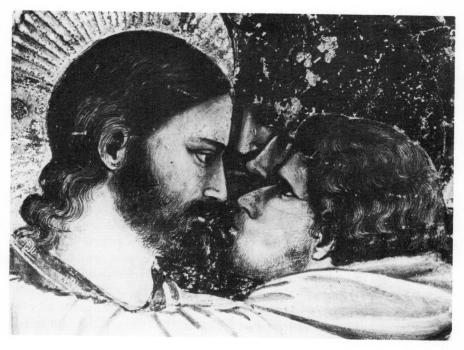

13 Giotto, *The Betrayal* (detail)

rectitude of Christ's eyebrow, as against the sinuous and deviant eyebrow of Judas; the taut severity of the hair of Christ, the lax, highlighted curls of Judas). We find *vertical* against *non-vertical* alignment (the bridge of the nose, the forehead, and the first tangent of the halo establishes a clear upward or *ascensional* axis for Christ; with Judas, the first tangent of the protuberant bone above the eye tends towards a horizontal, *mundane* axis, matched by the asymptotic tendency of the concave nose, the line below the chin, and the lines in the cloak below the neck and along the arm). We find *expansion* versus *contraction* (with Christ, the distance between eyebrow and hairline is extended and unbroken, the distance between eyebrow and eyelid enlarged and the epitheleal fold fully stated; there is a wide traverse between nostril and the curves of the lip, and a long vertical from the chin towards the sternum: with Judas, the distance between eyebrow and eyelid is correspondingly reduced and interrupted, eyebrow and eyelid join together in a single line, a narrow interval separates the nostril from the upper curve of the lip, and the neckline is hidden).

How the viewer is now to interpret these principles of opposition is subject to no absolute test of correctness, and this absence of univocal criteria confirms that the provenance of the information is *interpretation*, that it no longer concerns the iconographic codes of recognition, or the one-to-one pairings of denotative reading, but instead concerns the comparatively uncertain connotations on the 'far side' of the threshold of the schema of recognition. One possible reading might convert the oppositions *linear* :: *curvilinear*, *vertical* :: *non-vertical*, *expansion* :: *contraction* into this range of semantic parallels: the sacred versus the profane, spiritual versus worldly, the noble against the ignoble, the tranquil against the agitated, truthfulness against mendacity. Another, perhaps more acute reading, might attend instead to the *symmetry* of the two profiles, and to the marked repetition of the fan-like design that radiates from the point where Christ's brow, hair, and halo converge, into the tri-dimensional fan or rotation of profiles in the background between Christ and Judas. Interpretation here would note a conversion of the principle of opposition, which it readily concedes, into a principle of *interchangeability*: Christ and Judas, diacritically or mutually co-defined, are now found to share a secret identity where the opposites meet and are negated; each participates in the identity of the other: an interpretation that is not without some powerful consequences both for the theology and the psychology of Giotto's image.

The point is not that such interpretation makes any authoritative claim to accuracy, but on the contrary that because it requires a certain amount of hermeneutic effort, because it must extract meaning from the image under conditions of difficulty and uncertainty, the connotations are experienced as *found*, not made; and this exactly confirms the natural attitude, where meaning is felt to inhere in an objective world and is not apprehended as the *product* of particular cultural work. Connotational values are certainly present in the image, but not in the definitive style of the denotation: whereas the meanings of halo, cross, or the Chi Rho are precisely delimited by the iconographic codes, elusive meanings such as 'mendacity', 'perversity', 'interchangeability' require an effortful excursion into the outer territory 'beyond' the minimal schema of recognition; and it is precisely when exegesis is made to feel effort, when it must go out of its way to uncover its object, that the effect of the real is enhanced. Since the elusive meanings are hard to draw out of the image, and seem to engage the viewer in a private act of investigation far more intimate and personally determined than the public activity of iconographic recognition (in the political history of the image, connotation and privatisation are inter-

twined), they are valued over those meanings which the image places on display; because they are understood as superflux, as detail unrequired by the image's civic or official project, the logic of suspicion lowers its guard and accords to the elusive meanings the status of proof: somewhere in this unmapped territory of connotation, the truth of Giotto's *Betrayal* is to be found.

It is not in the contingent and undemonstrable mysteries of perception that realism forges the special relationship between denoted and connoted meaning, as Barthes suggests, but in the contradiction installed by a univocal iconology, between the necessary and the gratuitous. Once installed, connotation then serves to *eclipse* denotation, for in contrast to the image in Byzantium it is no longer the lode of denotation that the painter is working: the major lines of technical advance in the Renaissance, from perspective to anatomy, from physiognomics to atmospherics, will all take place in the connotational register. Following the wilful logic of realism, connotation thus serves to actualise its partner: because I believe in the connotation, I believe that the denotation is also true; because I believe in his parodic relation to Christ, in his subhumanity, his perversity, his fatality, his tragic darkness, I come to believe in Judas; and believe *despite* my resistance to the patent work of signification present in the minimal schema, in the halo, the torches and the disconnected spears, and in the image's evident subservience to scripture. Expansion of connotation sublimes the density of the patent coded practice, renders it translucent, and establishes in its place an encounter between the realist gaze, cautious to the point of resentment, and a world whose truth has overcome every reservation.

Despite the appearance of competition between denotation and connotation – empirical observation seeking to dislodge the rigid armature of the schema – the effect of the real is less a question of conflict than of symbiosis or covert alliance. Without the ceremonious and codified protocol of right recognition, there could be no scale of increasing distance from the semantic necessity of the gospel text (the minimal Byzantine schema) towards the comparative neutrality of the *tête d'expression*, to the superfluity of the data concerning space, light, texture, colour, reflection and atmosphere with which the Renaissance and post-Renaissance image will be saturated. Its realism will not result from an identity between image and world (Essential Copy), but rather from an instituted difference between levels of the sign. The excess produced by this difference can only last for as long as the official iconographic dispensation maintains its power; which may

perhaps explain not only the remarkable persistence of text, and the central and paradoxical place of textual or history painting within a tradition apparently committed to Zeuxian realism, but the disappearance of the effect of the real once that dispensation, in the nineteenth and twentieth centuries, comes to an end.

Chapter Four

The Image from Within and Without

A formalist semantics of the image can achieve a great deal. There can be little doubt that in those few studies where art history has suspended its apartheid policy and has allowed itself to be influenced by 'structuralist' methodology, the results have attained the highest order of interest.[1] Yet formalism by itself can never *fully* account for the effect of the real in painting, and indeed in some respects may lead its analysis into an even greater state of confusion than formerly prevailed, before the Saussurian intellectual current came to trouble the peaceful Atlantic world. The contradiction we must now divulge, not without some regret, concerns an asymmetry between denotation and connotation that threatens the whole formalist conception of semantic *enclosure*. Had art history maintained contact with anthropology, it might perhaps have been able to isolate this asymmetry long ago, possibly even before structural anthropology made its own belated discovery of conflict between the assumptions at work in its project.[2] From one point of view, a decade of structuralist art history would have been exciting to live through: from another, which is that of the present argument, the intellectual isolation of art history may now place it in advance of the disciplines that are finding the experience of shedding structuralist procedures so painful; though a prior condition for this must be that its intellectual isolation come to an end: without that, both structuralist and post-structuralist art history must be consigned to the realm of possible and impossible futures.

Both the original assertion that 'distance from the patent site of meaning is read as distance towards the real', and its linguistic transformation into 'excess of connotation over denotation constitutes the effect of the real', may be said to depend on an *internal ratio* within the sign-format of the image. *Vraisemblance*, it is argued, results from a law of *proportion* between

classes of information: neither denotation nor connotation singly may elicit the recognition of lifelikeness, for that comes only from their mutual distribution; from a balance, or more accurately an imbalance, between the two terms. Yet as the image passes from the codes of denotation to the codes of connotation, the codes themselves undergo radical alteration. Certainly denotation belongs to an internal order of the image, and its codes need not necessarily operate anywhere beyond the four sides of the canvas: recognition of a Nativity, a Betrayal, a Madonna Enthroned, is taught and learned as a specific skill to be applied *to images* in order to enable the correct identification of their subject-matter, but is not automatically transferrable beyond the local domain of iconography and of viewing practice. The codes of connotation, by contrast, operate within the general social formation; they may also be transferred to painting, in which case the effect of the real is likely to arise; but they exist prior to such possible transferral, and with certain images, for example the theoretical minimal schema of recognition, or painting styles that remain close to the minimal schema, they are not brought into play by the image at all. Formalism, which takes the global position that meaning (or recognition) results from an *internal* order of the sign, rather than from external reference beyond it, is able to state what no other approach within art history has yet been able to state, the importance of the ratio between denotation and connotation in the production of *vraisemblance*; but having admitted connotation as an essential term in that production, it thereby breaks the internal order of the image, the cordon or cartouche cast around the image, and opens the image directly on to the social formation. From this point onwards, the semantics of the image can no longer be discussed in terms of oppositions or proportions between elements contained by the four sides of the frame; in order to generate its assertions concerning the role of ratio and of distribution within information, formalism has in fact introduced a kind of Trojan horse.

It is a collapse by stages. That the codes of connotation lack the aspect of *codification* present in the iconographic or denotative codes is clear enough. Whereas the viewer can consult an iconological dictionary to determine the precise meaning of the attribute carried by a particular saint, with the crucial codes of connotation – the codes of the face and body in movement (pathognomics), the codes of the face at rest (physiognomics), and the codes of fashion or dress – no equivalent lexicon exists: there is no dictionary of these things that we can consult. Knowledge of these codes is distributed through the social formation in a diffuse, amorphous manner

that contrasts sharply with the exact and legalistic knowledge of iconology. In the absence of any clearly available place of definition, these three great codes of connotation have as a consequence no exact origin; and the mind, in order to cope with the question 'where do these meanings come from?', takes the shortest possible route: the meanings have not – or so it seems – been articulated by any system; they bear no trace of artifice, legality, or ulterior source; and, following the logic of suspicion, they are elevated to the category of Being. Formalism is thus fully prepared, and in certain phases is actively eager to attribute an *unconscious* character to the knowledge it analyses. The concept of naturalisation, both in sociology and in social anthropology, posits that those who live within the social formation have *no awareness* of the conventional nature of the montage of values, beliefs, conventions, maxims, rituals and myths which constitute their reality. Articulation into coded definition is possible only for the observer who, not having been naturalised by the social formation under study, shares none of the unconscious assumptions of its members; the objectification or at least the patent definition of such assumptions is precisely the task he is to perform.

Nowhere is the unconscious character of social knowledge more stressed than in structural anthropology. Here, 'collectively the sum of what all the myths say is not expressly said by any of them, and that which they do say (collectively) is a necessary poetic truth',[3] a fiction that condemns to perpetual latency the underlying structural truth knowable only to the (de-)mythologist. By analysing the corpus of Greek mythology through such binary oppositions as *above :: below*, *this world :: other world*, *culture :: nature*, it is certainly possible to construct schemata summarising the whole system of Greek myths;[4] in so far as this structural truth of the myths remains unavailable to those who live 'inside' them, the experience of the myths is part of naturalised, that is limited, knowledge. In the same way, formalist semantics may analyse a connotational system through such binary oppositions as *linear :: curvilinear*, *vertical :: non-vertical*, *expansion :: contraction*, and a similar or identical claim may be made that the viewer of the image lacks the articulated and fully exteriorised knowledge of these oppositions which it is the work of the analyst to construct, that the viewer inhabits a world of *limited knowledge* which prevents him from grasping that the connotational codes are in fact just as artificial, coded and conventionalised as the codes of iconography. Unable to perceive their coded character, the viewer will measure them as distant from the patent work of signification visible at the denotative level of the image,

and the effect of the real will be induced: such is the formalist claim.

What is wrong with this approach is the inability of formalist semantics to conceive of a mode of knowledge which, belonging neither to the unconscious of a primitive or oceanic *participation mystique*, nor to the codified explicitness of structural analysis, resides instead in an inter-mediate region of what we might call *practical consciousness*.[5] This region may certainly be occupied by the systems of myth, but for the present purpose it is clearer to take the example from cultural lore, of the proverb. Proverbs are part of explicit cultural knowledge: they are expressly imparted and may, at any rate in principle, be learned by rote. But the knowledge that decides the exact conditions in which the citation of a particular proverb is appropriate, and the symbolic implications of its local appearance, is of a *tacit* or *implicit* kind.[6] The protocols governing the appropriateness of proverbial quotation may not be susceptible to explicit articulation by members of the society who, nevertheless, are able to observe the protocols precisely and without deviation. Such knowledge cannot be characterised as unconscious, in the sense that the operator of tacit codes moves in an oceanic trance or cites the maxim somnambulisti-cally; yet neither do the codes possess the legalistic, openly articulated, declarative status of, for example, a codex of law. It is knowledge acquired by example from the social formation and inseparable, in the experience of its possessors, from the concrete instance; its structure cannot be abs-tracted from the situations in which it is revealed *in profiles*, that is, imma-nently within its contextual embodiment.[7]

While binary analysis could find it within its power to describe the global architecture of such tacit or implicit codes, the elements isolated by such analysis, because abstracted from their immanent material context, would not *automatically* possess a semantic dimension. To be sure, the kinds of opposition at work in an explicit code, such as scriptural iconol-ogy, traffic signs, or semaphore, do possess precise semantic value: a red light indicates *in every case* that the vehicle must stop, the combination of reclining Virgin, diagonally swathed Infant, and star, indicates in every case that the subject is a Nativity, the angles between the flags indicate in every case a particular letter or message. Of these systems we can say that they are both *explicit* (they exist in codified form) and *univocal* (they are without ambiguity). The codes of connotation – pathognomics, physiog-nomics, dress – are the inverse of such systems. With no available lexicon or codex, they cannot be learned or taught by rote, and knowledge of their workings must be acquired by example, from actual material context.

Incapable of abstraction from context, their meanings are subject to fluctuation according to change within context; the meanings of the codes of connotation, by contrast with the codes of iconology, are therefore both *non-explicit* and *polysemic*.

The theory of naturalisation, stressing the limited knowledge of the operator, readily admits the non-explicit character of connotation: formalist semantics is empowered by that admission then to posit an interior ratio within the painterly sign, a proportion or golden mean between areas of the explicit and of the non-explicit which will then provide an account of the effect of the real. The aspect of polysemism which follows on from the variability of material context, however, challenges the formalist principle whereby meaning is said to be generated exclusively from internal oppositions between elements; variation according to context breaks the enclosure (of the myth, of the maxim, of the picture-frame) and gives analysis no option but to attend to the external and situational environment of interpretation as an activity occurring always within the social formation.

In fact, structuralist anthropology has often proceeded by analysing *only* the formal oppositions between elements, without moving on from that to statement of the underlying meaning of the myth. To demonstrate that the corpus of Greek mythology can be broken down into oppositions between *above* :: *below*, *this world* :: *other world*, *culture* :: *nature*, and to show that despite their superficial diversity individual myths are transformations of these binary elements, does not entail making statements about the essential meaning of the myths, either collectively or individually. The discovered oppositions are free to remain descriptions of transformational laws at work in the production of mythical narrative, in the same way that to reveal the oppositions between syllables in phonetics does not entail commitment to a further description of semantic morphology. Yet it is famously the case that structuralist anthropology is subject to what seems an irresistible temptation, having completed its binary schematisation, to go on to state what the oppositions then *mean*; and mean universally, wherever the myth appears and by whomsoever it is stated. Let us take the famous remark of Lévi-Strauss:'. . . the Oedipus myth . . . provides a kind of logical tool which relates the original problem – born from one or born from two – to the derivative problem: born from different or born from the same'; it supplies a fiction enabling a 'satisfactory transition between the theory [that man arises autochthonously, from the earth itself] and the knowledge that human beings are actually born from the union of man and woman';[8] and while the true meaning of the myth may have

remained unconscious to the Greeks (and to Freud), it is now made con-
sciously visible to ourselves for the first time: the truth behind the fiction.

One tendency that needs exposing, in this drift of morphology towards
semantics, lies in its confused and intuitionist application of a linguistic
model to non-linguistic material. No linguist constructing a grammar can
afford at any stage to dispense with the concept of competence: only by
checking his material against the linguistic competence of a (preferably)
native speaker can he be sure that the material in fact conforms to the rules
of the language. Certainly structural anthropology fails, in this case, to
meet that essential condition: not only are the Greeks, and Freud, long
since gone, and the American Indians never consulted as to what would
be an incoherent myth (*cf.* an ungrammatical sentence), but to quote again
from Lévi-Strauss, 'it is in the last resort immaterial whether . . . the
thought processes of American Indians take shape through the medium of
my thought or whether mine take place through the medium of theirs'.[9]
Only by a total abstraction of myth from the concrete situations in which it
appears can such interchangeability occur. It would be equally immaterial
whether the iconographic codes of a Renaissance painting were operated
by a quattrocento Florentine or by a twentieth-century art historian, for
these codes are univocal, and transcend (are unaffected by) social context.
But with the codes of *connotation*, such abstraction cannot arise; it is *always*
in material practice that the latter appear, and *only* by consulting the com-
petence of an informed and experienced operator can their structure be
revealed. Barthes's failure, in *Système de la Mode*, to consult either fashion
designers or fashion wearers, as a check to his analysis, vitiates and dis-
credits all the generalisations he proposes, in that 'dream of scientificity';[10]
though the bracketing-out of competence as a criterion can be taken as
symptomatic of the structuralist strategy, and of its grand imperative:
eliminate practice.

Yet even more dangerous, to the cause of clarity, is the formalist disposi-
tion to treat *structure* as though it were *information*, and to regard what may
be only a feature permitting communication as communication already.
*The analyst introduces into the object the principle of his own relation to that
object.* He is not an inhabitant of the social formation, he lacks the tacit
knowledge of its members; an outside observer, his task is felt as the
explanation of the mysterious society before him, to others of his own
culture; his work is therefore hermeneutic, exegetical. That is perhaps a
fair assessment of his own position. The error consists in then attributing
to the members of the society his own relationship to it: they, too, become

communicators, the fundamental medium of their culture becomes information, the whole range of their behaviour, from the exchange of women to the narration of myth, becomes the transmission of information. He deals with data, not material practice; their material practice is sublimed into data.

From this it is only a step to the portrayal of naturalisation as conspiracy. The word 'naturalisation', suggesting the passive, the half-awake, the victimised, already contains the paranoid seed. Tacit knowledge is not learned by formula, but by example; it does not *require* a legalistic codex, or articulation-into-explicitness. The reading of a certain gesture performed in the course of a conversation, or of a certain costume, or of a certain vocal accent, does not need first to route itself towards a central lexicon for an act of decoding; its meaning is embodied in local circumstance. Learning the music of the *gamelan* does not entail the prior mastery of a notation, or the acquisition of performative techniques away from the place where the *gamelan* orchestra gathers; the child musician is placed in the lap of a competent performer who puts the hammers into the child's hands, and then his own hands over the child's, transmitting the technique directly, somatically, and without reference to any codex outside the concrete situation.[11] The whole vast repertoire of tacit knowledge is conveyed and conserved in just this way, through material practice and by way of the body of labour; patent articulation does not arise; the need for codification is not felt, and were it to do so the efficiency of skill-acquisition would in many cases be impeded or impaired.

If cultural life is conceived in informational or exegetical terms, however, the absence of patent articulation will be viewed negatively, as non-awareness of a truth which the analyst, despite his lack of tacit knowledge, is nonetheless convinced that he perceives; perceives precisely because no one within the society is able to share his perception. Because the linguistic model he inherits lacks any mediating term between *langue* and *parole*, and knows no region between the legalistic code (the 'laws' of grammar) and its instantiation, what he observes will be seen in reference to a *langue of which the society lacks knowledge*. Neither the Greeks nor Freud knew the truth of the Oedipus myth: that it was a consoling fiction designed to mask the uncomfortable transition from the theory that man was born of earth to the knowledge that man was born from intercourse. This truth was concealed by the myth; the function of the latter was exactly to conceal it.

Yet the screening-out of practical and operational determination within cultural life is the reverse of what analysis should here be investigating.

The rules at work in the reading of the face, body, costume, posture, in other words the rules responsible for the connotation of the image, may be without their definitive *summa* or codex, but this absence should be not taken as evidence of a fundamental deceptiveness in social life, or of an insidious decree that must be exposed and denounced. If the principles governing a system remain informulable to its operators, this does not entail that the operators are in any sense blind, entranced, or manipulated from the outside (natural*ised*), any more than it entails that the rules do not exist. Rather, the rules are immanent within contextual situations, cemented into practical techniques, in the way that the eye of a needle calls for its thread, or that the operator of any technical process feels the next stage of the process to be anticipated and called in being by the stage before.

Absence of explicit articulation is in no way an index of limited knowledge; it is rather an index of the degree to which the rules governing the process are embodied within technique.[12] It is therefore not only the internal ratio of denotation to connotation that is responsible for the effect of the real; but the fact that the connotative codes inhere within the social formation, that they cannot be operated in abstraction from the social formation, and that they carry the connotative dimension of the image directly into the social formation. The formalist barrier or *cordon sanitaire* separating world from image may establish an internal ratio in the first place, a ratio evident within the four sides of the image and nowhere else; but once connotation is introduced into the image, the image is penetrated or ventilated from a domain outside the formalist enclosure.

If the image in which connotation plays an important role – the image as much in Palaeologue Byzantium as in trecento Italy – seeks a discontinuity with the strictly iconographic codes, it thereby enters into *continuity* with material practice; its technical advances permit more and more of the tacit or doxological codes to circulate within its boundaries. The effect of the real may therefore be attributed to a protocol of recognition that tiers the image into a hierarchical configuration *above* and *below* the threshold of the minimal schema of recognition. Above that line of demarcation, the codes are explicit, patently articulated, openly iconological; they possess an origin that is known and can be pointed to (the iconological manual, the scriptural text). Below that line, the effect of the real will intensify, not only because of the rhetoric of persuasion and credulity, or because of the logic of suspicion, but because in proportion as denotation recedes, the knowledge drawn upon by the viewer enters into ever closer contact with the

contextuality where alone it manifests.

It is this second stage, of contact with social formation, to which formalism is blind: only the first stage, the withdrawal or distance from explicit codification, can it easily recognise. As a consequence, formalism must always represent the effects of *vraisemblance* as the deceitful, the Machiavellian, as part of the general social *pharmakon*.[13] The crucial concept here is that of the *doxa*, the general body of typifications and stereotypes, proverbs and lore, psychologies of love, wealth, age, honour, progress, and so forth, which constitute the given cultural 'norm'.[14] What is claimed for realism is that it smuggles in the doxic stereotypes at the moment when consciousness has lowered its guard. Not in the patent iconological codes will the doxa be stated, for their positioning must be strategic; they must mix in, variously disguised, with the honest preterite of connotation. As the reader reads Balzac's *Sarrasine*, he is in reality being subliminally exposed to and manipulated into submission before, the doxa of high capitalism; while the viewer views the *Paris Match* cover, he is surreptitiously being normalised by an unstated ideology of colonialism and empire. The recurrent feature of this kind of analysis is the attribution of an unproven *bad faith* to the analyst's dummy, 'the' reader, 'the' viewer: the latter's stupidity and gullibility are taken for granted – as are the analyst's superior intelligence and scepticism. Too impoverished in method to construct or imagine any other factor as responsible for the effect of *vraisemblance* than a half-witted logic of suspicion, formalism portrays the operator of tacit code as inveterately imbecilic, devoid of any capacity to judge evidence in terms other than those of bias's absence, as a born dupe whose idiocy deserves no pity, though his susceptibility to the invariably hypocritical and *Victorian* doxologies (Progress, Wealth, Honour) merits severe reprimand. Can we really be expected to go on believing in the existence of these dim-witted brother readers and viewers, these phantom hypocrites and simpletons for whom a mere nuance of the ratio within the evidence will be enough to persuade that the evidence has not been interfered with, and therefore must be true?

What formalism must learn to understand is that rules of tacit knowledge do not emanate from a centralised, invisible Authority that causes the social machinery, populated by sleepwalkers, to move by remote control; tacit knowledge does not arise by occult edict, but rather from a suite of practical instances that furnishes the material for the operator's own improvisations-within-context. *Linear* :: *curvilinear*, *vertical* :: *non-vertical*, and *expansion* :: *contraction* are not *already*-semantic terms generating mean-

ing that can then never be traced back to its lair, but *pre*-semantic terms which acquire whatever meanings will be theirs by application to and insertion within a concrete and practical reality. In tacit systems such as physiognomics or pathognomics, where knowledge of the system's workings can be arrived at only from instantiations, there is no question that 'the real' referred to in 'the effect of the real' is an impalpable or hallucinatory mirage through which the social agents dazedly move: the real here is as solid as the material world of ordinary experience. The image under realism extracts from instantiation a profile, in every sense, of knowledge: a subtle body of forms (linear/curvilinear, vertical/non-vertical, expanded/contracted) which, in the passage from instantiation within context to their statement on canvas and away from context, sheds that part of its material nature in which determined meaning had resided. Separated from the materiality of situation, such forms may develop a transcendence, an elevation beyond reference, a transfiguration which on occasion can amount, as in the case of the Giotto *Betrayal*, to the revelation of a *corps glorieux*. Yet in that abstraction from materiality and from concrete situation, gestures which in context would have been precisely meaningful become despecified, facial expressions which *in situ* would possess precisely delimited significance become portentous, facial characteristics which in mundane life would be relegated to limited-semantic or non-semantic status (deep-set eyes, naturally everted lips, tilt of the head) are now magnified, through loss of particularisation, to 'universal' significance.

We must therefore assert that formalism understands only part of the realist equation. Not only, if at all, in the journey *away from denotation* does the image acquire its lifelikeness; but in the journey of the codes of connotation *away from situation* and into an image where, stripped of the delimited significance embodied in actuality, the actions of the codes become diffuse, generalised, potentially but no longer instantially meaningful. Contemplating these despecified, evacuated forms, it is for the viewer to construct and to improvise the forms into signification, through the competence he has acquired from his own experience of the tacit operations of the connotational codes: not only the arrow *A*, but the arrow *B*.

If the naturalism of Western painting is persuasive, it is so not only because of a logic internal to the image and existing solely in the enclosure of the frame, but also because mundane experience so associates the subtle body of signs with the material body of practice that the codes of pathognomics and physiognomics, of dress and address, are fleshed out at once; and not as part of a paranoid campaign to immerse the social agent in a sea of directives whose true nature must at the same time be kept from him, but because physical life, the life of material practice, is of itself and in its very aspect of clay, the arena of meaning.

In 1966 there appeared in a French literary periodical a cartoon of four *maîtres à penser* in hula-hula skirts – Claude Lévi-Strauss, Roland Barthes, Michel Foucault, and Jacques Lacan – engaged in animated musings in the shade of some tropical trees: *le déjeuner des structuralistes*.[15] It is perhaps as accurate a picture of 'structuralism' as we will ever get. If anything can be said to be held in common by these emblematic figures, it is their avowed debt to linguistics; and when collectively the structuralists have failed to question their assumptions, when their method has really gone off the rails, it is their particular strain of linguistics that must take the blame. The misfortune of the French is not to have translated Wittgenstein; instead, they read Saussure.[16]

SOURCE: Ferdinand de Saussure, *Course in General Linguistics*, trans. Wade Baskin, ed. Charles Bally and Albert Sechehaye (New York, Toronto, London: McGraw-Hill, 1959) p. 112.

It is hard to imagine a more noumenal account of language than the *Cours de linguistique générale*: the location of the signified is in the deepest recesses of the *innerer Vorgang*. The linguistic fact is to be pictured as a series of continuous subdivisions marked off both on the plane of ideas (*A*) and the plane of sound (*B*). Certainly it is of the essence of Saussure's teaching, then to qualify this picture with the momentous disclaimer, that the organisation of the signifiers in *B* is a *self-sufficient* system, that the

meaning of the word is determined diacritically in B, by the structure of oppositions within the acoustic material. Yet since A and B are vertically traversed by the same lines, the disclaimer amounts to very little: the model precludes the excess of A over B : there is no signified separable from its 'corresponding' signifier (no concept separable from a particular word or 'acoustic image'), no signifier separable from its signified (no utterance that does not correspond to a mental event). In the famous metaphor:

> Language is comparable to a sheet of paper: thought is the front and sound is the back; you cannot cut up the front without at the same time cutting up the back; similarly, in language, you cannot isolate sounds from thought, nor thought from sound; you would only manage to do this by a process which would result in the creation of pure psychology or pure phonology. [17]

But how coherent is this doctrine? In our discussion of pain and pain-behaviour it became clear that the meaning of the word 'pain' cannot be derived from mental events, whose unavailability to inspection renders impossible that act of comparison which alone will determine whether individuals x and y intend or refer to the same noumenal experiences, in their use of any given word. We discovered that even were it possible for mental events to be produced and examined, the mental accompaniment to linguistic performance could no more serve as a reliable standard of competence than the mental accompaniment to mathematical calculation; and that satisfactory rules of usage could, moreover, be established without reference outside or beyond material practice.

Applying these arguments to Saussure's model of two confluent realms (of ideas and of sounds) alleged to bond together in language-activity, it is obvious that Saussure's picture of the 'recto' and 'verso' is a metaphysical one. There are no means of ascertaining whether the area of B bounded by the vertical lines exactly matches its notional counterpart in A (the speaker might, for example, have *no* corresponding mental experience). By the same token, there is no method of determining whether the bounded area signified in A is identical for all speakers (perhaps Saussure does not need that identity; but his system does require that for each speaker the same signifier evoke the same signified, that A and B are *individually* constant – which is a matter for speculation); and even if the plane of ideas were demonstrable in separation from the plane of sounds (impossible by Saus-

sure's own definition), it would not follow that mental accompaniment to utterance, taken by itself, is capable of providing either a necessary or a sufficient standard for correct usage. Perhaps it is true, and the material of language *can* be held directly responsible for the events occurring within the speaker's noumenal horizon: that the limits of my language (to reverse Wittgenstein's emphasis, though in this only following what has become custom[18]) are the limits of my world; yet if the link between *A* and *B* were in fact absolute, nothing could prevent us from inverting the alleged causality, or from agreeing with Port Royal that the speaker's mental events determine his discourse. However curious, in the present age, both of these causal accounts may appear, even the first and fractionally the more remarkable of the two has not been without its subscribers: the mental field of the Hopi Indian is reputed to be a formation as unique as his language;[19] and if such metaphysical reverie tends not to occur within perceptualist accounts of the image, this may not only be because of the astounding results which would soon be obtained, but because perceptualism, particularly as expounded by Gombrich, subtly by-passes its own schemata at the same time as it insists on them, and in that gaze of the innocent eye against which it so loudly protests, comes back to the consoling stabilities of Universal Visual Experience – an experience hardly less mysterious than that of Saussure's speakers.

In a noumenally centred picture of the world, every signifier will have its signified. Once the term *perception* is replaced by *recognition*, however, we must suspend the Saussurian formula 'Sign = Signifier / + / Signified' and restate it along these lines: in recognition, the signifier seeks *another* signifier; it is the relation between the signifiers that forms the sign (Sign = Sr → Sr). That relation is not vertical, but horizontal or lateral; it is less instantaneous than it is deferred. The formalism extrapolated from Saussure, however, will scan the object of its enquiry as though seeking the hidden signified that must somewhere exist inside it; and when the expected signified not surprisingly fails to appear, at once the formalist will appeal back to noumenal base and justify the difficulty or failure of his search as *deficiency within the object*: the Greeks were not aware of the concealed signified of the Oedipus myth ('consolation'); the masses involved in mass communication lack the sophistication of the de-mythologist who tears the veil from their eyes;[20] the speaker is the victim of his 'fascist' language.[21] With the discovery of the deferred or staggered nature of the sign, formalism undoubtedly entered a second and more turbulent phase: neither the Derrida of 1967 (*L'Ecriture et la différence, La*

Voix et la phénomène, De la grammatologie), nor the Lacanian texts of metonymy and desire, admit the category of the signified in its noumenal form (as the self-sufficiency of an evident logos).[22] The recent banishment of the signified has certainly enabled the production of a more accurate account of Sr → Sr relations: instead of a corpus of signifiers open at each point to their uniquely congruent signifieds, that corpus is recognised as closed in on itself, as annular, hermetic; where the meaning of the individual signifier had been consubstantial and coterminous with its signified, now we find its meaning through indirection, obliquely, we find it always elsewhere: the first of the major binary oppositions in Saussure, *Sr :: Sd*, is deleted. Yet without a corresponding revision within the second of the major oppositions in Saussure, *langue :: parole*, the deletion of the first achieves little except a reinforcement of the theory of deficiency-within-the-object: if the signifiers are found *not* to circulate, if the Joyceian text remains the exception in literary practice, there is still nothing within the linguistic model to account for that inertia; closure has replaced openness, but the immobility of the signifier must be attributed to a force *outside* the linguistic system, holding the signifier, and the subject, in position.[23]

Saussure's *Course* is committed to the synchronic analysis of language: diachrony is demoted to the status of *execution*. Aiming to enclose 'the terrain of the *language*', as opposed to the vast and disorderly corpus of linguistic practice, Saussure defines the goal of his work as the extraction of a 'well-defined object', 'an object that can be studied separately'.[24] On the grounds that attention to execution is liable to stand in the way of constructing that well-defined object, the *langue*, he then sets apart the 'executive side' of speech, as a process of no interest to those who seek knowledge of the *langue* behind or beyond actual linguistic practice. The significant reversal in Saussure is that practice accordingly becomes the *negative* of theory; it is represented as that *against which* the operation of describing the *langue* is conducted. From this negative conception of practice, Saussure rapidly moves towards its elimination by claiming that 'execution is never the work of the mass', but is 'always individual'.[25] The *parole* or atomic unit of speech, belonging to a world of individual choice and preference, is thus pushed out of the picture altogether: because it is free and *at the disposal* of a subject who at the level of *parole* is alleged to experience no constraints other than those of grammar and *langue*, it lacks the character of regularity which alone is of interest to science; and since the constraints on *parole* are those of *langue*, Saussure finally dismisses the

parole as redundant, since all its regularities and constraints exist in fact at the level of *langue*: it is therefore to the level of *langue* that investigation must address itself.

The difficulty of this exclusion of any intermediary term between *langue* and *parole* emerges once we try to conceive what kind of information the *parole*, defined in this bipolar fashion, must contain. The sign is not only defined diacritically, but by opposition to all the other signs, to every other word in the *langue* at once and to the same degree. Yet were this actually to be the case, the information contained within each sign would become *impossibly diluted*.

The dilution can be illustrated if we picture the plight of the sign in cybernetic terms, and define the quantification of information through the principle of exclusion.[26] A single numeral in the series 1–10 contains less information than an alphabetic letter in the series 1–26, since the numeral excludes only nine alternatives, whereas the letter excludes twenty-five; similarly an alphabetic letter in a series 1–26 contains less information than, for example, a Chinese ideogram which excludes several thousand alternatives. If each *parole* or individual enunciation is seen always and only against the background of the total field of signs, we discover that the *parole* is a kind of quantitative monster: measured against *langue* as a totality, all at once, each *parole* is found saturated with information to the magnitude of $n - 1$, where n is the total number of signifiers. The informational density becomes insupportable and the *parole* acquires the kind of gravitational field that in physics produces black holes. At the same time, this near-infinite quantity of information is identical for all signs; each unit excludes the same number of alternatives, and thereby acquires the kind of steady-state variation that in acoustics produces white noise.

That this does not and cannot correspond to any recognisably *human* linguistic or other symbolic system goes without saying, and of course a Saussurean apologist will now point out that these extremes of informational climate are to be understood as occurring in logical not empirical space. No one will deny it. Yet the formalism extrapolated from a model as remote from practice as this will hardly be able to prevent its application to material data through the transformation of *langue/parole* into the couple *code/message*; each message will be seen *in the first place* against the background of the code; and if the senders and receivers of messages themselves are not found to refer to code, their failure to do so is liable to representation in negative terms.

Saussure has no theory of practice. Confronted with practice, formalist

analysis will on the one hand construct its master-*langue* (a transfor-
mational map, for example, of all Greek myths) – not once consulting those
who produce the units (mythemes, lexemes, semes, gustemes) to ascer-
tain, from their practical competence, what are the constraints *they* recog-
nise as responsible for the regularities in their combination of the units;
and on the other hand, finding no codification of the *langue* available in
patent or articulated form to its users, and certainly nothing like his dia-
gram of the *langue*, the formalist will take it that the operators are *lacking* in
knowledge. From the claim of lack proceeds the claim that the operators
live in a haze of naturalisations; and from there it is now but a step to the
conclusion that a power *external to the symbolic system* is responsible both
for the 'work' of naturalisation, and for the absence of those combinations
of units which do not arise.

Perhaps the most interesting by-product of Saussurean thinking is this
theory of the exteriority of power and of social formation to human sym-
bolic systems (in this implied politics of an outer social pressure encroach-
ing on symbolisation and inhibiting or impairing its functions, Saussure
and Gombrich are curiously alike). Saussure knows of no middle ground
between the global system of language and the minimal unit of the sen-
tence. The speaker checks his utterance against the *langue*, but apart from
that, no constraints *within* language exist: the speaker may say exactly
what he chooses. The work of Jakobson elaborates further this picture of
interior freedom. In the speaker's selection of each word in his utterance,
only class-rules obtain: for example, as I reach the word 'aches' in 'My
heart aches', the rules of syntax indicate that this next word will be a verb
(and not another noun) – but all the verbs are equidistant from this
moment in the sentence, all are equally available.[27] The freedom of inner
choice will enable me to select one from their number; and once I have
made my selection and closed the sentence, the meaning of the utterance is
complete. Nothing from the outside, from the social formation or from the
material context of my utterance, will have influenced either the *meaning* of
the utterance or my *selection* of words.

The fallacy of the first idea, that meaning derives from the internal order
of the language-system and owes nothing to the material context of its
utterance, can be rather pungently illustrated by means of the following
story, from Dostoievsky's *Diary of a Writer*:

One Sunday night, already getting on to the small hours, I chanced to
 find myself walking alongside a band of tipsy artisans for a dozen paces

or so, and there and then I became convinced that all thoughts, all feelings, and even whole trains of reasoning could be expressed merely by using a certain noun, a noun, moreover, of utmost simplicity in itself [Dostoievsky has in mind a certain widely used obscenity]. Here is what happened. First, one of these fellows voices this noun shrilly and emphatically by way of expressing his utterly disdainful denial of some point that had been in general contention just prior. A second fellow repeats this very same noun in response to the first fellow, but now in an altogether different tone and sense – to wit, in the sense that he fully doubted the veracity of the first fellow's denial. A third fellow waxes indignant at the first one, sharply and heatedly sallying into the conversation and shouting at him that very same noun, but now in a pejorative, abusive sense. The second fellow, indignant at the third for being offensive, himself sallies back in and cuts the latter short to the effect: 'What the hell do you think you're doing, butting in like that?! Me and Fil'ka were having a nice quiet talk and just like that you come along and start cussing him out!' And in fact, this whole train of thought he conveyed by emitting just that very same time-honoured word, that same extremely laconic designation of a certain item, and nothing more, save only that he also raised his hand and grabbed the second fellow by the shoulder. Thereupon, all of a sudden a fourth fellow, the youngest in the crowd, who had remained silent all this while, apparently having just struck upon the solution to the problem that had originally occasioned the dispute, in a tone of rapture, with one arm half-raised, shouts – What do you think: 'Eureka'? 'I found it, I found it'? No, nothing at all like 'Eureka', nothing like 'I found it'. He merely repeats that very same unprintable noun, just that one single word, just that one word alone, but with rapture, with a squeal of ecstasy, and apparently somewhat excessively so, because the sixth fellow, a surly character and the oldest in the bunch, didn't think it seemly and in a trice stops the young fellow's rapture cold by turning on him and repeating in a gruff and expostulatory bass – yes, that very same noun whose usage is forbidden in the company of ladies, which, however, in this case clearly and precised denoted: 'What the hell are you shouting for, you'll burst a blood vessel!' And so, without having uttered one other word, they repeated just this, but obviously beloved, little word of theirs six times in a row, one after the other, and they understood one another perfectly. [28]

The six speech-acts are all different: yet formalism, insistent that if mean-

ing is to be found, it will be found in the internal relationships of the *langue*, is tone-deaf; as far as formalism hears anything, it is the identical word, repeated six times. On each occasion, according to the formalist view, the meaning will have issued from the mental signified that corresponds to the signifier *x*, and since signifier *x* is the same in every case, each speaker must have intended the same thing.

The fallacy of the second idea, that selection is a purely 'vertical' activity, that nothing intervenes between the free inward choice of the speaker and the whole paradigmatic axis, lies in its rejection of language as material practice. If it were true that no intermediary term existed between *langue* and *parole*, the addressee would not know how to relate the signifiers he hears to the signifiers of the language as totality. The general meaning of signifier *x* can be found, more or less crudely, by consulting the dictionary: here, the mutual proximities of the signifiers are mapped: signifier 1 'goes with' and can in many cases be substituted for signifier 2; signifier 2 is its nearest affiliation. Without the topological order represented (reflected) by the dictionary, signifier 1 would be equidistant from all the signifiers in the *langue*; a speaker would not know *how* to make a selection from the paradigmatic axis, nor would an addressee know which of the words at his disposal approximated the words he hears. A mediating term is necessary if the system is to possess and to permit intelligibility. That term is *discourse*. Whereas *langue* makes no reference to practice, discourse is constituted by practice: discourse is language *as it circulates* within the social formation. The number of grammatically correct sentences that can be generated by permutating the words of a language is theoretically very large: *in practice*, the number of grammatically correct sentences that possess intelligibility is a fraction of that total number. Those sentences which do not reflect the material conditions of the social formation cannot circulate within the social formation. *Langue* is unable to generate discourse out of itself: it is at the *intersection* between *langue* and material life that discourse is produced. A word that has lost contact with the conditions of material life petrifies into non-intelligibility: a sentence unable to make contact with the conditions of material life never acquires intelligibility.

Linguistics can provide no stable base for the study of the non-linguistic sign until Saussure's original signifier/signified dyad is conceived dynamically and operationally; until the following transformations are accomplished:

from (Sr :: Sd) *to* (Sr → Sr) *to* $\dfrac{\text{Social formation}}{\text{Sr}} \Longrightarrow \text{Sr}$

'Linguistics is only part of the general science of semiology; the laws discovered by semiology will be applicable to linguistics, and they will circumscribe a well-defined area within the mass of anthropological facts.' Saussure's prophecies have turned out to work in reverse: the 'laws' discovered by a flawed linguistics have been applied to, have created, a flawed semiology.

As the most material of all the signifying practices, painting has proved the least tractable to semiology's anti-materialist proclivities. Only the iconographic codes of painting possess the enclosed, univocal, socially non-specific character suited to the formalist outlook. Apart from that uppermost tier where alone ideas of 'code' and of 'message' are viable, painting is embedded in social discourse which formalism is hardly able to see, let alone to explain in its own terms. The 'meaning' of a painting will not be discovered by the construction of Sassurean *langues* for the discourses of the bodily hexis: gesture, posture, dress, address. Nor can it be discovered *in* the painting, as a pre-formed and circumscribed feature. It is in the interaction of painting with social formation that the semantics of painting is to be found, as a variable term fluctuating according to the fluctuations of discourse. If the image is inherently polysemic, this is not *by excess* of a meaning already possessed by the image, as hagiography would have it, but *by default*, as a consequence of the image's dependence on interaction with discourse for its production of meaning, for its *recognition*. One aspect of materialist art history must therefore consist in the recovery or retrieval of evidence left behind by previous interaction of image with discourse, and the correlation of that evidence with what can be discovered about the social formation's historical development. But for as long as an image maintains contact with the discourses continuing to circulate in the social formation, it will generate new meanings whose articulation will be as valid an enterprise, in every respect, as the archival recovery of meanings that have previously arisen. Another part of materialist art history will be sensitive to the necessarily classic status, the enduring activity, of those images which have not yet lost contact with the social formation: the two key expressions of materialist art history will therefore be archival, historiographic; and critical, interpretive.

Where painting continues to galvanise writing, that writing is both more and less than painting's supplement. If supplement is that which completes, fulfils, terminates, it is a word that cannot apply to the *uncurtailable* activity of recognition. If supplement is addition over and beyond an existing boundary, the image is unbounded, and least of all by the four walls of

its frame. Writing is the trace of an encounter which will never know its object in absolute terms, but which will continue for as long as the image can circulate within society; for as long as the image remains alive.

The Gaze and the Glance

The persistence, even within the present century, of a natural attitude riddled with error and contradiction might well seem mysterious or 'epistemic', might seem clear proof of the narcotic power of naturalisation, were the metaphysic of presence not embedded in the concrete practice of representational painting, in the actual craft: if the natural attitude is bewitched by a false logic, the spell is first cast by material technique. Investigation of that technique is by no means easy; not that we are short of terms in which to discuss studio practice – rather, our vocabulary of practice has developed in the absence of a theory of practice: its origins lie in the technical manuals of the Enlightenment,[1] and have passed from there into the institution of connoisseurship, with its traditional disdain for theory. Moreover, theoretical interest in the image, over the last few decades, has been largely preoccupied with the new order of the image represented by the Photograph: though the assumptions of photography and of cinemaphotography are constantly examined and re-examined, both in the institutions and in the journals devoted to the photograph, painting remains that which the photograph has eclipsed and rendered obsolete; *its* assumptions are explored only rarely; its status has become that of a *deposed* order of the image. Investigation of the painterly sign must deal with effects of spatiality and temporality, and with conceptions of the body, that are without counterpart in the study of the photographic image; effects and conceptions that are in themselves highly elusive, logically devious, and resistant to most of the prevailing critical vocabularies: finding even essential terms is a struggle.

In linguistics a specialised category is reserved for utterances that contain information concerning the locus of utterance, to which linguistics attaches the label *deictic* (from *deiknonei*, to show). In the analysis of painting the concept of deixis is indispensable.

Its scope is best indicated by example.[2] Although the division of time

into three great periods, of past, present, and future, seems at first sight to
correspond to the traditional division of the verb into past, present, and
future tenses, in natural languages there are many tenses which on this
basis alone one would not be able to place with certainty. The distinction,
for instance, between *he ran* and *he has run* is not a question of 'when' the
running took place, still less of a temporal remoteness of 'the running'
greater in one case than in the other: it is not a matter of reference to an
event less or more recent, but rather of the relation between the event and
the circumstances of the utterance: *he ran* describes only the past event,
and nothing further; *he has run* supplies the same information about the
event, but adds to it further information concerning the relation between
the event and its description. (*Amatus est*, in school Latin, is conventionally
analysed into 'he is in a state of having been loved' ('. . . but is not loved at
the moment' is a possible inference); in the same way, *he has run* can be
analysed into 'he is now, at this moment of speaking, in a state of having
run'). French makes a similar distinction between the tense known as the
aorist or preterite (*il courut*), which in this century has become an exclu-
sively literary tense, and the compound *il a couru*, a tense of vernacular
speech. The aorist presents an action which came to completion at a certain
time before the utterance; and it describes that action without involvement
or engagement on the part of the speaker recounting the action. The com-
pound past *il a couru* not only describes the completed action, but adds a
comment from the speaker's own perspective – he is now, from this view-
point of my speech, in a state of having run, of having been loved. The
aoristic tenses (simple past, imperfect, pluperfect) are characteristically
those of the historian, reciting the events of the past impersonally and
without reference to his own position. The events, since presented neu-
trally, in 'bardic' disengagement, essentially have no narrator; having no
narrator they address no present or nearby audience, and it is only by
abrupt change of gear into a deictic mode that an aoristic narrative finds its
addressee ('dear reader'). The deictic tenses (the present, and all com-
pounds of the present) by contrast create and refer to their own perspec-
tive. The wider class of deixis therefore includes all those particles and
forms of speech where the utterance incorporates into itself information
about its own spatial position relative to its content (here, there, near, far
off), and its own relative temporality (yesterday, today, tomorrow, sooner,
later, long ago). Deixis is utterance in carnal form and points back directly
(deiknonei) to the body of the speaker; self-reflexive, it marks the moment
at which rhetoric becomes oratory: were we to visualise deixis, Quintilian

would supply us with a vivid and exact picture – the *hands* of the rhetor, the left facing inwards towards the body, the right outstretched with the fingers slightly extended, in the classical posture of *eloquentia*.[3]

Western painting is predicated on *the disavowal of deictic reference*, on the disappearance of the body as site of the image; and this twice over: for the painter, and for the viewing subject. Here the position of the painting is asymmetrical with that of the photograph, for photography is the product of a chemical process occurring in *the same* spatial and temporal vicinity as the event it records: the silver crystals react continuously to the luminous field; a continuity that is controlled temporally in the case of holography, and both temporally and spatially in the case of photography. The design of the camera, like that of the *camera obscura*, limits the physical contact of surface and field through a gate of focused exposure; all its ingenuity is exerted to contain and to harness the fact of continuum: the camera is a machine operating in 'real time' (as this phrase is used in cybernetics); and it is by its initial immersion in and subsequent withdrawal from the physical continuum that the photograph, in so many analyses, comes under the sign of Death.

For an equivalent in painting to this temporality of process we must look outside Europe, and above all to the Far East: if China and Europe possess the two most ancient traditions of representational painting, the traditions nevertheless bifurcate, from the beginning, at the point of deixis. Painting in China is predicated on the acknowledgement and indeed the cultivation of deictic markers: at least as early as the Six Canons of Hsieh Ho the greatest stricture for painting, after 'animation through spirit consonance', is said to be 'the building of structure through brushwork';[4] and in terms of its classical subject-matter, Chinese painting has always selected forms that permit a maximum of integrity and visibility to the constitutive strokes of the brush: foliage, bamboo, the ridges of boulder and mountain formations, the patterns of fur, feathers, reeds, branches, in the 'boned' styles of the image; and forms whose lack of outline (mist, aerial distance, the themes of still and moving water, of the pool and the waterfall) allows the brush to express to the full the liquidity and immediate flow of the ink, in the 'boneless' styles.[5] In such a work as the Cleveland Museum's *Buddhist Monastery in Stream and Mountain Landscape* (Illus. 15), landscape is certainly the subject, but equally the subject is the work of the brush in 'real time' and as extension of the painter's own body; and if that is true for this early, Northern Sung painting, it will be true to an even greater extent with Chinese painting after Tung Ch'i-ch'ang, and with Japanese painting

14 Wen Cheng-ming, *Seven Juniper Trees* (detail

15 Attributed to Chu
Jan, *Buddhist Monastery
in Stream and Mountain
Landscape*

after Sesshu.[6] The work of production is constantly displayed in the wake of its traces; in this tradition the body of labour is on constant display, just as it is judged in terms which, in the West, would apply only to a *performing* art.

The temporality of Western representational painting is rarely the deictic time of the painting as process; that time is usurped and cancelled by the aoristic time of the event. Productive work is effaced even though Europe has always employed media which in fact permit deixis considerable scope: encaustic, tempera, and oil paint are potentially even more deictically expressive than calligraphic painting, in that their work consists of moulding and modelling as well as painting: the variable viscosity of the pigment opens up a parameter of the trace unavailable to ink. Yet through much of the Western tradition oil paint is treated primarily as an *erasive* medium. What it must first erase is the surface of the picture-plane: visibility of the surface would threaten the coherence of the fundamental technique through which the Western representational image classically *works* the trace, of ground-to-figure relations: 'ground', the absence of figure, is never accorded parity, is always a *subtractive* term. The pigment must equally obey a second erasive imperative, and cover its own tracks: whereas with ink-painting everything that is marked on the surface remains visible, save for those preliminaries or errors that are not considered part of the image, with oil even the whites and the ground-colours are opaque: stroke conceals canvas, as stroke conceals stroke.

The individual history of the oil-painting is therefore largely irretrievable, for although the visible surface has been worked, and worked as a total expanse, the viewer cannot ascertain the degree to which other surfaces lie concealed beneath the planar display: the image that suppresses deixis has no interest in its own genesis or past, except to bury it in a palimpsest of which only the final version shows through, above an indeterminable débris of revisions. Picasso's technique of image-construction is only the extreme statement of what is in fact the habitual, the ancient process: a first image is placed on canvas in order to induce in the painter a reaction that will replace it; this second image in turn will generate a third, a twentieth image; yet at no point is the durational temporality of performance preserved or respected: on the contrary, each increment of durational time is referred back towards its predecessor only to efface it, and referred forward to an as yet uncreated future of the image in which the present, deictic increment will have ceased to exist.[7] For Picasso, the work of erasure stops only when the initial image is completely subverted, when

the viewer can no longer work out by what route the image on canvas has been reached; and from one point of view, this emphasis on improvisation involves a heightened and thoroughly un-classical activation of deictic work.[8]

Yet in its presentation of an image whose transitional phases no one is able to reconstruct, Picasso only repeats the classical mystification of opaque pigment handled always under erasure. Like the stylus in the mystic writing pad, the brush traces *obliteratively*, as indelible effacement; and whatever may have been the improvisational logic of the painting's construction, this existence of the image in its own time, of duration, of practice, of the body, is negated by never referring the marks on canvas to their place in the vanished sequence of local inspirations, but only to the twin axes of a temporality outside *durée*: on the one hand, the moment of origin, of the founding perception; and on the other, the moment of closure, of receptive passivity: to a transcendent temporality of the Gaze.

This we must approach as technical term. Both in English and in French, vision is portrayed under two aspects: one vigilant, masterful, 'spiritual', and the other subversive, random, disorderly. The etymology of the word *regard* points to far more than the rudimentary act of looking: the prefix, with its implication of an act that is always repeated, already indicates an impatient pressure within vision, a persevering drive which looks outward with mistrust (*reprendre sous garde*, to re-arrest) and actively seeks to confine what is always on the point of escaping or slipping out of bounds.[9] The *regard* attempts to extract the enduring form from fleeting process; its epithets tend towards a certain violence (penetrating, piercing, fixing), and its overall purpose seems to be the discovery of a second (re-) surface standing behind the first, the mask of appearances. Built into the *regard* is an undoubted strain or anxiety in the transactions between the self and the world, and in this effortful scansion it is opposed to the *coup d'oeil*, which preserves and intensifies the violent aspect, the 'attack' (in the musical sense) of *regard*, yet by the same token creates an intermittence of vision, a series of peaks traversed by valleys of inattentiveness when the self, recuperating after the outburst of its activity and with its resources temporarily depleted, withdraws from the external world into an apartness alluded to yet lacking in firm definition. An unmistakable hierarchy operates across the two terms, as though one came from the diction of an aristocracy and the other from the plebs, as though *regard* belonged to the protocols of the court and were formally reversible, the *regard* of the self becoming visible to the *regard* of others, of the Other; while *coup d'oeil* is

vision off-duty and retired from visibility, its brief raid into the outer world earning immediate return to a natural intransitiveness and repose.

In English, a similar division separates the activity of the *gaze*, prolonged, contemplative, yet regarding the field of vision with a certain aloofness and disengagement, across a tranquil interval, from that of the *glance*, a furtive or sideways look whose attention is always elsewhere, which shifts to conceal its own existence, and which is capable of carrying unofficial, *sub rosa* messages of hostility, collusion, rebellion, and lust. Setting to one side the complexity of the French terms in their passage through a long and rich intellectual development, let us stay with the broad, vernacular division of the English terms and elaborate one connotational strand: the implied dualism of the Gaze and the Glance. Painting of the glance addresses vision in the durational temporality of the viewing subject; it does not seek to bracket out the process of viewing, nor in its own techniques does it exclude the traces of the body of labour. The calligraphic work of Chu Jan or Sesshu cannot be taken in all at once, *tota simul*, since it has itself unfolded within the *durée* of process; it consists serially, in the somatic time of its construction (a more precise translation of the First Canon of Hsieh Ho suggests the gloss 'consonance of the body with the object the body is to represent': it is from the body of labour that the animation of the representation emerges).[10] Suppression of deixis in the West operates by abstracting from the physical practice of painting and of viewing a valorised moment when the eye contemplates the world alone, in severance from the material body of labour: the body is reduced (as much in Gombrich as in Alberti or in Leonardo) to its optical anatomy, the minimal diagram of monocular perspective. In the Founding Perception, the gaze of the painter arrests the flux of phenomena, contemplates the visual field from a vantage-point outside the mobility of duration, in an eternal moment of disclosed presence; while in the moment of viewing, the viewing subject unites his gaze with the Founding Perception, in a perfect recreation of that first epiphany. Elimination of the diachronic movement of deixis creates, or at least seeks, a synchronic instant of viewing that will eclipse the body, and the glance, in an infinitely extended Gaze of the image as pure idea: the image as *eidolon*.

One example must stand for many. Against the *Buddhist Monastery in Stream and Mountain Landscape*, let us juxtapose the Titian *Bacchus and Ariadne* (Illus. 15 and 16).[11] Where the landscape in the hanging scroll was motionless and all motion resided in the brush, here everything is subject to a fundamental figure of Arrest (the time of the painting is that of the

enounced, not the enunciation). What is removed from the world is its duration: the bodily postures and gestures are frozen at points which normal vision is unable to immobilise, which can never be seen by the glance; a maximum of distance is introduced between the disorderly, rhythmical, dionysian vision of the dancers, of Bacchus, of Ariadne, and the cold, synchronic, omniscient gaze of the painting's founding percep-tion. The term shed in that separation is precisely the body, as source of a possible troubling of the panoptic, split-second clarity the image seeks: vision as it unfolds before the participants in the scene is the corporeal, spasmodic vibrancy of flux; vision as it is presented to the viewer is that of the Gaze victorious over the Glance, vision disembodied, vision decarnal-ised. The mode of the image is emphatically aoristic. Where in deixis the utterance is continuous, temporally, with the event it describes, here the image aims at a discontinuity between itself and the scene it represents, discontinuity so extreme that the origin of the image (this is its fascination) in fact becomes irrational. Just as the aorist presents action that is now over, action seen from the viewpoint of history, so the aoristic gaze con-templates the drama of Ariadne's encounter with Bacchus from the pers-pective of the last act, when Ariadne will be honoured after her death by translation into the constellation Corona, in memory of the jewels that had guided Theseus through the Labyrinth. The action is over as it happens: the viewpoint is that of an all-knowing eternity beyond sublunary change. In its root form, the word *consideration* refers to exactly this transcendent operation of vision, where the stars (*sidera*) are seen together, the constella-tions made and named by subduing the random configurations of the night sky to the order of celestial geometry: the constellation is that which just exceeds the boundary of the empirical glance. Vision as it scans the night sky can never take in the constellation all at once, *im Augenblick*: Corona is formed by an abstraction from the limited focuses of the glance, a surpassing of the intermittent, shifting field of practical vision into the theoretical eidos of an oval that nocturnal vision will never see. Presented in the full light of day, Titian's constellation reveals the contradiction – the impossibility of the considerating Gaze, at the same time that the painting of the Gaze reaches what must be its technical zenith.

Where the painting attributed to Chu Jan, or the *Seven Juniper Trees* of Wen Cheng-ming (Illus. 14), had incorporated and impersonated flux in the flow of its inks on the silk, here the mastery of the stroke lies in painting out the traces that have brought the strokes into being: the easel-paintings of the West are autochthonous, self-created; partheno-

geneses, virgin-births. On one side, process has been eliminated from the
world: everything that was in rhythm is arrested and everything that had
been mobile is petrified. On the other, process has been eliminated from
the painting: the stroke does not exist in itself, except to transmit the
perception alleged to precede it; the oil-medium does not exist, except to
erase its own production. The logic of the Gaze is therefore subject to two
great laws: the body (of the painter, of the viewer) is reduced to a single
point, the *macula* of the retinal surface; and the moment of the Gaze (for
the painter, for the viewer) is placed outside duration. Spatially and tem-
porally, the act of viewing is constructed as the removal of the dimensions
of space and time, as the disappearance of the body: the construction of an
acies mentis, the punctual viewing subject.

The *Bacchus and Ariadne* lies at the end of a development which begins in a
quite different semiotic and somatic regime. Prior to the Renaissance
neither the mosaic art of the South nor the glass-painting of the North
radically questions the archaic dispensation that had legitimated the image
as a place of textual *relay*. After the close of the Iconoclastic period, the
image in Europe is issued a precise and limited command: *illiterati quod per
scripturam non possunt intueri, hoc per quaedam licturae lineamenta contemp-
latur.*[12] Since the overriding mandate of glass and mosaic is to present
scripture without further elaboration beyond that which is required to
disseminate the pre-formed corpus of denotation (the minimal schema of
recognition), there is no requirement that the text be articulated from the
viewpoint of the individual craftsman or be received by an individuated
spectator: just the reverse – for the schema to be guaranteed precise recog-
nition, it must keep to its minimal form. The viewing subject is addressed
liturgically, as a member of the faith, and communally, as a generalised
choric presence. The image is part of a whole architectural *Umwelt* where
the body is enclosed on all sides and addressed in all dimensions: the
space of the Byzantine image is dramatic, a theatre of religious ceremonial;
and, like the space of the mosque, it is also acoustic, for the image is only
the liturgy in another and more accessible form. The spectator at Hosias
Loukas, at Hagia Sophia, at Canterbury and Chartres, is constructed as a
physical, ambient witness to the Sacred Word; he is not yet the optically
specified and disembodied presence he will later become, since the body
in its totality is the focus of the visual, as of the hieratic regime: the Church
will baptise, marry, punish, bless, and give its final rites to this body of the
Incarnation where spirit and matter fuse.

16 Titian, *Bacchus and Ariadne*

Within this *architectural* dispensation of the image, not even those narra-
tive structures which will later be used to address the spectator as unique
observer of *this* sacred episode detain and isolate viewing attention, since
the capacious space of the edifice has been charged with maintaining the
entire corpus of texts: in the glass cycles of Canterbury, the Sacrifice of
Isaac is not separated out from the corpus and proferred for exclusive
inspection, but is accompanied by the Passover, the story of the Grapes of
Eschol, Moses in the Desert, the Crucifixion; the individual act of viewing
is interwoven with its related types and anti-types, in a narrative synthesis
of both Testaments.[13] Since liturgical temporality embraces the whole year
and not the particular moment of viewing time, the textual dynamic is
rotational, each component episode part of a turning wheel of scripture in
which the individual instance and the total repertory are subject to no

particular dissociation, but on the contrary participate in each other's nature. So far from being a spatial or temporal point, the viewer of the ecclesiastical image is an embodied presence in motion through a circular temporality of text and a choreographic (in the full sense) space of vision; the substance and mobility of his physique are fully involved in the work of receiving the images, as he receives the Eucharist, the Doxology, the Word. *The body does not see itself*; the gaze under which it moves is not yet the introjected gaze of the Other, but of God (Illus. 17).[14]

The crisis of this visual regime is precipitated by expansion beyond the minimal schema. Once information oversteps the threshold of recognition, a principle of fissure is introduced into the unity of the liturgical *rota*: as the viewer moves from one connotationally expanded image to the next, he confronts each time a new scene, one which has broken free of its sequence, has renounced its place in the choric cycle, and asks to be viewed in increasing isolation both from its physical neighbourhood and from the global *langue*. The intensity both of the fissure itself and of the painter's efforts to anneal the fissure is clearly evident in the Giotto and Giottesque fresco cycles at Assisi and Padua, where the surface area *between* scenes is worked in two contradictory styles: both as *band*, joining the seceding episodes back together in a spatial coherence of mural space, to counterbalance the increasing fracture of the narrative space; and at the same time as *interval*, pulling the scenes apart and reinforcing their individuation by transforming the space of the wall into that of the frame. The mural space, formerly the most powerful assertion of the primacy of architecture in the visual economy, is now suppressed as plastic form, and becomes neutralised into a kind of non-space, neither part of the three-dimensional surround of the edifice, nor clearly affiliated to the individual episode: a sort of categorial scandal in which the *langue/parole* divisions of the narrative order (the cycle, the episode) and the double set of instructions to the spectator (to see the space as scaffold/as surround) confusedly elide.

Connotation and *frame* are interdependent terms. In so far as the image exceeds its denotative function, it has already broken from its matrix, from the cyclical banding of the *langue*; it no longer invokes, *in absentia*, the corpus from which it is derived. Taken now *in praesentia*, it thus creates for the viewer a space and indeed a metaphysic of presence, since the viewer is correspondingly singled out from the liturgical chorus and specified ostensively, as the recipient of this particular narrative segment, a segment that less and less implies the original circle from which it is taken. The consequence of an individuated viewing subject derives in the first place

17 *Christ Pantocrator*

from the internal ratio of denotation to connotation within the visual sign: the relation of excess brings into being both the concept of a cordon round the image, and a spectator who is addressed as *thou*, a singular subject the image proposes and assumes. What is interesting is the independence of this configuration of frame, connotation, and individuated subject, from the elaboration of the codes of perspective. The configuration is already established in Cimabue whose presentation of three-dimensional space is, to say the least, rudimentary: the specificity that derives from narrative structure and the specificity that derives from spatial structure are *separate* evolutions, mutually out of phase. Indeed, in the Giotto fresco cycle they tend to conflict: at Padua, each individual panel visibly struggles against

18 Master of the Barberini Panels, *Annunciation*

the fracturing effect of recessional space.[15] The *Betrayal*, for example, is noticeably bi-dimensional and seems actively to resist that massive separation from its mural banding which the image would suffer if it were to include the perspectival depth we know Giotto was certainly capable of introducing into it: the disposition of the weapons takes the form of a frontal semicircle, the heads glimpsed between Judas and Christ cluster in fan-like formation round the picture plane, and Christ's halo permits only slight, somewhat incoherent accommodation to three-dimensional space. Here, the handling of space works to *contain* the secessionist tendency of connotation.

Again, in the *Annunciation* by the Master of the Barberini Panels, in Washington, two separate modes of specification are rather raggedly superimposed (Illus. 18). At the level of information, the *Annunciation* refers not only to the general *langue* of Gospel schemata, but to a specialised set of subdivisions within the Annunciation topos. Working only with the codes of iconography, the contemporary viewer would have been able to place this particular Annunciation against a set of variations established largely through the positions of the Virgin's hands, and corresponding to five distinct states or phases of the episode: Disquiet, Reflection, Inquiry, Submission, Merit; he or she would have recognised the image as the schema corresponding to the second of these phases.[16] This kind of fine-tuning in the reading of symbols constructs the viewer firmly, and independently of whatever may be happening within the spatial construction of the image, as the receiver of *this*, this single and highly particularised schema. The Kress *Annunciation* is not to be viewed against a whole cyclic movement of sacred history, but rather as part of a locally delimited set of minor variations on the Annunciation theme, of which four (Disquiet, Inquiry, Submission, Merit) are currently being excluded. The viewer who is to supply these excluded terms is asked to perform a minute and almost optional interpretative act which even in the year of the painting's appearance may well have been beyond many viewers' competence. The narrative address is thus far more singularly vocative than it is, for example, in the Giotto *Betrayal*, where the proposed viewer is still a comparatively non-individuated liturgical participant, called on to view the *Betrayal* against a vast Passion cycle; a more intimate address asks at this point for fine discriminations amongst Annunciations; it assumes a viewing subject who can be relied on to perform immediate scansion of this 'unique' Annunciation, and who is accordingly being treated more as a connoisseur than as a choric worshipper.

In addition, the Annunciation is portrayed as taking place in, or rather in front of, a precisely triangulated recessional space. The codes of perspective require that the viewer take up a position opposite the vanishing point indicated by the plunging arcades, cornices and flagstones; this second construction of a viewer who must have assumed an exact point in space is *then* superadded to the first. But the two constructions, in the Kress *Annunciation*, do not quite synchronise. In the iconographic subdivision of the Annunciation into 'stations' the relationship between 'fixed' and 'moving' parts has something of the quality of a shadow puppet or marionette, while the frontal, frieze-like space of Angel, Virgin, and urn is not articulated smoothly enough into the architectural background, which seems to hang behind the figures in the manner of a backcloth. In this faulty alignment we can see that the construction of the viewing subject is in fact multiply determined; the desired homophony devolves into the polyphonic zigzag of voices mutually out of phase.

It is not until Alberti's *De Pictura* that the problems of unified space, unified information, and their correct relative alignment are fully theorised, and in a single term: *compositio*. Although we are used to thinking of pictorial composition as a matter of the relationships between different areas of the picture plane, its original meaning is rhetorical and approximates more closely the modern term 'syntax':

> It is indeed usually the case that, when the spectator spends time examining the painting, then the plenitude of the image gains favour. But this plenitude should be elaborated according to controlled variation, and subdued and modified by nobility of subject-matter, as well as by its verisimilitude. I greatly condemn those painters who, merely because they wish their work to seem abundant in detail, or because they cannot bear to leave any area of the image unfilled, on that account fail to practice *composition*, and instead scatter everything about in a confused and haphazard fashion, so that the narrative seems rather to be disordered, than enacted.

> Fit enim ut, cum spectantes lustrandis rebus morentur, tunc picturis copia gratiam asquetatur. Sed hanc copiam velim cum varietate quadam esse ornatum, tum dignitate et verecundia gravem atque moderatur. Improbo quidem eos pictores qui, quo videri copiosi, quove nihil vacuum relictum volant, eo nullam sequuntur compositionem. Sed confuse et dissolute omnia disseminant, ex quo non rem agere sed tumultuare historia videtur.[17]

Composition here is conceived as a unity of theme and of information, rather than a unity of space, or a balancing of surface areas. The crucial terms – *copia*, *dissolutus*, *varietas* – are taken from humanist rhetoric, and in particular from the rhetoric of the Ciceronian periodic sentence, with its careful priorities of main- and sub-clauses, central and peripheral emphases.[18] Alberti is recommending that the painters co-ordinate their data in the unified hierarchical formations exemplified by Ciceronian Latin, and by Alberti's own Ciceronian prose; it is likely that he is also criticising particular painters whose styles value *copia* over *compositio*, and episode over unitary theme – painters such as Pisanello and Benozzo Gozzoli. At the same time, the coherent field of information must be organised spatially, around a single axis.

> I beg studious painters to listen to me . . . they should understand that, when they draw lines across a surface, and fill the parts they have drawn with colours, their sole object is the representation on this one surface of many different forms of surfaces, just as though this surface which they colour were so transparent, so like glass, that the visual pyramid passed right through it from a certain distance and within a certain radius of the centric ray . . .

> Quare obsecro nos audiant studiosi pictores . . . ac discant quidem dum lineis circumeunt superficiem, dumque descriptos locos implent coloribus, nihil magis queri quam ut in hac una superficia plures superficierum formae repraesentur, non secus ac si superficies haec, quam coloribus operiunt, esset admodum vitres et perlucida huiusmodi ut per eam tota pyramis visiva permearet certo intervallo certaque centrici radii et luminis positione cominus in aere suis locis constitutis.[19]

Perhaps some clarification is needed: the visual 'pyramid' is the cone of light passing through the lens of the eye onto the retina; the centric ray is a theoretical axis extending from the convergent point of the cone, the *fovea centralis*, to a point on the surface around which the image is to cohere – what is usually known as the vanishing point. Now, it would seem that in this rigorously perceptualist account of representation, the body of the painter is reduced to the 'interior' arc between retina and brush, and that the body of the viewer is correspondingly simplified into a punctual site of reception; that Alberti's conception of the subject is already Cartesian in its reduction of the space of painting to dimensionless punctuality.

There can be little doubt that in its theoretical form, as presented by *De Pictura*, this is indeed the reduction Alberti intends: the eye of the viewer is to take up a position in relation to the scene that is identical to the position originally occupied by the painter, as though both painter and viewer looked through the same viewfinder on to a world unified spatially around the centric ray, the line running from viewpoint to vanishing point (it is probable that Alberti has in mind the model of the *camera obscura*); unified spatially, but also informationally, since all the data presented by the image are to cohere around a core narrative structure. Yet curiously, the construction of a punctual and disembodied subject is precisely what painting organised around a single vanishing point fails to achieve.

In the first epoch of perspective, dominated by the Albertian 'box' or *costruzione legittima*, the image provides an avenue of approach that directly addresses the *physique* of the spectator.

Let us say that the Raphael *Marriage of the Virgin* succeeds where the *Annunciation* by the Master of the Barberini Panels failed, and that the two aspects of unification proposed by *De Pictura*, of information and of space, are not simply superimposed but fully integrated; that the 'back-cloth effect' has been overcome (Illus. 19). Nevertheless, because the Albertian concept of the centric ray – the line between the viewpoint and the vanishing point – is *axial*, the viewer proposed and assumed by the image is in fact given no *single* point from which the image is to be seen. Alberti's conception of pictorial syntax is in fact far more delimiting to the subject than his doctrine of space. In the Ciceronian sentence, the organisation of information into strict hierarchies of priority affords the reader little room for manoeuvre: the subject-position is mapped out in advance, by imbrication of blocks of information into an ascending series of importance; through the use of units capable of shifting information from a higher to a lower level (e.g. relative particles), Ciceronian rhetoric imposes a gubernatorial perspective on the information it purveys, and this in turn fixes the subject in a unitary position of submission before that ruling perspective.[20] At this level, the Raphael successfully meets Alberti's requirement: the *compositio* of the *Marriage of the Virgin*, as a narrative structure, specifies precisely which zones of the image are of primary, of secondary, and of tertiary status.

Yet spatially, the address is not to a *punctual* subject, but to a viewer who is physically embodied: the characteristic forms of the *veduta*, in the Albertian epoch of painting, are architectural: flagstones, arcades, cornices, windows, porticoes; the space they habitually recreate is that of the

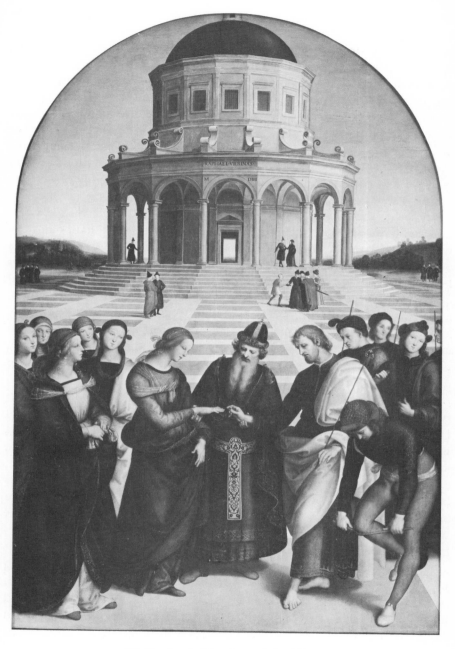

19 Raphael, *Marriage of the Virgin*

piazza. The architecture of the *veduta* proposes a spectating body accustomed to defining itself as one among many in a vast array of precise, bounded, minutely located physical forms; the streets like canyons, the open expanses of the square, all these cues of urban movement describe a body tracked along a mobile path, a body always advancing and retreating, measuring and quantifying.[21] In its production of the centric ray between viewpoint and vanishing point, the Albertian regime assumes the viewer not simply as an ambient witness, in the manner of Canterbury or Hosias Loukas, but as a physical presence; and in this sense the vanishing point is the anchor of a system which *incarnates* the viewer, renders him tangible and corporeal, a measurable, and above all a visible object in a world of absolute visibility. The centric ray constitutes a return of the gaze upon itself: the cone of lines emanating from the Albertian eye is redoubled in its opposite, a cone radiating towards it out of that point from which all the architectonic lines radiate: in the Raphael, from the blank opening at the centre of the temple. At the picture plane, the two cones intersect; which is to say that the single vanishing point marks the installation within the painting of a principle of radical alterity, since its gaze returns that of the viewer as its own object: something is looking at my looking: a gaze whose position I can never occupy, and whose vista I can imagine only by reversing my own, by inverting the perspective before me, and by imagining my own gaze as the new, palindromic point of disappearance on the horizon.

Despite the dyadic reversibility of the two gazes, there is nothing interpersonal about this vision that sees itself seeing: if the implacable God of Hosias Loukas could be appeased by prayer, as an invisible place towards which the stream of public and private liturgy was directed, now the subject lacks its divine partner: no other gaze is actually confronting mine, except that of a rectangular, luminous void on the horizon. A third factor has been introduced, a viewpoint which is not that of a separate creature or personality, but of an impersonal arrangement, a *logic* of representation which changes the viewer himself into a representation, an object or spectacle before his own vision. In operating the codes of monocular perspective the viewing subject creates a self-definition as *this* body approaching the image in *this* space: where the space of Byzantium had been physical, had been somatic, yet the body was never individually interpellated and never saw itself, Albertian space returns the body to itself in its own image, as a measurable, visible, objectified unit. From the generalised ambience or atmosphere of religious witness, it solidifies a form which will

provide the viewing subject with the first of its 'objective' identities.

What we are really observing, in this first geological age of perspective, the epoch of the vanishing point, is the transformation of the subject into object: like the camera, the painting of perspective clears away the diffuse, non-localised nebula of imaginary definitions and substitutes a definition from the outside. In its final form, which we will emblematically indicate through Titian and Vermeer, the only position for the viewing subject proposed and assumed by the image will be that of the Gaze, a transcendent point of vision that has discarded the body of labour and exists only as a disembodied *punctum*. Yet what is fascinating about Albertian space is the persistence of the body as the privileged term in its visual economy. The crucial difficulty raised yet left unresolved by *De Pictura* concerns the puzzle of the relation between these three vertices: the point from which the scene was observed by the painter (the Founding Perception); the point from which the viewer is to look at the image (Viewpoint); and the point on the horizon towards which the perspective lines converge (Vanishing Point). With the *camera obscura*, which provides the conceptual framework for *De Pictura*, alignment of the three is simple: the Founding Perception is gathered at the aperture of the chamber (lens, iris), and perfect viewing is achieved by placing the Viewpoint of the spectator at the same aperture, looking towards the screen; in terms of the painting practice Alberti advocates, the viewer finds a position in relation to the image from which the field before him exactly corresponds to the Founding Perception, a position existing at some point along the centric ray.[22] Yet there is an ambiguity here: is the centric ray an empirical entity, matching the physical experience of gazing across the space of an orthogonal piazza, towards an actual vanishing point on the horizon; or is the centric ray a theoretical entity around which the space of the image is to be organised in simply mathematical terms?

What even the most 'Albertian' painters are unable to resolve is the relation between a purely *fictional* vanishing point, and the position *physically* to be occupied by the viewer. In the work of Piero, for example, the impression of monumentality, of superhuman scale, derives largely from a portrayal of the figures in a new perspective that is exaggeratedly low: as the spectator 'moves into' the viewpoint that corresponds, across the centric ray, to the vanishing point of the image, there is a crushing sense of diminution of the spectator's own scale, an alteration of the customary ratio between bodies in the visual field: in normal viewing experience, human beings are seen in this way only if the viewer's body is lowered – in

fact, is kneeling in prayer. The effect assumes, still, that the viewer will want to align his own body in relation to the image before him, if not in actuality, at least in the mental accommodations he makes between the viewpoint proposed by the painting, and his own physique. To this extent, Piero is activating a notion of 'correct' bodily disposition that reveals the extent to which the Gaze is still theorised physically, with the body as its central support.[23] Again, in the Masaccio *Trinity*, the viewer is to occupy a space at ground level, directly opposite the illusionistic sarcophagus; his eye level corresponds roughly to the level of the outer stage on which the patrons kneel (Illus. 20). Calculating for this angle of vision, the image then welds together the vanishing point of its own perspective with the point actually occupied by the observer, across a centric ray perpendicular to the picture plane. Examining the surface, the viewer will find most of the fresco to cohere about this anticipated position: the plunging perspective of the sarcophagus is well below eye level, the heads of the donors are slightly above, the lines of the coffered ceiling duly protract inward and downward to the centric ray, and the figure of God-the-Father seems to tilt backward, as though seen from far beneath. Moreover, the scale of the figures within the image is consonant with the scale of the viewer's body, as though the ground plan of the viewer's physical environment were continuous with the ground plan of the painting; and since the centric ray is unnaturally low in relation to the figures, the scale seems magnified or monumental, as in Piero.

These spatial effects assume the viewing subject as an actual bodily presence, reacting to scale within the image as though to the scale of normal experience: the vocative address of the image is directly somatic. That is, so to speak, the Albertian side of the Masaccio *Trinity*: it posits continuity of ground plan from the exterior to the interior of the image; its natural tendency is towards *trompe l'oeil*; and it anticipates the kinaesthetic, 'muscular' response of a viewer who, from comparison with his own experience of scale, will interpret the height of the figures as magnified even when their dimensions do not exceed life size. Yet at the same time, there emerges within the image a quite different conception of the viewing subject, in which the centric ray is thought through not as a physical axis, but as a set of non-empirical co-ordinates: a *second* vanishing point is included in the image, roughly at the height indicated by the Madonna's extended right hand.[24] It is around this separate, post-Albertian point that the schema of the Crucifixion coheres, *in a zone the body of the viewer cannot occupy*: whereas the head and shoulders of God-the-Father tilt backwards,

20 Masaccio, *Trinity*

to be seen from a position in real space, the body of Christ remains in parallel with the picture plane; the foreshortened modelling of Christ's face, legs, arms and torso presumes a viewpoint that is spatially elevated far above the viewer's own body. The image thus divides into zones of empirical and of theoretic perspective; a division it refuses to acknowledge, except in one key area: the head of the Madonna (Illus. 21). Looking at the detail of the face from the position of the viewer, we find the left side of the face coherent about the second and theoretical vanishing point (if we were to cover the right side, this would be a frontally posed three-quarter portrait): the right side, by contrast, coheres about the empirical and embodied viewpoint of the spectator. The conflict is in the first place spatial, a clash between dimensional systems that warps and distorts the features of the Madonna, as though the space of Einstein were displacing the space of Euclid; yet in the wider sense it is a clash between contradictory definitions of the viewing-subject: as *this* body in *this* space; and as a non-empirical *punctum* of observation.

21 Masaccio, *Trinity* (detail)

The difference between the first, Albertian epoch of perspective, and its second and culminatory epoch can be seen by comparing the Raphael *Marriage of the Virgin* with two paintings by Vermeer: the *View of Delft* (Illus. 22) and *The Artist in his Studio* (Illus. 23). In the Raphael, both the architecture of the scene, and the gestures, postures and facial expressions of the figures turn towards the spectator in direct invocation: the spectator is the absent focus of these glances and walls, and of this whole dramatic action, mounted, one might say, for his particular benefit. The figures are *advertent*, fully aware of the presence of an unseen witness towards whom they direct their physical stances; the space in which the figures are disposed is conceived theatrically, as a spectacular arena where the body exists only as far as it is *seen*. In turn, the viewer enters the particular axial zone where he has to stand if the symmetry of that scenic space is to be perceived non-astigmatically, without lateral distortion – the image may have freed itself from the architecture of the Church, yet it continues to address the spectator as though it embodied a plastic, sculptural space where the body of the viewer is positioned *processionally*: just as the worshipper in ecclesiastical space orients himself around the cardinal axes of the edifice, so the viewer is placed in a space of priorities, where axial emphasis confers on space a quality of the sacred and where axial alignment makes sacred the body that incorporates the axis into itself, as the body of the Virgin is made sacred by placing her finger, exactly at the vertical axis, into the ring. Yet this sacramental address to the body is already archaic; co-ordination between the body of the viewer and the distribution of information in the painting becomes, even in Raphael's lifetime, increasingly obsolete. The *View of Delft* belongs to a different spatial regime and stages nothing: it is a vision of the inadvertent, vision in inadvertency. Now that the architecture is disposed freely in space, and the parallels of cornices, windows, and porticoes bend according to a perspective system that has dispensed with the vanishing point, the spectator is an unexpected presence, not a theatrical audience; nothing in the scene arranges itself around his act of inspection, or asks him, in Albertian fashion, to place his body at *this* particular point at which the founding perception was 'gathered'. Both Alberti and Vermeer theorise painting around the *camera obscura*, yet with Alberti the 'centric ray' indicates to the viewer that if he were to place his body at this particular point or along this particular axis, he would see the scene *in the same way* as the painter, with everything on the same scale as the scale of the real world, and an implied continuity (the theme of the flagstone) between the ground-plan of the

founding perception, and the ground-plan of viewing. The Vermeer records the perception with unprecedented accuracy, but the perception is presented to the viewer to examine from his own position – he is not being invited to move up to a viewfinder, or to step inside the perception; there is an asymmetry between the original perception, recorded in the image, and the act of viewing. *Trompe l'oeil* is in fact renounced: the bond with the viewer's physique is broken and the viewing subject is now proposed and assumed as a notional point, a non-empirical Gaze.

An analogy from computer-based video display may help to clarify this difficult spatial transformation. When sectional drawings are 'rotated' on a television screen, the space through which the images turn is wholly virtual – perhaps the purest virtual space so far devised: no one has actually seen this space in the real world; ultimately its only 'real' location is within the distribution of data in the computer program. It is this abstraction of

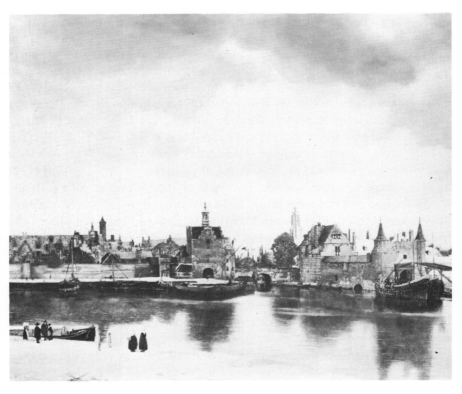

22 Vermeer, *View of Delft*

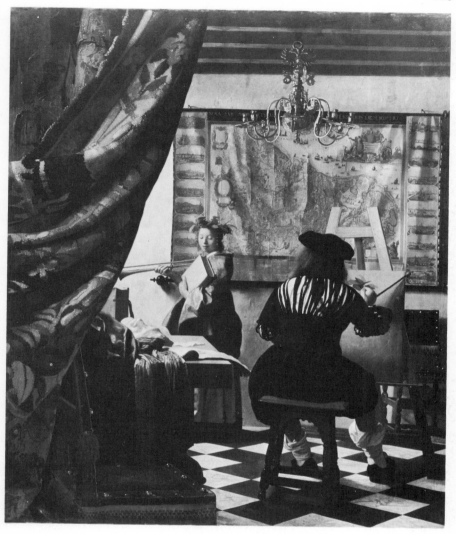

23 Vermeer, *The Artist in his Studio*

virtual from empirical space that the Albertian *camera obscura* prevents: Piero anticipates a translation of visual data into the terms known by the bodily hexis; Masaccio turns the virtual face of the Madonna downwards, to meet the embodied, empathetic, kinaesthetic response of a viewer placed in three 'real' dimensions. In Vermeer, the viewer and the painter no longer cohabit the same continuum, and so far from entering into the inner perceptual field of the painter's body, the viewer sees that body from the outside, from behind. What the turning of the artist's back indicates (Illus. 23) is the exclusion of the viewer as physical presence; he is not introduced, as a courtier, to figures who ceremoniously welcome his advance; he is not given this place to stand in, this privileged focus of a spectacular moment. Nor does the image cohere around a single point of observation. *The Artist in his Studio* states and restates, through a gamut of instances, the theme of the adorned surface: in the map, the three surface areas of cartography, of rubric, and of the topographic views; the woven design of the curtain; the meticulously veined marble of the tiles; the convex reflections of the chandelier; the varying luminosity of the wall; and, recapitulating all of these, the unfinished canvas on the easel.

In the hands of Metsu, each surface would be subject to a law of single viewpoint: if an object close to the viewpoint is presented in sharp focus, the objects behind it are in haze: if we see clearly the written characters of a letter read in the light of a window, the picture on the wall behind is blurred. But in Vermeer the surfaces are presented as existing on *different levels of transposition* into the painting. Whereas the map is painted through meticulous transcriptions, with each detail of the map reproduced on canvas by a direct one-to-one isomorphism, the reflections of the chandelier are handled through the broad strokes of a brush loaded with liquid pigment: with the map the work of the brush is assiduously concealed; with the chandelier it is advertised, as an *elliptical* technique at odds with the careful one-to-one correspondences and precise transcriptions of the map (Illus. 24). Again, as we pass from the cartographic area of the map to the topographic views at its borders, we move from high-fidelity transcription of perceptions that are, perhaps, slightly out of focus, to views whose simplification we cannot place with certainty: the topographic views seem drained of content and not simply unfocused; their outlines are bleached and rudimentary, as though a whole stage of pictorial finish had been left out; their information has not merely been blurred, but filtered, indicating a level of transcription discontinuous with that employed in the 'faithful' registration of the map's cartography.

24 Vermeer, *The Artist in his Studio* (detail)

The longer one looks at a Metsu the more one is impressed by the consistency with which focus is arranged; in Vermeer, what seems at first to be uncertainty of focus gradually reveals *notation*, rather than focus or perception, as the main organising principle in the image. While the ribbons of the artist's tunic are clearly delimited and hard-edged, the folds of the figure's stockings are transcribed in a notation whose grid is much broader and less differentiated: the conflict of grid cannot be recuperated by appeal to focus – the difference in planar depth between tunic and stockings is insufficient to cause the disparity between high- and low-fidelity transcription; and as the eye attempts to bind the areas into unity of focus and to read the Vermeer as though it were a Metsu, what emerges more and more strongly is the uncanny perceptual incoherence of the image. Each area of the Vermeer juxtaposes a precise, isomorphic level of transcription and a loose, laconic level of omission, simplification, latitude. With the curtain to the left of the scene, it becomes impossible to determine whether the simplification of the woven design is to be assigned to high-fidelity registration of perceptions that are out of focus, or to a sweep-

ing, generalised transcription of perceptions 'originally' in sharp focus;
nor, with the strokes of the brush on the unfinished canvas, can the viewer
determine to what degree the simplification of form is to be attributed to
the painter at his easel, and to what degree attributed to Vermeer. It is as
though Vermeer had discovered a universal principle of duplication: the
ideal structure of the map is represented, but in addition the image also
presents, as something almost separate or separable, the accidental history
of the map as a physical surface striated by light; the image presents the
convex reflections of the chandelier, yet also it presents and dramatises the
notation from which the illusion of reflection is constructed; the curtain is
depicted, yet in addition the image displays, announces, exaggerates, the
work of the signifier in transcribing the curtain. At no point are we
allowed a Zeuxian image, bathed in the luxury of an evident *eidos*: where
Metsu records perceptions, Vermeer notates them, and then dramatises
(paints) the act of notation; he exaggerates the interference-patterns be-
tween conflicting grids of transcriptive fidelity until we can no longer
accept the image in perceptualist terms: text and meta-text are given
together, and the relation between them is uncertain, is troubling, because
although the viewer can see that a particular gauge of transcription gov-
erns each surface area, he is not told the precise nature of the gauge:
viewing the image becomes impossible. At no single distance from the
painting will the spectator discover its global intelligibility, for the painting
is not conceived in the model of a physical transaction, but non-
empirically, as a plurality of local transcriptions which nowhere melt in the
fusion of a simultaneous disclosure. The viewing subject assumed by the
image has no existence in tangible space: just as the painting has been
painted by no one (which artist, in which studio, has created what is
seen?), and lacks an empirical origin (what is the 'real time' of the image?),
so it is to be received as notional, notational, as a mathematical fiction: the
viewer can try any number of points and distances away from the canvas,
but the image will never cohere, singly or serially, around them.

 If Albertian space took away from the viewer one dimension, the space
of the Gaze takes two: when viewing has broken free of the bodily tem-
plate, the subject it proposes is a point, a vertex. Let us remind ourselves of
the temporality of real-time process: calligraphy unfolds in duration and is
the product of gesture. The temporality of a Sesshu is a *distension* of normal
time: skills it has taken the body many years to acquire are mobilised and
expanded in a performance that shows itself as both headlong and per-
fectly deliberate: since the power of decision has been transferred (we are

speaking of ideal conditions, of a myth of mastery) away from codex and from *langue* to the body itself, the inertia of consultation with the codex, of choice and hesitation, has been by-passed; skill here consists in leaving the brush in the hands of a muscular intelligence. The viewing subject proposed by calligraphy must approach the image kinaesthetically: 'The power intent was suggested by conceiving a stroke outside the paper, continuing through the drawing space to project beyond, so that the included part possessed both power origin and insertion.'[25] The aesthetic value of the trace resides precisely in what can be inferred about the body from the *course* of the trace: the brush strikes the paper *in media res*, and as it lifts from the paper its energy is not yet spent; the viewing subject is constructed gymnastically, as an organism whose somatic memory understands the origin and the insertion of the stroke as it understands the origin and insertion of its own musculature (from the inside): two real-time processes, of the trace and the glance, meet at the interface of the picture plane. Painting of the Gaze breaks with the real time of durational practice: the *Bacchus and Ariadne* has painted its own strokes out, as it has recorded an empirically impossible moment when the life of the dance and the death of the constellation are collapsed together; *The Artist in his Studio* dissolves the bodily address of Albertian space in the computative space of a notional point outside duration and extension. Unique, discontinuous, discarnate bodies, move in spatial apartness, under the gaze of the Other: perhaps it is Giacometti who has the last word on what it is to be in a gallery.

The image under realism must not only provide the world with its Zeuxian reflection: it must structure the temporality of the image according to two vertical moments, twin revelations, one in the mind of its creator for whom the image is there fully armed from the beginning, the other mirrored in the mind of the viewer; two epiphanies welded together in a single moment of presence. For the painter, the irregular and unfolding discoveries of the glance are collected and fused into a single surface whose every square inch is in focus, as though the fovea of central vision had expanded and filled the entire retinal bowl; for the viewer, the serial or intermittent time of the glance is once more robbed of its duration, taken out of real or somatic time, and compressed into an instant of consideration; just as, spatially, the shifting or ambulant mobility of the glance is taken out of the musculature and suspended at a point in non-empirical space. Clearly this temporal myth of the image can only function for as long as no interval between the moment of origin and the moment of

reception is allowed to appear: there can be no *time* for the image itself. Outside practice, and in disconnection from the body, it has no duration, since nothing may intervene between the twin disclosures of the World; performing a massive labour over what may be years, the traces of labour are nevertheless always disowned. We know that between the synchronic axes of disclosure there has been a period of construction, yet this knowledge will be disavowed by the painting's own technique: from the trecento on, the Western tradition develops complex liminal carriers whose function is to *bind* the two axes into one, harmonic devices belonging equally to both 'vertical' moments.

Our understanding of composition, for example, even now hovers uncertainly between tri-dimensional and bi-dimensional loyalties: the same term is used to describe the surface-relations between the rectangles of a Mondrian, as the depth-relations between figures in pyramidal space. Indeed, in the present century it is probably difficult to understand these two senses at once, to hold them together in the mind without tending towards a Berensonian extreme of deploring flatness and valorising depth, or a modernist extreme of analysing all three-dimensional images into the flatness of the picture-plane; and while twentieth-century taste is highly sensitive to the spatial schism of painting split between the spaces of surface and depth, and tends to find aesthetic value even in the schism itself (we are now able to place in a single category, and without discomfort, Ingres, Picasso and Vasarély) it is perhaps no longer easy to follow the subtlety of work created in consistent loyalty both to the plane and to recessional space (it is easier, at present, to understand the space of Ingres, Picasso, or Vasarély, than it is to understand that of Raphael). Yet the harmonic device that plays simultaneously on the three dimensions of the founding perception and the two dimensions of the canvas and the moment of viewing, this pattern of two against three is *the* underlying

compositional figure of the realist tradition: composition under realism *is* this shifting of forms between two and three dimensions, subject always to the Gaze, the fused epiphanies, in which both sets of dimension equally participate: in the Gaze, the image is both the depth of the founding perception, and the flatness of the picture plane.

As with composition, so with the colour-circle: the palette is similarly divided between registration of the random array of colours in the (alleged) perceptual origin of the image; and the internal chromatic harmony of colours on surface, within the four sides of the frame. The image under realism must strike a balance between those *refusals* of obvious internal colour-relationships which are needed to insure the 'formalist' effect of the real, and the chromatic disorder which would result if the refusals went too far. Composition and colour in the West act as *shifters*, terms which seem to migrate from the moment of foundation to the moment of reception, though in fact carrying out a mission of much greater subtlety: it is precisely the appearance of *oscillation* between the axes that supplies the axes with definition. Out of the indefinitely large number of hues in a given image, certain among them will be privileged, whether by overstatement or understatement, repetition or isolation, concord or discord with the chromatic neighbourhood. The exaltation of certain privileged hues establishes an internal boundary and enclosed order for the image, a unity which is there not from the moment of origin (or this is how the effect asks to be interpreted), but for the viewing subject, for the moment of reception. At the same time, this ennobling of certain hues establishes the chromatic background from which they have been raised as undistinguished, as having no consciousness of display, as subject to no distortion by expectation of witness; the remoteness of such colours from the internal and privileged order can then, according to the formalist axiom, be read as moving away from the moment of viewing towards the moment of origin: remoteness from the internal order which revolves around the viewer establishes and reinforces, on the far side, the myth of the founding perception.

As with composition and colour, so also with perspective. In Albertian space, the image is divided evenly between the three dimensions shown by the *camera obscura*, and the two dimensions of the painting's surface: the centric ray lies *between the two and the three*, and the distinctive architecture of Albertian space is at once the sculptural, rotational environment of the surrounding city, and the flat, axial backdrop of a proscenium stage. In the case of the post-Albertian spatial dispensation, composition divides again:

the space of Vermeer lies dimensionally *between the two and the one*, between the planar logic of the picture surface (no problem in discovering Mondrian, when looking at Vermeer), and the mathematical logic of the notional viewpoint. Space, colour, and composition are handled by the Gaze as so many kinds of interference pattern, evenly distributed between the moment of origin and the moment of viewing: their action is simultaneously to establish the twin moments of the Gaze as separate axes, and to bind the axes together in epiphanic fusion. Their temporality is therefore never in the present, never in the durational time of painting practice: retrospective, they look back to the three-dimensional, randomly coloured world disclosed by the founding perception; prospective, they look forward to the bi-dimensionality and the internal chromatic logic of the surface, the cartouche enclosed by the four sides of the frame. Technically each stroke of the painting must align itself, *as it is being made*, according to that vertical orchestration of the Gaze; the stroke's temporality is there, in the aorist and the future of the Gaze, and never in the deictic present of practice, of the body: the body itself is that which our painting always erases.

In the traditional analysis, all operations of the sign involve at least two aspects, of combination, and of selection; there is no sign that does not join together independent elements, and exclude others: let us call this a *minimal precondition* of information.[26] Language consists at least in the successive or 'horizontal' relations between words as they unfold in the sentence (grammar); and in the simultaneous or 'vertical' relations a word enters into with others in its semantic neighbourhood (*topos*). The structure of painting is not so dissimilar to that of language: it, too, unfolds in duration, indeed twice over – once in painting practice, and once again in the activity of viewing; and it, too, possesses a repertoire of iconographic forms which the viewer needs to know if he is to assign the individual painting to its appropriate semantic neighbourhood. Yet in the tradition of painting we are examining here, both combination and selection are disavowed: the painting is not sign, but percept; and the minimal precondition of information is obscured.

Western painting denies syntagmatic movement: it addresses visuality in an impossible and mythical guise, of stasis. The unattainability of the Gaze is clearly evident in the conventions of pictorial composition: the great forms of composition, whether the pyramidal structures of the High Renaissance, the bas-reliefs of Neo-Classicism, or the vortices of Turner and of Delacroix, so exceed in scale the limited, local discoveries of the

Glance that their existence cannot be apprehended within experience. As the eye traverses the canvas, the path of its movement is irregular, unpredictable, and intermittent; and though, through its traversals, the Glance will gradually build up a conceptual version of the compositional structures, these cannot be taken in *by* the Glance; they are not disclosed during the actual time of the Glance, but exist on either side, before the Glance and after it: before, in that information yielded to the present Glance is back-projected into the sum of inferences concerning composition which has accumulated so far; after, in that the process of accumulation means that full apprehension of the compositional order is always postponed, until more information from the work of the Glance will have been admitted. Although composition addresses itself to a gaze of Argus, with a thousand foveae held motionless to a thousand points on the canvas, the practice of viewing must necessarily approach such simultaneous knowledge through deferral: the material construction of the eye permits only one area of the image to clarify at each moment, while its acute mobility precludes regularity of scansion. As a result, composition splits the image into two temporal registers: the instantaneous, duration-free time of the compositional structure (which is also, given the assiduous efforts of the 'shifters', the alleged instant of the founding perception); and a protracted, fragmented *durée* of viewing, which labours to build an eventually total scheme of the image and to apprehend the composition *im Augenblick*, but which cannot achieve this scheme through the limited empirical means at its disposal. Composition drives a wedge between a moment of full presence, when the abundance of the image is released in complete effusion; and a series of partial and provisional views closer to the labours of Sisyphus, than the splendours of Argus: however avid for total possession, the Glance can never be sated.

For as long as the dream of an instantaneous and timeless painting – the Essential Copy – rules in the art of the West, the Glance takes on the role of saboteur, trickster, for the Glance is not simply intermingled with the Gaze, as it is with the Byzantine or the high-deixis image, but is separated out, repressed, and as it is repressed, is also constructed as the hidden term on whose disavowal the whole system depends. The flickering, ungovernable mobility of the Glance strikes at the very roots of rationalism, for what it can never apprehend is the geometric order which is rationalism's true ensign: faced with the geometry of the Ionian temple, the Glance finds in itself no counterpart to the enduring, motionless and august logic of architectural form, since all it can take in is the fragment,

the collage, and unable to participate in the unitary mysteries of reason, the Glance is relegated to the category of the profane, of that which is outside the temple.[27] Before the geometric order of pictorial composition, the Glance finds itself marginalised and declared legally absent, for this celebration of a faculty of mind to step outside the flux of sensations and to call into being a realm of transcendent forms, this ceremony of higher logic which the Glance is ordered to witness, is beyond the scope of its comprehension: all it knows is dispersal – the disjointed rhythm of the retinal field; yet it is rhythm which painting of the Gaze seeks to bracket out. Against the Gaze, the Glance proposes desire, proposes the body, in the *durée* of its practical activity: in the freezing of syntagmatic motion, desire, and the body, the desire of the body, are exactly the terms which the tradition seeks to suppress.

If on one side of the sign the movement of the syntagm is arrested, on the other the presence of paradigm is equally denied. In linguistic analysis, 'paradigm' refers to relations of substitution between words: two words are said to be paradigmatically associated if they can be substituted for the other without disturbing (according to Jakobson) the grammatical coherence of the utterance; or (according to the present argument) without disturbing the topological contour of the discourse. The equivalent within the image to paradigm in language is the schema: through the interchange of the visual schema with terms operating in the codes of recognition, the image is identified. In the post-Byzantine dispensation of the image, the mode in which the schema is presented to the viewing subject is one of *perpetual transgression.* When the viewer is faced with overt repetition of a traditional formula, there is scant possibility of his doubting or failing to perceive that the image before him issues from a *coded* signifying practice, with a limited repertoire of forms and limited resources of permutation. It is this acknowledgment of the *work* of representation that realism obscures. Just as deictic allusion to durational temporality is removed from the trace, so the co-presence *in absentia* of the repertoire is apparently withdrawn from recognition. When the viewer discovers no transgression of the schema, but finds instead the patent repetition of a stereotype, the 'here' of presence is taken from him, since the image is not only this one, in this place, but the others, in many places: other representations of this scene, and the other representations of the other scenes within the global repertoire of forms. When the schema appears under the guise of transgression, however, the degree of departure from precedent and norm may be read as pressure on the schema from the outside (from perception),

25 Cimabue, *Lamentation of the Virgin*

forcing it to bend, move, yield.

In its most dramatic moments of acceleration 'towards the real', the Western tradition is openly iconoclastic. When the stiff, diagrammatic schemata of Byzantium 'begin to move', when the image starts to treat as variables the postures, gestures, and expressions which in the icon had been more or less unchanging, the means of variation may well, for all the viewer can know, have been improvisational, that is, accomplished on the surface of the image for the first time. But since the surface of the image is declared nonexistent by the disavowal and effacement of deictic markers, since the process of building the image on the surface has been bracketed out, transgression of schematic design must be attributed to the pressure of an origin outside the image and outside the body (the musculature) of labour: to the force of perception, moulding the schema to its prior shape. The figures of Lamentation on the Cimabue Crucifix at Arezzo may even now intimate some of the powerful disruptive charge they must first have had, if we consider them against the repertoire of inflexible Byzantine

formulae they so violently alter (Illus. 25). Again, in the portraiture of
Baldovinetti and of Pollaiuolo, the basic schema on which the 'markers of
individuality' are placed is starkly visible, as a harsh profile which, though
enabling the statement of a considerable quantity of information concern-
ing the unique physiognomy of the sitter, nevertheless threatens the struc-
ture of presence by allowing the repetitiveness of the formula (the profile-
stencil) to show through (Illus. 26, 27).[28]

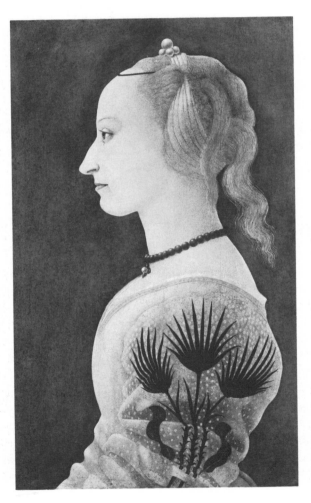

26 Baldovinetti, *Profile Portrait of a Lady*

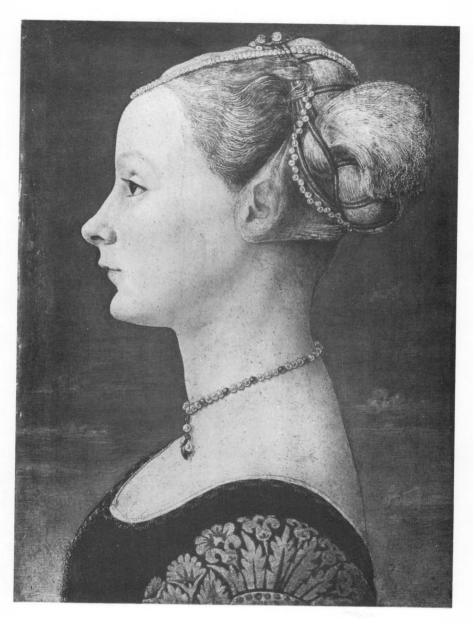

27 Pollaiuolo, *Profile Portrait of a Lady*

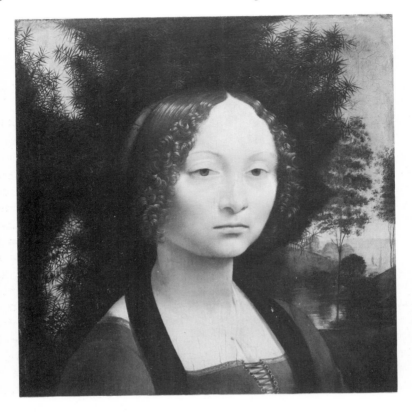

28 Leonardo, *Portrait of Ginevra de'Benci*

By contrast, in the heads of Verrocchio and of Leonardo a massive increase of information concerning evanescent conditions of lighting effectively conceals the underlying portrait-schema or stencil, *even though* that information is entirely contingent to the purpose of recording the sitter's facial characteristics. The portraits of Leonardo tend in fact to use the information concerning lighting to *conceal* the singularity of the sitter's countenance: the salient points of the face (the corners of the lips, of the eyes, and the end-points of the eyebrows) which, for example in Antonello da Messina, are still regularly used as the key sites on which to place the cues of the sitter's physiognomic singularity, in Leonardo are literally obscured by the lighting, blurred, so that although from one point of view there has actually been a decline in *vraisemblance* (we end up with less information about the sitter), the fact that the inherited schema of

portraiture has been hidden from view gives the image an intensity of lifelikeness absent from Antonello (Illus. 28).[29] Similarly, by retaining so many traditional iconographic features of the schema of Deposition, the Rembrandt *Descent from the Cross* casts into the harshest relief its innovations in the presentation of Christ's body, and the cruelty of its destruction of the classical schema: the traditional schema becomes the emblem of everything this particular image rejects – the dignity of death, the nobility of suffering, the security of the body's contours and boundaries; the reality of death is conceived exactly as the destruction of the *recognisable* body (Illus. 29). Or once more, to choose only from examples imprinted firmly in the reader's mind, the Caravaggio *Supper at Emmaus* achieves the scandal of its Realism by refusing the legibility of the body which had come to type the bodies of Christ and of the Disciples through schemata of masculinity, gravity, grace: the central figure is cast in terms of schematic inversion, of effeminacy, hedonism, vulgarity, while the disciples bear the attributes of an ignorant, and above all of a hardened suffering (Illus. 30).

Complementary to this continuous iconoclastic history, the tradition *requires* a perduring matrix of schemata: without a consensually agreed and more or less permanently installed iconography, realism would have nothing to prevent itself from becoming a deteriorating, a degenerative system. Manipulation of paradigm is subject to a strategic paradox: even as the schema is presented as though for the first time, *e nihilo*, it must also appear as *citation* from an invariant repertoire of classic forms. From this perspective, it is the body itself that provides resolution of the paradox, the unchanging law against which transgression reacts; provides indeed the master-term of the iconographic codes: if the paradox is so easily resolved – resolved anew with each painting – it is because the body recommends itself as *the* privileged site of articulation between the general and the specific. On the one hand, the nude is developed anatomically, through a quasi-objective science of medical vision that tends towards the non-individuated, the diagrammatic, towards deliverance of the body's *typicality*; on the other, it is developed through accumulation of epithet, through anecdote: the forms disclosed and legitimated by the 'clinical' gaze afford almost limitless opportunity for the transgression of their own generality. The outright clashes between schema and individuation that occur, crucially, in the work of Vesalius, and in the Anatomy Lessons of Rembrandt, are only particularly harsh or explicit moments in a collision which, in the double movement of stating and of withdrawing or obscuring the bodily schema, is constantly taking place.

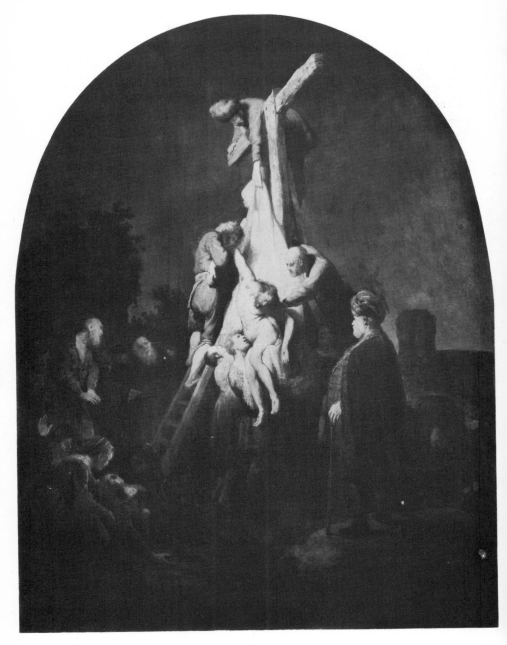

29 Rembrandt, *Descent from the Cross*

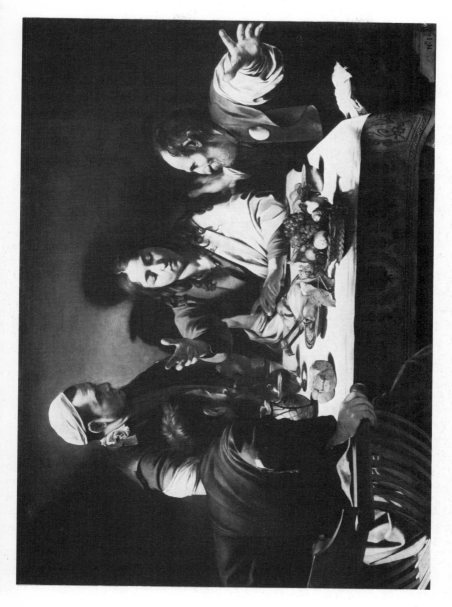

30 Caravaggio, *Supper at Emmaus*

If the founding axiom of Jakobson's semiology is true – that all sign-systems can be analysed into a vertical axis of selection from the repertory of available forms, and a horizontal axis along which the selections are combined – then in the case of the painting both axes of the sign are *veiled*: the schema is invoked only in order to be transgressed, taken out of the matrix of selection; the *durée* of painting is systematically disavowed. The result of this double assault on or obfuscation of the painting is its eventual unthinkability as sign – the impossibility of theorising the image except in terms of its own propaganda, as the re-presentation of perception, as the Zeuxian mirage. Two quotations, from the Goncourts, are helpful in achieving the kind of reorientation of theory the present argument is attempting. The first, on Fragonard:

> His effects suggest that he used a chalk without a holder, that he rubbed it flat for the masses, that he was continually turning it between his thumb and forefinger in risky, but inspired, wheelings and twistings; that he rolled and contorted it over the branches of his trees, that he broke it on the zigzags of his foliage. Every irregularity of the chalk's point, which he left unsharpened, was pressed into his service: when it blunted, he drew fully and broadly; when it sharpened, he turned to the subtleties, the lines and the lights.[30]

The second, on Chardin:

> Look at [his work] for some time, then move back a few paces; the contour of the glass solidifies, it is real glass. In one corner there is apparently nothing more than a mud-coloured texture, the marks of a dry brush, then, suddenly, a walnut appears, curling in its shell . . .[31]

The image is produced, produces itself, irrupts, as the spectacle of the subject in process: the chalk's friction and attrition visible *across* the signifieds of tree and branch, the Chardin still-life emergent, intermittent, as form breaking the enclosure of meaning and legibility; the picture plane is the scene of interruption, punctuation, a sensuous materiality turning and re-turning on itself. In describing the image, what the Goncourts sense is something other than the diffusion of percepts, just as in deconstructing the tenets of perceptualism what analysis begins to see, or at least to glimpse, is a shadowy activity *behind* the image, manipulation of the sign as plastic substance, interpretation of the sign as a material work, *practice*

of painting and of viewing; production, productivity. The question now to be pursued is this: what is the provenance of that productive work? Against perceptualism, and the natural attitude, we have proposed a number of alternative positions: that painting *as sign* must be the fundamental assumption of a materialist art history; that the place where the sign arises is the *interindividual* territory of recognition; that the concept of the sign's meaning cannot be divorced from its embodiment *in context*. That much, one hopes, has been established; yet the mode of the sign's interaction with the social formation has yet to be explored. Its exploration is a responsibility we cannot afford to ignore. But before that exploration can begin, we must first shift our perspective from the *image*, the imago, the spectre, to the *painting*, to the carved sheet of pigment, to the stroke of the brush on canvas: despite its obsession with the body's endless variability, with the spectacular and protean transformations of a body under constant visibility and display (no tradition of the Nude, outside Europe), the image finally knows the body only as a *picture*. To dissolve the Gaze that returns the body to itself in medusal form, we must willingly enter into the partial blindness of the Glance and dispense with the conception of form as con-sideration, as Arrest, and try to conceive of form instead in dynamic terms, as matter in process, in the sense of the original, pre-Socratic word for form: *rhuthmos*, rhythm, the impress on matter of the body's internal energy, in the mobility and vibrancy of its somatic rhythms; the body of labour, of material practice. It is this dynamic, subversive term we will now examine.

Chapter Six
Image, Discourse, Power

The most acceptable conception of the place of painting in the social formation remains to this day that of *technical self-determination*. This is a notion both right and left will willingly support.[1] Let us suppose that at a certain point in the evolution of painting in the eighteenth century, there appears both in England and in France a distinct and innovative iconography of – poverty: the emphasis is no longer on the exterior manifestations of working life, the outdoor labour of the agricultural community, on the workplaces of forge, field, and yard, but rather on the interior of the labourer's dwelling and on the spaces of his leisure: parlour, hearth, tavern (Greuze, Morland, certain aspects of Gainsborough).[2] And let us further suppose that historians studying the period contemporary with the iconographic shift produce incontrovertible evidence of structural changes both in the economy of labour, and in the family; that they are able to agree to a table of factors indicating possible reasons why the interior of unit of the family had entered a new phase in the distribution between work and rest, and between the economies of husbandry and of patriarchy. How will the two sets of observations, that concerning the representation of poverty, and that concerning the structural changes in the social formation, be correlated?

Explanation in terms of causal flow is hardly persuasive. Even if it is satisfactorily proven that changes in the economic structure coincide with the appearance of the Greuzian family (in its hermetic enclosure from the outer world, with its ailing patriarchs and neurotic domesticity), coincidence is not yet determination; even if the correspondence is strikingly synchronised, and an unprecedented iconography of the family as a unit in separation from society does in fact appear in tandem with the emergence of a new kind of family life and organisation, still it does not follow that related economic and political transformations homogeneously *cause* the Greuzian family to appear on the surface of the canvas (this hardly needs

stating). Correspondence of an ultimately uni-directional kind (from soci-
ety to image, and not the reverse) may indeed exist, yet propositions
concerning that correspondence remain incoherent until both the specific
place of Greuze's mutation of the general iconographic repertoire of famil-
ial representation, and the specific role of the image in the social formation
as a whole, are clarified, or at least admitted as objects of enquiry. Rep-
resentation of work and leisure cannot be examined solely against the
background of data describing the structural changes of work, leisure, and
their interrelation with the domestic economy, but must be seen also
against the second background, of representation as an evolving structure
modifying according to laws operative within its own provenance.[3] The
problem is one of understanding the articulation of a technical process
against the history of social formation, of charting one material evolution in
the sphere of practice against its reflection and refraction in a further
domain of practice; how the problem is resolved will depend crucially,
therefore, on how we understand the terms 'reflection' and 'refraction' in
connection with the sign.

In the perceptualist account, both these terms are equally weighted; and
exactly these terms are indicated. In so far as the schema is to be under-
stood as a manual or executive structure, moulded by the pressure of novel
perceptual demands, and constantly falsified against the visual field, the
schema is that which distorts reflection, that which can never produce
representations containing 'true' information, and which therefore must
content itself with representations containing, at best, no 'false' infor-
mation: the schema is an agent of anamorphosis, warping the visual field
through *a constant and internally consistent principle of deviation*. In so far as
the schema is to be understood as a perceptual structure or grid, then again
it acts to refract an anterior reality whose stimuli allegedly exceed or 'bom-
bard' the schema's filtering reticulations. Perceptualism thus proposes the
schema as an entity whose refraction of outer reality occurs in a domain
existing *in separation* from the social formation, in the technical solitude of
the perceptual and technical apparatus. The history of this solitude makes
no reference to any domain outside that double apparatus (of retina, or
brush): it is a history of autonomous technical advances, or at least elabor-
ations: the structures of schema and society are mutually non-derivable.

The concept of technical autonomy remains firm even when the 'sep-
arate development' policy of orthodox perceptualism is revised by consider-
ation of the role of patronage. The revision might be stated as follows:
since the manufacture of any object requires a certain level of technical

competence, and since independently of those factors which do not pertain to the technical process there are skills and procedures that must be designated as *inherent* to the work of manufacture, then no process of manufacture can be analysed by mapping its internal system in exclusion of the flow of labour, capital, and exchange through the global economy: the economics of patronage must be included in the analysis. Indeed, in the small-market situation of the atelier, close interaction with the sources and the fluctuations of capital is inevitable: the economy of the atelier has no body of convertible assets to free itself from moment-to-moment dependence on outer patronage; no plant, no machinery, no realisable protection from market forces: all it can exchange is labour. The network connecting atelier to capital movement is tightly drawn: the atelier has neither the scale of production, nor the capacity to create plant asset, that would permit the growth of interval between itself and capital flow. In the wake of perceptualism's purest formulation, there has therefore emerged a description of artistic process in direct contact with patrons and patron classes: it is an advance long overdue. Yet the model remains crudely mechanistic, and indeed unless it lessens its commitment to economism, amounts to the latter-day restatement of mechanistic causalism: what is true of manufacturing process is not also and automatically true of *semiotic* process, and only becomes true for the latter if the image is considered *solely* as a physical object artifact, a commodity; as though the Rosetta Stone were best approached through mineralogy, or the literary text through a systems-analysis of the printing-works.

The most extreme, and certainly in terms of political influence the most powerful statement of this position occurs in the work of the Russian linguist N. Y. Marr. Marr inherited an intellectual system that had long since resolved the problem of the relationship between artistic production and social formation through the classical model of Historical Materialism: base-structure/superstructure. Taking the base-structure as consisting of the ultimately determinant economic apparatus of the society, and assuming the unified interaction of productive forces and relations of production, then 'art', alongside legal and political institutions and their ideological formations, is assigned, firmly, to the superstructure. The question Marr addressed was this: given the necessary truth of the base/superstructure model, what is the articulation of that model with language? in which tier of the model should we place *the sign*?[4]

Marr's answer left no room for doubt (only for heresy): the sign is unambiguously a category of the superstructure. In 1926, in his discussion

of Marxism and Japhetic theory, Marr asserts that 'contemporary palaeon-tological discussion of language has given us the possibility of reaching, through its investigations, back to an age when the tribe had only one word at its disposal for usage in all the meanings of which mankind was aware'; that from the beginning human language has been immanent in social context and incapable of sustaining meaning in abstraction from context; and that human language has therefore been class-language from its very origin: there never can be, and there never has been, a human language which is classless.[5] Again, in a paper of 1928:

> In concentrating our entire attention on the internal causes in the 'creative' processes of speech development *we cannot, by any means, place that process in language itself. Language is just as much a superstructural value as painting, or the arts in general.* By the force of circumstances, by the testimony of the linguistic facts, we have been compelled to trace the 'creative' speech process – the factors of creativity – in the history of material culture, in the society created on the foundations of material culture, and in the world-views which have formed on that base.[6]

> Not only the concepts expressed by the words but *the words themselves and their forms, their actual appearance, issue from the social structure, the superstructural moulds*, and through them from economics, from economic life There are no physiological phonetic laws of speech, the physiological side of the matter is a technique adapted, changed, perfected and ordered by man. This means that their conformity is to the laws of society; laws of oral speech exist, phonetic or sound laws of the speech of mankind exist – but these are social laws.[7] [Author's italics.]

What Marr is attempting is not actually to locate the sign in its interaction with *social* formation, but something rather different: to assert the posteriority of the sign to the *material* formation. The style in which the assertion is cast is overtly mythological: complaining that the Indo-European linguistics of his period is 'naturally incapable of bringing to light the process of the emergence of speech in general, and the origination of its species',[8] he posits an origin of speech at the neolithic moment of the appearance of tools. Just as pressures in the material environment of the primeval epoch necessitated the creation of tools which answered that prior necessity, so the pressures of the material environment called into being the sign, as dependent derivate from prior need and circumstance:

first the material formation and circumstance, *then* (temporally posterior, yet logically simultaneous) the sign moulded from the material formation. The sign is accordingly no more than *the impress of base on superstructure*: it follows that original contour without deviation, accepting the impact of the material base on itself as wax accepts the impact of the seal. The sign is the *expression* of the given reality, its negative profile; first the original matrix of economic reality, then out of that matrix there appears the *inscription*, isomorphic in every parameter with that-which-is-to-be-inscribed.

It is the inert and limpid character of Marr's conception of the sign that presents the greatest obstacle to theory. The implication Marr wishes to project from his myth of origin concerns the impossibility of independent innovation in the production of the sign: for language to change there must first be a change in the material formation. But let us look closely at this: Marr is positing a materiality that *of itself* engenders sign, at its every point of change; a mystery of spontaneous generation of signs directly out of material substance. Yet the economic or material base never *has* produced meanings in this mysterious sense;[9] the world does not bear upon its surface words which are then read there, as though matter itself were endowed with eloquence. *Only* in the social formation does the sign arise; and while Marr *seems* to concede this social and interindividual character of the sign, at the same time he overlays that conception of agents collaborating across the interindividual social space with a second, contradictory, and iron-clad pronouncement that it is in matter – in the prior contour of material reality – that the sign arises, as its negative relief, or stencilled echo; the sign's own materiality, its status as material practice, is sublimed or vaporised in an idealist *épochè* as drastic as the Cartesianism of Saussure.

Certainly innovation *within* the sign, on Marr's account, cannot take place: first the change in objective matter, then, and only then – and with causal immediacy – the change in the sign. The *effectuality* of the sign is replaced by its redundancy; it becomes an unaccountable adornment, since every aspect of its form, its contour, its profile, has appeared already, in the material formation. The *history* of the sign is replaced by instantaneity: the meaning of the sign can only emerge in the microscopic ostensive act, as *this*; Marr's language has no memory, no capacity to separate out from the flux of matter any archival trace, no power to generalise, compare, or evaluate away from the infinitesimal zone of the *this*. The category expunged from linguistics as surely in Marr's account as in Saussure's, is once again the *discourse*, as the evolutionary topology of the language, its structure of recurrent affiliation from signifier to signifier.

The essential dynamic of Sr \rightarrow Sr is in fact immobilised, since the signifiers are never seen as collectively mobile, but are instead alleged to be crests of the universal flux, arbitrarily adjoined by material but not by semiotic movement. What Marr is finally asserting is the *absence* of the social formation in the production of the sign: no agent, in the practical activity of the sign, links term to term; in no consensual territory can discourse form and collect. We cannot say that Marr's description corresponds to *human* language; not necessarily because it takes a human consciousness to supply the signified to the signifier, but because the agreement to accept a material entity as signifier cannot be undertaken by matter-in-itself; because the movement from signifier to signifier cannot be achieved without *work*; and because the collocation of signifiers into discursive *topoi* cannot take place without archival separation from the *this*.

Let us try to picture, following Marr, the phenomenon of dialogue.[10] In fact, the speakers have nothing to say, except perhaps the aboriginal word (which is not at all the multi-accentual, discursively plural 'little word' of Dostoievsky's tipplers). But let us try to make them talk: the first speaker produces an utterance. It already matches, by definition, a prior event in the material world. Before it can be answered, a second event must occur. The second utterance, too, will be redundant – but let us say that the first speaker has not yet seen the second event, and that his partner is trying to draw his attention towards it. The second speaker cannot pause as he reflects the new event, since delay here would amount to the archival separation of discourse from matter, to the historical dimension which Marr's insistence on the perfect moulding of speech to material formation has decreed to be impossible. The first speaker looks towards the place where the utterance points: but *where* is the utterance pointing? Matter surrounds the speakers *ubique et undique*; for 'this' to be selected from the continuous *Umwelt* of circumstance, discursive formations must have already differentiated the continuum; a topography of difference must already have formed. In order to understand the ostensive particularisation of the utterance, the first speaker must share conventions of reference that associate the signifier, on a regularised and consensually established basis, with certain patterns of recurrence in the material formation. *Even to inaugurate* the empty running commentary which is the most Marr's theory can hope to describe, there must be transgression of Marr's model of perfect and integrated moulding of sign to material formation; there must be the installation of archival interval; consensual agreement occurring in separation from material formation; and the alignment of signifiers into

recurrent neighbourhoods or *topoi* – in short, the institution of discourse.[11]

The crucial reformulation that must be introduced into Marrian semiotics (hardly a problem for us, in the West, but still a problem, *the* problem, in the East[12]) is to break the barrier between base/superstructure which in effect places the sign in exteriority to the material formation – an exteriority that merely repeats, in a different register, the Saussurian separation of signified from signifier. Where Saussure's signified is contingent and redundant with regard to signifying practice, Marr portrays signifying practice as contingent and redundant with regard to material formation; in both cases, the sign is posited as the Zeuxian reflector of that which nevertheless cannot be located *outside* signifying work (pure matter, pure idea). What is needed is a form of analysis sufficiently global to include within the same framework *both* the work of the social formation which Marr assigns to the base, and the work of signifying practice he marginalises as superstructural imprint; an analysis at the same time dialectical enough to comprehend as *interaction*, the relationship between signifying, economic, and political practices. In the case of painting as a specific instance of signifying practice, the need for such a form of analysis is felt with particular urgency. In the dominant theorisation of painting – perceptualism – the social formation plays no part. The image is the result of fusion between an asocial, privatised noumenal field, and schematic techniques forged in the sequestration of the atelier; the only manifestation of society within the image is narrowed down to content: painting is edged off the social map.

In the more recent revision of perceptualism that takes into account the economic position of the atelier in financial structures of the society, privatisation of the painting is somewhat modified; yet the line of flow between the painting and the society remains that of *capital*, of an enabling energy-source providing the atelier with its necessary momentum, yet reducing the contact between the interior and the exterior of the image to that single line of commodity-exchange. What neither perceptualism nor its ancillary analysis of patronage have been able thus far to admit is the *immanently* social character of the painterly sign: aside from those codes that belong exclusively to iconography, *all* the codes of recognition flow through the image just as they do throughout the social milieu; as part of the global structure of signifying practice they interact *at every point* with the economic and political domains. Emphasis on the technical autonomy of craft process serves only to prolong theorisation of the image as manufacture, as commodity, and for as long as it is understood as *that*, the inter-

communication of painting with social formation across the sign is obscured by a mystificatory economism making no distinction between painting and the other 'fine arts' – furniture, porcelain, glass, clock-making, all the manufactured goods whose trade not only sponsors the art journals, but constructs as a unified category and as a single object of knowledge processes involving the sign and processes not involving the sign, under the general and impoverished heading of Connoisseurship. While the current alternative to the latter institution, the 'radical' option of a sociology of art, remains committed to the Marrian supremacy of base over superstructure, and to a falsely totalised and reductively causal synchronisation of primary developments 'within' the social formation with secondary developments 'outside' it, in the external and superstructural margins of what is once again a *luxury*, a more or less reprehensible adornment superadded to the economic real, adornment that is perhaps to be praised when, like another Albertian window, it gives on to the base without distortion, yet is more generally to be censured when it fails to do so, when the mould of base and the cast of superstructure are found, which is likelier to be the case, not to interlock.

Reflection upon the work of N. Y. Marr might seem digressively archaeological were it not for the resurfacing of positions strikingly similar to those of Marr in the French semiological schools of the 1960s and 1970s. The central term describing interaction between sign and social formation now becomes *citation*. Thus for Gérard Genette, the *vraisemblance* of a signifying practice consists in its drawing on 'a body of maxims and prejudices which constitute both a vision of the world and a system of values';[13] while for Barthes *vraisemblance* is 'a perspective of quotations, a mirage of structures; we know only its departures and its returns; the units . . . are themselves, always, ventures out of the text, the index or the sign of a notional digression towards the remainder of an inventory; they are fragments of something that has always been already read, seen, done, experienced; the code is the wake of that already.'[14] Every term of this second passage, from *S/Z*, deserves the closest attention, for it is only by focusing closely on the words 'quotation', 'mirage', 'departures', 'returns', 'units', 'inventory', 'remainder', 'already', and 'code' that we can see the subtlety of Barthes's thinking and writing, in this work where Barthes is without question exerting to the full his impressive capacity for intellectual synthesis. The essential transaction between the enclosed structure of signs within the text and the outside is *quotation*: that is, selection from a pre-existing and finitely bounded corpus (*inventory*) of discourse. The

transaction is known only by its initial moment of selection from the inventory, of taking one *unit* from a list of many units (*departure*), and by its final moment when the unit has run its course (*return*); by synecdoche, the selection of a single unit calls into play, in its *wake*, the whole of the list (the *remainder*); nothing has been created within the text, within the image, that is new; everything is known *already*; so that finally – this point needs underlining – although the total list is called a *code*, in fact code is only what it *seems* to be, through the naturalisation (*mirage*), the familiarity of the list's contents. A code is, by definition, a structure of permutation and multiplication – the combinations of the Morse code, for example, are infinitely extensive; but code here is a structure of addition, citation, inventory, *list*; it is not *code* at all. In viewing the image, the viewing subject will therefore experience nothing he does not already know; everything is seen, done, experienced already; in this repetition of what is pre-formed and pre-established lies the pleasure (*plaisir*) of viewing.[15]

What is fasciniating in Barthes's concept of pleasure, as in Genette's description of *vraisemblance*, is the closeness of outlook to that of Marr, where, similarly, the signifying practice only repeats ('mould' and 'cast') that which antedates it: in both cases, analysis omits the essential term of *transformation through labour* on which any theory of practice worthy of the name must rest; an omission accomplished by conceiving the signs within the social formation (discourse) as a finite mass, subject only to redistribution: this is a *mercantilist* theory of the signifying economy. The law operating here is that of the conservation of energy, for although the sign is in close contact with many and in principle with all the forms of knowledge in the social formation, its relation to such signs is pictured as passive or intermediary: the image retransmits or relays signs preformed elsewhere, but its function as vehicle or shuttle precludes modification of the semiotic field; it can neither add to nor subtract from the total sum. The mass of the sign, globally considered, is a constant: all the image can do is to dispose or rearrange within the steady state of the system. The pleasures of viewing will accordingly be those of repetition; the image will not interrupt or break with the comfortable familiarity of the already-known; it will belong to the same kind of vague, urbane, disengaged interest that is reserved for people, performances, clothes, books one finds 'up to standard', but only through a *polite* subscription to cultural norms.[16] The painting of *plaisir* will repeat the familiar spatial and temporal order of the world; it will quote, consolingly, the loric maxims of Age (Raphael: *Col Tempo*), Wealth (Greuze: *La Dame de Charité*), Love (Gérard: *Cupid and Psyche*), Religion (all

of sacred iconology), and the rest; it will belong to pre-existing and stable generic categories (portrait, landscape, seascape, still life); yet it will change nothing – to the *practice* of painting, to work on and through signs in the activity of painting and of viewing, this 'solid-state' model remains blind, since in its view the essential term of *transformation* (labour: transformation of matter through work) has been replaced by *distribution*; nothing can be innovated – since the final sum is known beforehand; nothing can be advanced – except the cause of cultural identity and enjoyment (enjoyment of cultural identity), the soothing recital of doxology.

Against this theory of pleasure Barthes and with even stronger emphasis Julia Kristeva propose a counter-term for which we will find no immediate equivalent in Marr: the disruption of quotation (*plaisir*) by bliss (*jouissance*); and at first sight, the aesthetic of disruption would seem to mark a rejection of the Marrian doctrine of art as repetition of that which has been pre-established, and the emergence of the first stages of a theory of practice, of *practical consciousness*. Following the precedent of *Semiotikè*, we might speak of the *other* space of the image where the principle of repetition is unsettled, the homogeneity of the viewing subject dissolved in 'the collision of signifiers cancelling one another out';[17] and we might propose, like Barthes's *Leçon*, a mode of painting that not only repeats, but *turns*, and overturns, the discourses, fixing and privileging none of them.[18] Such an image will refuse to repeat the familiar spatial and temporal logic of the world; it will subvert the loric maxims of Age, Wealth, Love, Religion, will scramble the familiar doxologies; it will transgress the generic categories; and dissolve the fixity and homogeneity of the subject in the free play of the signifier. Given the work of Barthes and Kristeva, such a theory of the image is not difficult to image: yet how free is such 'free play' of the signifier? Only in a state of euphoric utopia, or dysphoric atopia, are the signifiers capable of *cancelling* each other out. If the signifiers are theorised at the level of *langue*, then indeed they may collide, disperse, form temporary groupings and nonce collectives, they may enjoy all the random motion of a cloud chamber, without constraint on their powers of free association; mobility of the signifier is theoretically endless – *outside* the social formation, and outside history. What the aesthetic of subversion recommends is either impossible, or useless, or both: impossible, in that the movement of the signifier is always within history: useless, in that the wish to be free of practice amounts to wanting a revolution *in vacuo*: precisely those images which attempt the impossible liberation of the signifier from practice, will be those without consequences in the social formation.

The aesthetic of *jouissance* is at the same time too humble and too ambitious. Liberation of the sign is conceived as the province or mission of art as a separate institution, an institution in disconnection from power: Barthes speaks of 'cette tricherie salutaire, cette esquive, ce leurre magnifique, qui permet d'entendre *la langue hors-pouvoir*' (*Leçon*).[19] No self-diagnosis could be more precise: the only alternative to the sign in its inventorised, banal, materially degraded form (*parole*), if that is how *discourse* is conceived, will inevitably be a return to the ideal purity of practice that has ceased to be practice, to the sign disencumbered of worldly corruption and resurrected in the glory of the *langue* (le splendeur d'une révolution permanente).[20] The ambition, here, lies in its aspiration to *splendeur*; but more to the point is the self-marginalisation, the *hors-pouvoir*. Here the description, in its non-recognition of the role of practice, is tantamount to a restatement of Marrian doctrine.

Let us take some actual examples. At the centre of Gros's *Battle of Eylau* (Illus. 31) there occurs a dramatic superimposition of two discourses of war. The ascensional gaze and outstretched benediction of Napoleon, the liberated officer kneeling in reverence before the sacred emblem of Empire, the attendant minor figures clasping their hands in prayer, all these gestures have their origin in religious ceremonial: according to Barthes, the gestures are so many citations from the general repertoire of bodily expressions, subset 'ritual movements'; by synecdoche, the citations call into play the whole inventory of hieratic signs, the actual citations and the 'remainder' of the list they drag in their 'wake' together constituting a doxic formation that is already known and already familiar or naturalised: the sacred character of Empire (Barthes himself comments elsewhere on the *numen* of Napoleon's gesture in *Les Péstiférés de Jaffe*).[21] By contrast, the figures on the ground activate codes that are deliberately remote from those of ritual: the frozen corpses are *unshriven*, their mouths gape open, their disordered hands touch the living, the emblems of their virility and vitality (flamboyant hair, moustaches, weapons, armour) disturb the majesty of the hieratic code, for what they indicate is an aberrant category where Life and Death coexist, and the ritual separation of Life from Death has not yet been accomplished. The gestures of the dead are citations from two separate codes, of military valour and of death; they repeat, in different registers, what the viewer already knows about the codes themselves, and about their interconnection. Yet what is innovatory in Gros's image is *this* juxtaposition: it is only here, in this painting, that this particular montage of the hieratic and the unshriven appears. Ideas of the Sacredness of

31 Gros, *The Battle of Eylau* (detail)

Empire and of the Emperor, of Valour, and of Death, certainly antedate the image as individual components – indeed, Gros adheres closely to the givens of a pre-formed iconography; he heightens the accessibility of his oppositions, intensifies the clarity of their legible outline: but the juxtaposition of the components in this unique collision, *The Battle of Eylau*, occur *here* as signifying production within *this* painting practice, as practice interacting with other practices – political, economic, ideological – in the same social formation, on the inside of the same cultural enclosure.

Similarly in Manet's *Olympia* (Illus. 32) the image addresses two extreme, and incompatible, codes, in this case codes of sexual representation: woman as Odalisque, *objet de culte*, woman presented for consumption as spectacle, woman as image; and woman as Prostitute, available physically and not only visually, woman as sexuality in its abuse, as sexuality exploited.[22] That the viewer is familiar already with the contradictory codes is not at issue: such familiarity is exactly what the image presupposes, and like Gros's *Eylau*, the iconographic legibility is heightened: the painting insists that its quotations from the tradition of the Odalisque be recognised, that the viewer acknowledge its echoes of Titian and of Ingres; just as it insists at the same moment that *Olympia* is a *fille publique* from Les Halles, right at the bottom end of the trade, and rather badly used.[23] Both discourses exist prior to the image, both are presented as citations from the prevailing, the *preliminary* doxa: what is new is their elision in a single frame.

Or again, the Géricault portraits of the mad (Illus. 33): from the first a contradiction, if the historic purpose of the portrait genre is to record a precise social position, a particular instance of rank in the hierarchy of power: the portrait of the insane is therefore an impossible object, a categorial scandal, since the mad are exactly those who have been displaced from every level of the hierarchy, who cannot be located on the social map, whose portraits cannot be painted; Géricault fuses the categories together, of privilege and placelessness, society and asylum, physical presence and juridical absence.

It may well prove the case, in given instances, that the innovations of a signifying practice are of slight consequence in the social formation as a whole: indeed, in the three examples just cited, awareness of the difficulty of *positioning* the image is already an overt and increasingly important component of painting practice. *The Battle of Eylau* may have found its immediate and enthusiastic public, but for Gros it marks a personal betrayal of Neo-Classicism: it is a public declaration of ineligibility as candi-

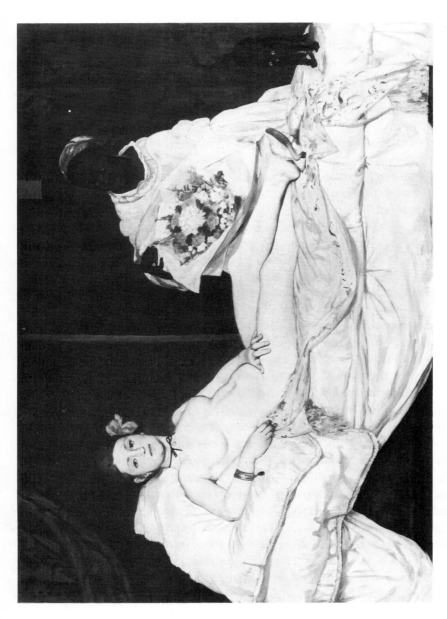

33 Géricault, *Madman*

date for leadership of the Davidian school; the battle paintings of Gros are amongst the first to sense innovation as isolation, and to register discontinuity with their cultural tradition as a necessary, deliberate, yet painful destiny.[24] The image of *Olympia* refuses to settle in any legible middle ground between the discourses of the Odalisque and of the Prostitute: it is committed exactly to equivocation, to the equal voicing of both positions; and it knows, its entire conception is aware in advance, that this stubborn commitment means that it will not be read through the existing codes, that it cannot flow smoothly through the existing discursive circuits (what is enduringly impressive about *Olympia* is the impassivity with which it bears that fore-knowledge; not the illegibility of the girl, but of *Olympia*'s address to those who will refuse it). Géricault's portraits of the insane are painted for no one; the image here is so generically unplaceable it does not even begin to look for a posture of address; addressing no one, its impas-

sivity is self-enclosed, its whole subject is precisely the nature of that enclosure of the self within itself; a discontinuity with the social formation that has nothing in common with modernism, with the *cult* of separation of image from intelligibility, the pursuit and the manufacture of separation that will, later in the century, follow in the work of the avant-garde; it is a *fate*.

These are images constructed in severance from the social body; and considering them strategically, we must grant that unless such images articulate their local acts of transgression with the stronger, the major movements and activities within the social formation, they are insignificant (where that word operates as a term of quantity, a measure of instrumental efficacy). No one is so misguided or out of the world as to claim otherwise: Géricault's portraits did nothing to modify the juridical status or treatment of the insane, nor did the appearance of *Olympia* at the Salon of 1865 do much, so far as we can tell, to change the life of the *petite faubourienne*; nowhere even in the hagiography of painting do we find the *in hoc signo vinces*. Yet this is only a truth of logistics, of *administration* of the image: the danger is that this obvious truth, this platitude of instrumental inadequacy conceals, makes it difficult to think through, a subtle and far more important truth, of topology. Instrumentally, an *Olympia* at the Salon of 1865 may be of little concern to the nocturnal economy of Les Halles; but the essential point is that its juxtaposition of Odalisque and Prostitute, or Gros's montage of the sanctified and the unshriven, or Géricault's elision of place and placelessness, all these collisions of discursive *topoi* occur *within* the social formation: not as echoes or duplicates of a prior event in the social base that is then expressed, limpidly, without distortion, on the surface of the canvas; nor as the free play of signifiers colliding in the atopia of *jouissance* (le passage incongru – *dissocié* – d'un autre langage, comme l'exercise d'une physiologie differente);[25] but as signifying *work*, the effortful and unprecedented pulling together of discursive forms away from their separate locations and into *this* painting, *this* image.

How the work of montage will survive in the social formation is a matter of the historically variable discourses which are then brought to bear on the image, through innumerable insertions into the social formation each of which occurs locally, in the reaction of each glance of the viewer to that first work. To repeat the hard logistics governing those myriad encounters: combinations of signifiers which do not make contact with discursive formations actually operative within the society will never acquire intelligibility; combinations which lose contact with discourse will atrophy, will

petrify as meanings that can no longer be construed. But the history of the production of meaning does not end once the painting is displayed in the Salon: it is then that a further work of production begins, within viewing practice. To make a distinction between the two phases of practice, in painting and in viewing, is only a convenient fiction and nothing more, for the production of meaning is continuous within practice across both the painting and the viewing subject; it is not the static *thing* of Marrian theory, a moment taken from the evolutionary process of the base and frozen in the Gaze of history; nor is it a fixed and bounded entry from the inventory of citations; it is mobility, volatility, the volatile encounter of the signifying practice with the political and economic practice surrounding it, in a field enclosed by the same boundary, mobility *across* the bodies that traverse the field, within whose boundaries they also move.

Let us suppose that an image sinks without trace; or let us suppose that it is at once taken up by other practices, that it is borne aloft by the people in revolution, like the *LePelletier assassiné* of David: either way, the destiny of the image lies in the sphere of *contingencies*, of contact between signifying, economic, and political practices in the *same* logical and material space, of practical activity. For Marr, as for Althusser, the practices of the sign are displaced to a false, an impossible other space outside the social formation. In Marr the sign is shaped once and for all by the mould of base; its form is charactered for all time by that first impress; the space of the sign is one of envelopments which instantly crystallise around the base, and are shed as the base outgrows them. In Althusser, the sign is *added* to the subject as the subject is placed into its fixed ideological positions, the sign is injected as a tranquilliser to soothe the pangs of an interpellation that occurs first, and inexorably, at Base level; and we must say also that in those writings of Barthes where the relation between signifying work (in the image, in the text) is portrayed as *citation*, as static repetition, we find the impossible outside to practice, the *atopos*, is again resurrected.

Of these three aberrant topologies, it is probably Barthes's which, at least in the Atlantic world, has been the most influential. The chimera of the *langue* posits an infinite play of significations (atopia), which is *then* seized upon and variously subjugated, diminished, and impoverished by 'outside' powers. In all theorisation of *langue*, this double pattern of infinite variation and external prevention of variation inevitably appears, since if it is maintained that the individual signifier derives its meaning *only* from oppositions to all the other signifiers in the *langue*, then no cause within the system can be found to account for regularities of association, no inter-

nal factor can be found to explain why signifiers should collect into gregarities or neighbourhoods. Misguided theory is then forced to look outside the system of the *langue* for a preventive agency actively denying the atomic mobility of the signifier – an external power pressing in on the signifying field and distorting it into the shape of its own interest, contouring it in the shape of its external mould. From that point it is no distance to naming the external powers responsible for the repression, and attributing to them the traditional features of interdiction, concentration, and exteriority by which Power is 'known': it is the centralised Monarchy, forcing the image into its service as emanation from the throne (LeBrun, D'Angiviller); it is the Party, enforcing the values of *ideinost* and *partinost*; it is Capital, expressing its ownership of power by transmuting the image into commodity, consumption. The conceptions of power's location in the social field follow here the classic topologies of paranoia; something *outside*, invisible, some essence of exteriority is closing in.[26]

Let us keep our attention fixed on the hard logistics of instrumentalism: it is historically true that the image is constantly subject to appropriation by major collocations of power elsewhere in the social formation; but that does not entail – indeed it should highlight the reasons why it does not entail – a topological placing of power as always the image's exterior, and of the image's work of signification as *dissocié, un autre langage, l'exercise d'une autre physiognomie*. The topology is rather one of dynamic interaction of practices within the same boundary, the same Möbius enclosure of the social formation. The practices of painting and of viewing involve a material work upon a material surface of signs coextensive with the society, not topologically abstracted outside it; to remove the concept of interactive labour is only to extend the doctrine of the Gaze into a doctrine of manipulation. Yet painter and viewer are neither the transmitter and receiver of a founding perception, nor the bearers of an imprint stamped upon them (in the Imaginary, in atopia) by the social base; they are *agents* operating *through labour* on the *materiality* of the visual sign; what must be recognised is that crucial term labour, work of the body on matter, transformation of matter through work, the minimal definition of practice as what the body *does*: the alteration of the semiotic field in the *durée* of painting, in the mobility of trace and of Glance.

There can be no doubt: theorisation of the image as citation (Marr's *impress*, Barthes's *doxology*) leads directly to a practice of painting that knows only one lever on the power allegedly outside it: the stereotype; and only one mode of address: exhortation, *narodnost*. The ideology of the

image becomes this: artistic practice cannot take its own disruptions of the various signifying conventions as somehow rooted, automatically, in the struggle to control and position the body in political and ideological terms; it has to articulate the relations between its own minor acts of disobedience and the major struggles – the class struggles – which define the body and dismantle and renew its representations; otherwise its acts will be insignificant.[27]

The strategic clear-sightedness of this ideology is absolute; as a critique of modernism, of the supposition that a free play of the signifier will automatically liberate the subject from control, it lays bare the sterility, the soulless formalism of that impossible object, the 'open' text; yet what must be questioned are two assumptions at the troubled margins of the ideology: the model of prescription (the image 'has to' articulate itself on to the social formation, it *must* advance into struggle); and the passivity, the fixity of the body (as the *object* of control and positioning, the *disposable* term of practice).

Prescription is precisely what is not required of the image: it is inevitable that signifying practice will project into the social formation, since the sign exists only in its recognition, 'dialogically', as interaction between the signifiers presented by the surface of the image or of the text, and the discourses already in circulation: those sequences or collocations of signifiers that cannot link together with discursive formation never arrive on the scene, never cross the threshold of recognition, never acquire intelligibility. Viewing is always, by its very nature, and not only through a particular effort of projection or through a forceful drive of intention, in articulation with the society; only in articulation, and across that external arc of recognition, does the image exist as sign. There is nothing here that requires enforcement: those major lines of division within the society that are grouped together under the term 'class' will exist already, as will those regularities of discursive practice which accumulate as the repository of material knowledge, in the form of discursive *topoi*. The image, both in its production and its recognition, is from the beginning part of a continuum of social practice, and interactive with the other practices around it; no more than the inner events which accompany a mathematical calculation may be said to determine the correctness of the calculation, can the illocutionary force or vocative projection of an image be said to determine the way it will be recognised. The calculation is judged by its conformity or otherwise with the practical rules of calculation; the image is judged by its conformity or otherwise with the practical rules of recognition; rules which

need no *intensification* (as though they operated only intermittently, or with insufficient effectiveness), since they exist simply as preconditions and inevitable features of material practice. The image is not obliged to go out of its way to 'meet' the social formation, it does not have to exert itself with vigour, with determination, to link into its society, since it is always already there at its destination; it has never been in a state of disarticulation from the society.

To conceive of the body as a disposable term – object to be held in position, term of subservience, submission – is to bracket out the transformative capacity the body possesses through work. The body is certainly that which is inserted into the given institutions of ideology, of economy, and crucially of sexual identity, yet also it is that which forms those institutions, subjects them to endless revision, and if need be, overturns them; one cannot assume, from the invariability of structure, the invariability of production. What instrumentalist deployment of the image cannot afford to admit is that volatility, proteanism, unpredictability of a body it must therefore exhort and 'control' by supplying its work with a goal towards which its movements and its productivity must be guided.

In the stereotype, the error of prescription and the uneasy assumption of a non-productive body converge; yet how useful is this stereotype? Let us imagine that signifying practice obediently performs what the 'major' power enjoins it to perform: how useful will its services be? Certainly the denotative levels of the image will prove serviceable: in the iconographic codes, ulterior power finds its perfect leverage on the image, for what ulterior power requires is *legibility* (nowhere is the interest of hegemony in the act of recognition more clearly demonstrated than in the iconological protocols of Byzantium). Yet once the image extends its register below the level of denotation, once the area of excess of connotation over denotation is opened up, however useful that excess may be in establishing the evidential truth of denotation, the instrumental efficacy of the image can no longer be guaranteed. That excess is constructed in the first place by the inherent redundancy of the image – its informational 'expensiveness',[28] for the information the viewer is to derive from the image must be supported by other information whose inclusion is essential if the threshold of recognition is to be crossed: the figures of the Betrayal, the Madonna, the Deposition are built out of non-specific material whose iconographic specification comes *at the end* of an already lengthy elaboration. Moreover, for the moment of recognition to be unambiguous, and the hortative image cannot afford to be otherwise, the markers at the image's denotative level

must be plural (*cf.* the 'functional' redundancies of phonology and trans-literation): not merely one defining attribute, but many: costume, posture, facial expression, surroundings. And for the rhetoric of persuasion to be effective, the first corpus of redundancy (the data required as support or matrix for the denotative cues) must not appear to be separable from the multiple iconographic markers: the Byzantine solution, of basic and undif-ferentiated figures (the hieratic stencils of Byzantium) that are *subsequently* individuated by the appendage of denotative attributes, reveals too patently its symbolic mechanism, for the equation of the stereotype with actual and present social conditions (with 'struggle') to be possible. Under a genuinely persuasive rhetoric, under realism, the cues must be pre-vented from appearing as stranded, isolated denotative markers; and the tactic adopted by realist visual regimes, as much in the East as in the West, is typically to prioritise the cues in a descending order, from the *definitive* attribute, to secondary qualification, through to the semantically innocent detail; and having arranged the register of priorities, to co-ordinate it with the inevitable corpus of supportive data: the whole body of the figure must be utilised. The rhetoric of persuasion is not in a position to afford the luxury of waste: its images must not stray from target; above all, they must not wander into the quicksands of anecdote, and thereby jeopardise their essential typicality – it is by their manifesting the type *through* particu-larity that they will acquire access to the levers of power.

Yet the stereotype puts itself in a strategically impossible position. The obligations to multiply the denotative markers in the interests of clear recognition, to develop a register of connotations, to put to good use the image's necessary informational expensiveness, and to activate the codes of physiognomics, pathognomics, gesture, posture, dress, cannot help but augment the excess of the image over and beyond the didactic mandate it is enjoined to fulfil. The stereotype is pulled in opposite directions: it must deliver a clear and unequivocal message; and at the same time it must blur, complexify, exceed that message which alone is alleged to justify its exis-tence. The arrow *A* marks a movement away from a purpose to which the stereotype must nevertheless faithfully adhere:

At the same time, the codes of connotation that are activated as ancillary support to the official message follow an intrinsically indeterminate course: the non-denotative or sub-iconographic codes offer the image up to tacit interpretation as volatile as the play of contexts (the arrow *B*). The message which begins in a state of clear determination – the mobility of the signifier held in check by iconographic convention – ends in a state of indeterminacy, and no amount of exhortation, no degree of intensification of initial iconographic clarity can prevent it. The codes of connotation are *under*-determined. It is context which in the last instance supplies the point of insertion of the image, into the murky depths of the social formation: and in the case of gesture and posture, in particular, the mode of interpretation is what Durkheim called 'pure practice without theory';[29] the signifiers move in the manner of the dance; they communicate, so to speak, from the body to body, 'on the hither side of words';[30] gesture is the last outpost of the sign as it crosses from the codified into the concrete (where it disappears). The glance of the viewer is tentacular; it pulls the image into its own orbit of tacit knowledge, taking it as provocation to perform an act of interpretation which is strictly speaking an improvisation, a minutely localised reaction that cannot – impossible dream of the stereotype – be programmed in advance.

Elaborating away from the fixities and assurances of its iconographic codes, the stereotype enters an ambience of bodily practice where it risks seizure by contexts and by interpretative labour that may well destroy its official project. *Guernica*, a specific reaction to a single (if emblematic) political event, by raising the spectre of slaughter from the air, becomes a generalised nightmare where the historical fate of Guernica in 1936 recedes into *pretext* for this 'universal', and universally familiar, image of pain. Géricault's representations of the destitute population of London in 1820, born in minutely specific political and economic circumstance, can do nothing to prevent their recuperation, in other contexts, as consoling meditations, reactionary or otherwise, on the Human Condition. David's *Marat assassiné*, a single component in a precisely orchestrated sequence of Jacobin paintings and pageants,[31] becomes a diffuse, unfocused emblem of death, over which there hovers a piquant if mysterious atmosphere of forgotten history. By stating that social formation is *not yet complete*, that something must be done, the hortative image may indeed galvanise viewing reaction, yet there is little it can then do to control that reaction, or to restrain the local context of its reception from moving in on the image in sympathetic, suffocating response to its rallying cry, destroying the specif-

icity of the exhortation on the way. In the extreme cases – *Guernica*, the *Marat*, Géricault's London lithographs – nothing can prevent the original statement of incompletion (the 'something must be done') from being taken as an incompleteness *within* the image, as the dignified reticence of compassionate understatement: the familiar arc of declension from specific anger, to public monument.

In such cases as these one is dealing not only with the transformative power of context and of the work of interpretation in context, but with the actual reversibility of power-relations: volatility is the key word.[32] When the image takes upon itself to act on behalf of another power, yet continues to speak in its own name, the combined spectacle of delegation with the self-confessedly inferior rank of the delegate introduces a dangerous insta-bility into the field of forces: a command that would be obeyed if it came directly, may now provoke active resistance. When the didactic import of the image has been effectively lost in the passage from overdetermination to underdetermination, such reverses will not arise; but as soon as the scent of power is detected, the rhetoric is at risk: at any moment the direction of the signs may switch, and persuasion be felt as invasion. Nowhere is this reversibility more likely to occur than in the image of exhortation, since the gerundive cast can also be read as solicitation, importunacy, insufficiency: however impressively the power structure projects itself to me, at the moment when it is seen to ask for something, its imposing appearance changes to masquerade. The weakness here is struc-tural. The stereotype (in both economies, of the East as of the West) addresses me at a particular point in the social space (the conventions of realism interpellate me as this body, here); its vocative appeal at the moment of attack would seem to find in this minute locus some especial thing of value; yet a second later it withdraws that intimate contact and begins to speak impersonally, glacially, to the world at large – at the same time as it seems to find the mite worth taking, all the same. It is not that an inherent rebelliousness at such moments turns the addressee against the *res publica*; but rather that the stereotype addresses the viewer twice over, constructs him in two irreconcilable forms: as this potential donor of a vital quantum of solidarity, and as that featureless vector of political and economic energy (Worshipper, Citizen, Consumer, Producer). The stereotype resembles, one might say, the pre-recorded message, in that besides its content it also indicates, fairly safely, that the speaker is else-where: it is an alibi that always works, and since the authority which so masterfully addresses the viewer is sure to be somewhere else, the

stereotype in fact behaves as a licence for misrule: if the images are not actually defaced (examples: the destruction of David's *LePelletier assassiné*; the assault on the Lady Chapel, Ely) the propaganda they confusedly purvey is simply filtered out, as a kind of permanent and more or less irritating background noise (Moscow, New York). Through its very constitution as repetition and typicality, stereotype is the form of image most subject to fatigue, in the sense this word has in engineering; and if the stereotype can be said to represent anything, it is perhaps the fatigue of power.

Ordinary usage of the word 'stereotype' already indicates this flaw of stereotypical structures: if a representation is genuinely accorded evidential status, 'stereotype' is not the word we use; when it is felt to be backed by the full weight of a material reality, when the representation is fully embodied in practical experience, then 'stereotype' is the word that is exactly inappropriate. The system known as 'Identikit' is, by contrast, a pure form of stereotype in that its incomplete and tentative images know only a generalised outline of the face; they are built up in a state of ignorance, a state of separation from material knowledge which they constantly strive to overcome; at the end of the successful process the provisional hypotheses of Identikit can be replaced by the real thing – the photograph. The stereotype exists and is known at just those points where it does not tally with the evidence, where it comes away from the surface of practice: it establishes two zones, of enchanted representation and disenchanted experience. In the first, it purveys a representation of the social formation that repeats the familiar synoptic illusion of the Gaze: a complex flux of intermeshing practices is reduced to simultaneous intelligibility. Thus, in Marr, the base structure/superstructure model proposes a static unity of the social formation working in perfect synchronisation with itself: because the productive forces and the relations of production in the base are unitary, so the representations in the superstructure will repeat, confirm, *prolong* that original oneness; through the stereotype, that prior base unity becomes known in visual form (Socialist Realism). It is this dream of an *essential* image of the social formation which will be found whenever the stereotype comes to centralise the administration of images and under whichever political system.

(A parenthesis for media analysts: on the desk of my outer room I find copies, printed in the same month of the same year, of the Moscow publi-

cation *Krokodil* and the New York magazine *After Dark*. On one page of the first magazine, I find a version of a poster used at the recent May Day celebrations: it represents, in broad, generalised strokes of a single colour, the Worker. The connotations in the image are both unified and haphazard. The markers of the Worker's age are ambiguous, yet at the same time it is clear that they coincide with some statistical average; his entire body is taut with purpose and resolve; his clenched fist signals both indignation, the presence of righteous anger, and mastery of that indignation, its channelling less into the class struggle than into production. A stencilled, cartoon-like simplification of eyebrows and cheekbones marks a curious exaggeration of gender characteristics, a certain truculent virility that would seem to constitute a wayward excess of the image over and away from its function, were it not apparent that gender-position is also part of the representation's system of fixities, and *another* part of its brief to co-ordinate all the positionings of the body in its economic, sexual, and ideological practices into a single place, this *summatory* image which will encapsulate an essence of the proletariat. On a page of the second magazine I find again the same dream of the *summa*: an airbrush design, in the style of painterly hyper-realism, depicts four dancers at a discothèque. Here the discipline, the austerity of the image, despite its simulation of carnival, lies in its extortion from the body of its maximum usufruct of pleasure (and of signification); the body is subjected to a gymnastic drill of hedonism (they dance on roller-skates, one wears a track suit) as demanding as an Olympic routine; the faces, exaggeratedly bronzed, the upper lip fixedly raised in permanent display of the inner orthodontic marvels, in a rictus of enjoyment amounting almost to ethnological deformity (one thinks of the bound feet of women in Mandarin China, of the protuberated lips and giraffe necks of Central Africa) indicate a regime of gratifications as strict and as purposeful, in its fashion, as the taut determinedness of the Worker. In both images the multiplicity of the body's activities – the dispersal of the body across all its practices – is impounded into the uniquely legible and motionless statement of a single theme, a distilling of practice into the stasis of an essence: Production, Consumption.)

Yet it would be wrong to conclude, from this frequent absurdity of the stereotype, and from its inability successfully to accomplish its mission (inability to be attributed less to incompetence of performance – the images from *Krokodil* and from *After Dark* exist at a high level of technical accomplishment – than to the internal and structural contradiction of the stereotype) that the stereotype is inherently and permanently unviable.

The danger here is that of all academism: to view the world as a *spectacle* presented to an analyst who stands back from it and projects into it the principles of his own relation to the object, who conceives that spectacle as a totality intended as it appears to him, for cognition (as a structure of *knowledge*). The *intellectualist error*, in analysis of stereotype in painting, would be that of supposing that because the stereotype remains visible as stereotype, and because its expansion of connotation drags it away from the generalised clarity of the codified into the particularity and confusion of the concrete and of local context, that the stereotype automatically *fails to communicate*. It may well fail to do so; but we must also see that the stereotype is not only a structure of cognition, of information, of communicative signs (difficulty in seeing beyond 'cognition' is finally what renders Barthes's *Paris Match* semiological *décodage* unconvincing). If we think of the stereotype as a kind of failed transmission, we are still conceiving the overall purpose of the image as naturalisation of a world-view (naturalisation which the stereotype cannot quite accomplish): the successful stereotype would, thinking along these lines, be one which was assumed by the viewer accurately to represent the essence of his society (Consumerism, Production), a stereotype which had overcome its own internal law of contradiction, had by-passed resistance, and had been introjected by the viewer as Truth.

But let us keep our attention fixed on logistics. The regime of the stereotype is one of *systematic euphemisation*. The representations of the Worker, of the Consumer, are not intended as transmission of the truth, but only of a certain simplified fiction of 'enchanted' social relationships, a fiction of *practical* use-value: there is neither deceiver nor deceived. We will not necessarily find an entranced, mesmerised subject held in position by hallucination in the Imaginary, nor a fixed, controlled subject who actually accepts the veridical status of the stereotype: that the subject can be imagined as this fixed entity is exactly the pretence of the stereotype (and let us not extend that pretence into our own analysis). Participation in the regime of the stereotype does not entail a surrender by the viewing subject to the content of the exhortation; neither submission nor hypnosis, the process is rather one of a consensual agreement to accept such-and-such a stereotype as a fiction of legitimation advantageous both to the 'dominating' and the 'dominated' groups. These terms are placed with some disclaimer, because the truth of the matter is that in the societies whose visual culture we have been exploring, *physical* domination (slavery) is only an occasional (though by no means an exceptional) mode of control; authority

is typically exercised in the name of institutionalised, not personal, power.

In cultures of physical domination, no need for legitimation will arise, since the body of the subject is directly in submission; but to the extent that the function of domination is taken over by institutions, this physical mode of power becomes unnecessary; a secondary domination by systems which 'take their own course' replaces the elementary domination of body over body. In secondary domination, the ruling group must justify its authority through cultural values and forms; management, rather than control, is the customary expression of authority once overt and bodily subjection becomes impossible. The *entire* society must submit to these forms, if their regulatory intention is to become effective; a veiled exercise of power arises, through mechanisms that obey a new imperative: not to touch the body, where non-contact with the body becomes the mark of civilisation, contact with the body the mark of barbarism. The societies of 'civilisation' are therefore those whose order depends on the public acknowledgement of consensual fictions that *protect* the body from the elementary or barbaric mode of domination. Certain legitimating myths are accorded a contractual status where all parties have an active interest in maintaining the contract; the contract may coincide with belief, but *belief* is not its primary or prime necessity, only *agreement* (attitude).

Even if the stereotype were found at no point coincident with a reality outside it (the Trinity; the Consumer), such non-coincidence need not affect the practical use to which the stereotype is put. Society may, as Mauss puts it, pay itself in the false coin of its dream; but this does not entail that members of society live the falsity of their dream, only that collectively and individually the society has an interest in maintaining the standardisation of its currency. The difficulty the stereotype encounters, in trying to force its iconographic content through the grid of connotations, presents therefore no serious threat to its project; were it *only* a structure of communciation and social knowledge, as structuralism would have it, then indeed the threat would become real, and the continued use of this unviable entity, the stereotype, would seem highly mysterious, a mystery, attributable to the *participation océanique* of collective somnambulism. The stereotype, however, is not only cognitive, but practical: all it needs is *purchase* on the social formation; not insertion into it, followed by injection of the contents of its 'hype' (it is possible to see both William Burroughs and Marcel Mauss in the same perspective); and for purchase, no system has more to recommend itself than that of connotation. Exactly because the codes of connotation are underdetermined and acquire intelligibility *in situ*

(certainly a disadvantage for the image as a channel of communication), connotation exerts a tentacular pull on the image and draws it into *this* situation; painting from Giotto to Vermeer (to stay only with the limited examples at our disposal) evolves always towards the 'this', towards ostensive contact with social formation. The evolution crudely charted as movement from a stage of address to a generalised operator of tacit knowledge (Giotto), to a stage of address to a particular body in space (Masaccio, Piero, Raphael), to a stage of address to a theoretical point (Vermeer), this drift of the image away from the codified to the concrete is entirely in the direction of increased purchase of the image on its society. From one point of view – that of an instrumentalism theorised according to elementary domination – the evolution is a disaster, for at every move, the only level of the image's codes open to *direct* appropriation by institutional power (iconography) becomes ever more indistinct. In Byzantium, a regime less interested in purchase than in didactic communication of its liturgy and sacred texts, the iconographic codes had been supreme; the decline of the overtly iconographic deployment of images might therefore appear, as much to the eyes of structuralism as of Gombrich, as a secession of painting practice from social purpose. Yet such decline indicates rather the opposite to be true: with the expansion of connotation the image disperses within and adheres to the social formation as never before, moving continuously towards that maximised purchase which the introduction of mechanical means of reproduction will perfect.[33]

The 'Zeuxian tendency' of Western painting is only one expression of a generalised social process to which all members of the 'community of recognition' must submit. Where before, in elementary domination, history could be written in terms of one body's mastery over another, and *combat* could be seen as the principal mode of social interaction, in secondary or managerial domination the emphasis passes from the fiefdom, from dispersed feuding, and from familial or tribal gregarities to a collective arena whose prime focus is no longer the body but the signifier, and where *recognition* is the principal mode of interaction: all must submit to public acknowledgement of certain legitimating explanations of the social formation and to certain discursive formations, yet submission is no longer a capitulatory yielding up to control, as in combat, but rather acceptance on the part of each agent of a *weight* of consensus that is standard throughout the community, and which presses upon each agent to the same degree. No one can depart from the consensual formations – the discourses – of the signifier without, at the level information, risking a fade-

out into non-intelligibility, and also, at the level of conformity, risking secession from the contract of the signifier on whose maintenance the stability of the social formation depends: by a process of intermeshed censorship, the contract to which the individual agent submits he then imposes on all the others.

In this immense stability of a self-reinforcing system, change can come only from two directions: either from material conditions that modify the topology of the discursive formations; or from material work on the signifier achieving the same result. The former process is constant and serves the cause of adaptation: to introduce rigidity into the discursive formations, by means, for example, of censorship or punishment, may in the short term seem to be in the interests of the social-signifying system as a whole, but in the long term jeopardises the signifying contract, threatens the social foundation, by introducing disparity between signifying practice and the other (economic, sexual, political) practices in the society: it amounts to a fissile inclination at odds with the contract's coherent bonding. It is therefore in the long-term interests of social cohesion to allow signification to flow through the society without hindrance, since the discursive formations which will then emerge at the interface between the *langue* and the conditions of material life will not put the contract *under strain*: there will be 'backing' by the full force of material circumstance. On the other side of change, in the work of signifying practice, the consensual force of the contract itself works against the appearance of any violence of innovation, since radical departures from signifying practice, unless backed by material circumstance, will simply fail to acquire intelligibility, and fall into the void of non-recognition (the fate, perhaps, of *Olympia* in 1865). Signifying practice does not, in the long term, require constraint, since the interindividual territory in which it occurs is ruled by a law of 'co-operative production' in which no individual agent may modify the topology of the discursive formations too greatly without defeating what had been his own purpose, i.e. recognition of his modification.

While signifying practice may well seem at times to require constraint, at least in the eyes of certain factions (regimes of the stereotype), recourse to censorship is more likely to arise from a lack of understanding of the principle of *cross-censorship* to which all the agents have submitted in the original contract; each agent imposes on the rest the existing topological boundaries of discourse, not by active force of repression, but by default: secession from the territory of the contract results in non-intelligibility, in failure to innovate. The system is accordingly self-enforcing, in that acts of

deviation from the system fall *outside* the system's pale; its energy is self-enclosing and prevents, by the action of its own mechanism, the occurrence of 'leakage'. From this point of view, a dispensation of the image which seeks no more than to situate certain useful classes of representations (iconographies) in the society, and which allows those classes to be moulded by the local contingencies of viewing (in the 'tacit' reading of connotations) submits the general economy to less strain than a dispensation which censors the image through enforced stereotyping, and counters the 'tentacular' hold of connotation either by impoverishing connotation through the supplementary controls of a rubric (Western publicity), or by reverting to a rudimentary practice of hieratic, neo-Byzantine stencils (Socialist Realism). Painting and viewing are ultimately self-regulating activities, and do not require such anxious monitoring and exhortation: this is a *serene* system.

Epilogue
The Invisible Body

Towards the end of his life, Matisse, like Picasso, consented to be filmed at work in his studio. Part of the film was shot in slow motion, distending the movement of hand and brush in time so that each stroke seemed a gesture of consummate deliberation; as though in slowing the movements down the film were able to demonstrate for the first time a dimension of intention and decision that would never otherwise become known. Let us stay with this scene of suspense: the brush, held a few inches from the canvas, begins an arc that moves in slow motion closer and closer to the surface; the point of the brush contacts the canvas, and as the hairs bend, a smooth, even trace of pigment appears; as the brush is still completing that first arc, a second movement begins in the painter's arm, commencing at the shoulder, which moves towards the easel; at the same time, the elbow moves out from the easel, so that the wrist can rotate and realign, like a lever, all the angles of the fingers. The brush, unaware of these developments, is still completing its first movement, but at a certain moment its trajectory changes, slowly lifting from the surface at an angle different from that of its arrival; the trace becomes slender, its edges curving inwards as the hairs of the brush come together, exuding a thick, rich trail of pigment until, as the brush lifts from the canvas altogether, the last filament breaks with the surface, to complete the stroke in space.

Looking at the Chu Jan scroll in Cleveland, I can imagine all of these gestures; no film is necessary for me to locate these movements, for the silk is itself a film that has recorded them already; I cannot conceive of the image except as the trace of a performance. In part, the performance has been fully advertent, directed to the gaze of the spectator in the same way that a dancer projects his movements through the four sides of the proscenium to the audience beyond; the four sides of the scroll contain a spectacular space, where everything exists for consumption by the gaze, *im Augenblick*, as a *scaena*, a backdrop. But in part, the performance is

163

inadvertent, for although the strokes are so displayed that from their inter-locking structure I can visualise a scene, a monastery in stream and moun-tain landscape, the strokes also exist in *another space* apart from the space of spectacle; a space not so much convergent with the silk (though the silk intersects with it, it is a *section* of that other space) as with the body of the painter; it is *his* space, and in a sense it is blind; the movements executed there will, as they touch the silk, leave marks I can construct as a *scaena*, a spectacle, but these marks are also simply *taches*, traces left behind in the wake of certain gestures, but remaining below the threshold of intelligibil-ity (recognition), blind marks which support, eventually, the sigils from which I can construct the landscape scenically, but which are also inde-pendent of the sigils they bear; as the body of the dancer exists physically for the others on stage, projecting outwards past the proscenium arch, certainly, but also here, seen by the other performers, on the 'wrong' side of the arch. For the dancer, the space of the stage is an extension of studio space; periodically, he must move his performance to the theatre, but even then the stage retains a quality of studio space, into which the audience looks as though from a public gallery; in the Chu Jan, it is this choreo-graphic space, behind the proscenium surface, which also we look into, studio space seen from the *excluded* angle of the picture gallery.

It is this other space of the studio, of the body of labour, which Western painting negates; we are *given* the body with an intensity of disclosure and publicity without counterpart outside Europe, but it is the body in a differ-ent guise, as picture, to be apprehended simultaneously by the Gaze: the Gaze takes the body and returns it in altered form, as product but never as production of work; it posits the body only as content, never as source. Compensating this impoverishment of the body, the tradition rewards it with all the pleasures of seduction, for the body of the Gaze is nothing other than a sexual mask: the galleries of the West constantly display the Gaze of pleasure, as an archive that is there to be cruised. Perhaps the deepest level of seduction lies in the apparent presentation of the body under genetic time: here, buried in the archive, is to be found the semantic *accent* of lost communities of pleasure, the conscious or unconscious inflec-tion given the body by a remote culture whose libidinal currency is nonetheless still in circulation, the still-warm traces of a vanished physical civilisation: its distinctive carriage, the look of its skin and muscle, its machistic and feminine allure; its attitudes towards beauty and ugliness, towards the bodies of its children and its old; its ideas of vice and mortifi-cation, of sexual display, of ceremony and licence. In part this genetic

34 *Male Funerary Portrait*

35 *Female Funerary Portrait*

illusion is due to the simple longevity of the tradition: in no other civilisation (not even in China) has realism prevailed over periods long enough to engender so extensive a corpus of comparable representations. Probably the most striking aspect of the encaustic portraiture of antiquity is the credibility it lends to the idea of the body's endurance as persistent substrate to all cultural enterprise: the work of culture seems only a matter of costume and parure superadded to the recurrent genetic pattern (Illus. 34, 35). To which the longevity of the tradition adds its incontrovertible demonstration of the historicity of the human physique: in each social formation the pattern undergoes subtle modification, and from beneath the rapid, superficial epicycles of sumptuary change there emerges a deeper, geological graph of change in the body's successive epochs (Illus. 36, 37). And in a sense this is always the gallery's inner or secret theme: the body's tractability and ductility before historical pressure: it is as if painting gave access to a panoramic view of the process whereby plastic genetic material continually moulds itself in accordance with the milieu pressing in upon it and shaping its individual life-span.

Let us be clear: we are speaking of a seductive illusion. If, in the general concealment of the body of labour, painting of the Gaze accords an acute and privileged position to sexuality, this is because through exaggeration of the markers of sexuality, painting is able to draw into itself a libidinal and scopic drive whose local homogenisations here, within the sexual *Merkzeichen*, serve to underpin and to maintain the overall homogeneity of the Gaze (Illus. 38, 39). No foundation could be more secure: response to the cues of the sexual *Gestalt* is immediate and powerful; the scopic drive, once aroused, will exert all its force to synthesise the intermittent and dispersed material disclosed by the glance into a single image (of presence, of pleasure). The body of labour, in its studio space, is hidden by the brilliance of the posture, the facial or bodily feature, in which the viewer discovers his or her sexual interest: it is through the mask of seduction that the *scaena* becomes most coherent and most opaque – through local and libidinal fusions that the image solidifies around the 'this', this moment and this body of pleasure, in the here and now of its sexual engagement; the *durée* of labour gives way to the immediacy of appetitive time.

How are we to *think* that other space of duration, that other body of labour? Here, at the conceptual limit of the present essay, one can only provide suggestions and methodological guidelines: we have, as yet, no unified theory either of signifying practice or of the body. What we must suspend, clearly, is the conception of the body in representation which our

36 Attributed to Robert Campin, *Portrait of a Man*

37 Attributed to Robert Campin, *Portrait of a Woman*

own tradition proffers to us, as something fixed, pictorial, framed; we must attend, on one side, to the means by which the individual painting directs (rather than determines) the flow of interpretation across its surface; and on the other, to the collective forms of discourse, present in the social formation and subject to their own unfolding in time, which the painting activates: activates not as citation, but as mobilisation (the painting causes the discourses to *move*).

If there is power intrinsic to painting, power it exerts in its own territory and in its own name, it resides in the capacity of its practice to *exceed* the fixities of representation. Since it is only by working, by transforming the signifying material provided by the painting that the process of recognition unfolds, recognition is always in movement, is always an active rotation of the annulus of signs; viewing is mobility both of the eye and of discourse, in the disseminations of the glance. Since it is only through labour that the signs of painting appear on canvas, painting is itself a locus of mobility in the field of signification, a process which may be presented, by the

38 David Hockney, *Larry S., Fire Island*

39 Ingres, *Study for L'Odalisque à l'esclave*

conventions of the tradition, under the guise of static form, but which in the first place is a work on and through material signs, a practice at once entering into interaction with the other domains of practice in the social formation.

To understand the painting as sign, we have to forget the proscenic surface of the image and think behind it: not to an original perception in which the surface is luminously bathed, but to the body whose activity – for the painter as for the viewer – is always and only a transformation of material signs. That body may be eclipsed by its own representations; it may disappear, like a god, in the abundance of its attributes; but it is outward, from its invisible musculature, rather than inwards, from its avid gaze, that all the images flow.

Notes and References

CHAPTER ONE: THE NATURAL ATTITUDE

1 Pliny, *Natural History*, Book XXXV, 64–6.
2 *Purgatorio*, XI, 94–6.
3 *Philippi Villani Liber de civitatis Florentiae famosis civibus*, ed. G. C. Galletti (Florence, 1847); text here taken from Vatican Ms. Barb. lat. 2610 (circa 1395); cit. M. Baxandall, *Giotto and the Orators* (Oxford: Clarendon Press, 1971) pp. 70, 146–7. See also L. Venturi, 'La critica d'arte alle fine del Trecento (Filippo Villani e Cennino Cennini)', *L'Arte*, XXVIII (1925) 233–44; M. Meiss, *Painting in Florence and Siena after the Black Death* (Princeton, N.J.: Princeton University Press, 1951) p. 69; and E. Panofsky, *Renaissance and Renascences in Western Art* (Stockholm: Almqvist and Wiksell, 1960) pp. 14–19. 'Inter quos primus Johannes, cui cognomento Cimabue dictus est, antiquatam picturam et a nature similitudine quasi lascivam et vagantem longius arte et ingenio revocavit. Siquidem ante istum grecam latinamque picturam per multa secula sub crasso peritie ministerio iacuisset Post hunc, strata iam in novis via Giottus, non solum illustris fame decore ˙antiquis pictoribus comparandus, sed arte et ingenio preferendus, in pristinam dignitatem nomenque maximum picturam restituit.'
4 Baxandall, *Giotto and the Orators*, pp. 76–8.
5 G. Morelli, *Die Werke italienischer Meister in den Galerien von München, Dresden und Berlin* (Leipzig: Seeman, 1880). On Berenson's debt to Morelli, see M. Secrest, *Being Bernard Berenson* (London: Weidenfeld and Nicolson, 1980) pp. 90–2; and E. Samuels, *Bernard Berenson: The Making of a Connoisseur* (Cambridge, Mass. and London, England: Harvard University Press, 1979) pp. 97–105.
6 P. Francastel, *Le figure et le lieu* (Paris, 1967) pp. 234–5.
7 For the full inventory, see Pliny's account of the work of Ludius in *Natural History*, Book XXXVI; perhaps at its best in Philemon Holland's translation (reprinted by Southern Illinois University Press; New York: McGraw-Hill, 1962) pp. 421–2.
8 The strategy of the realist project with regard to painting here closely resembles its strategy with regard to textual practice: see S. Heath, *The Nouveau Roman* (London: Elek, 1972) pp. 15–43; R. Barthes, *S/Z* (Paris: Editions du Seuil, 1970); and G. Genette, *Figures II* (Paris: Editions du Seuil, 1969) pp. 73–5.
9 Husserl; cit. S. Heath, *The Nouveau Roman*, p. 13.

10 Cf. Barthes, *Le degré zéro de l'écriture* (Paris: Editions de Seuil, 2nd edition, 1972) pp. 11–17.
11 See Alberti, *De Pictura*, Book I, 5–20 (ed. C. Grayson; London: Phaidon, 1972) pp. 39–57. The archetypal form of the monocular diagram derives, however, from the notebooks of Leonardo.

CHAPTER TWO: THE ESSENTIAL COPY

1 P. L. Berger and T. Luckmann, *The Social Construction of Reality: A Treatise in the Sociology of Knowledge* (1966; rpt Penguin Press, 1979) pp. 65–70.
2 See, classically, Brecht, *Kleines Organon für das Theater, Gesammelte Werke* (Frankfurt: Suhrkamp Verlag, 1967) vol. XVI, pp. 659–707; and *Über den Realismus, Gesammelte Werke*, vol. XIX, pp. 287–382; also C. Prendergast, *Balzac: Fiction and Melodrama* (London: Edward Arnold, 1978) note to pp. 159–61; and S. Heath, *The Nouveau Roman*, pp. 19–20.
3 Durkheim and Mauss, 'De quelques formes primitives de classification: contribution à l'étude des representations collectives', *Année Sociologique*, VI (1901–2) 1–72; Horkheimer, *Dialektik der Aufklärung* (New York, 1944; rpt Frankfurt: S. Fischer Verlag, 1969); Berger and Luckmann, *The Social Construction of Reality*, pp. 110–46. For a radical reorientation of this tradition, see P. Bourdieu, 'Condition de classe et position de classe', *Archives Européennes de Sociologie*, VII (1966) 203–23; and Bourdieu, 'Champ intellectuel et projet createur', *Les Temps Modernes*, 246 (November, 1966) 865–906.
4 Two opposed conceptions of naturalisation meet in this crucial term, the habitus. We might call the first, the tradition of the *pharmakon*: here the habitus is understood noumenally, as a collective delusion (see previous note). In the second, habitus is understood materially, as a mode of practice: see, in particular, the magnificent text of Bourdieu *Esquisse d'une théorie de la pratique* (Paris, 1972) translated by Richard Nice as *Outline of a Theory of Practice* (Cambridge, England: Cambridge University Press, 1977); and D. Sperber, *Rethinking Symbolism* (Cambridge, England: Cambridge University Press, 1978).

5 V. N. Vološinov, *Marxism and the Philosophy of Language* (Leningrad: 1929 and 1930); trans. L. Matejka and I. R. Titunik (New York and London: Seminar Press, 1973) pp. 17–21.

6 Vološinov, *Marxist Philosophy*, p. 21.

7 Gombrich, *Art and Illusion: A study in the psychology of pictorial representation* (1960; rpt Oxford: Phaidon, 1977) p. 1. Cf. p. 328: 'The purpose of this book was to explain why art has a history . . .'

8 Ibid., p. ix.

9 Hume, *A Treatise on Human Nature*, Book I, Part III; *An Enquiry Concerning Human Understanding*, sections III–VIII; see also M. Dummett and A. Flew, 'Can an Effect Precede Its Cause?, in *PAS*, supp. vol. XXVIII (1954); and R. M. Chisholm and R. Taylor, 'Making Things to Have Happened', in *Analysis*, XX (1960) 73–8.

10 Russell, *History of Western Philosophy* (1946; rpt London: Unwin, 1980) p. 647.

11 Popper, *The Logic of Scientific Discovery* (1959; rpt Hutchinson, 1980) pp. 251–82.

12 See Popper, *Objective Knowledge: An Evolutionary Approach* (Oxford: Clarendon Press, 1972) pp. 242–4.

13 Gombrich, *Art and Illusion*, pp. 55–78.

14 On 'taxonomic aberration', see Lévi-Strauss, *Anthropologie Structurale* (Paris: Plon, 1958) pp. 11–266; *La Pensée Sauvage* (Paris: Plon, 1962) pp. 178–211; M. Douglas, *Purity and Danger* (1966; rpt London: Routledge and Kegan Paul) pp. 7–57; and what is perhaps the most elegant of all the French texts in Structural Anthropology, Detienne, *Les Jardins d'Adonis* (Paris: Gallimard, 1972); in superb translation by Janet Lloyd as *The Gardens of Adonis* (London: Harvester, 1977).

15 'These examples demonstrate, in somewhat grotesque magnification, a tendency which the student of art has learned to reckon with . . . the familiar will always remain the likely starting point for rendering the unfamiliar You must have learned the trick if only from other pictures you have seen': Gombrich, *Art and Illusion*, pp. 72–3.

16 On the 'manual' schema, see *Art and Illusion*, pp. 110 ('Originally . . . the artist probably did what we have known artists to do in such circumstances: he cast around for an existing schema that would *lend itself to adaptation*'), 122, 126–7, 134–44; on the 'noumenal' schema, see pp. 62 ('the artist begins not with his visual impression but with his *idea or concept*'), 154–5, 198–203, 236–8 (this is only one reader's sample; my emphases).

17 See, in particular, Morelli, *Kunstkritische Studien über italienische Malerei* (Leipzig: F. A. Brockhaus, 1890–1893).

18 W. Köhler, *Gestalt Psychology* (New York: Liveright, 1974) pp. 206–78; and K. Koffka, *Principles of Gestalt Psychology* (New York: Harcourt, Brace and Co., 1936) pp. 648–79.

19 Gombrich, *Art and Illusion*, pp. 4, 170–203.

20 Gombrich, *The Sense of Order* (Oxford: Phaidon, 1979).

21 Ibid., pp. 95–117; cf. Flaubert, *Madame Bovary*, Part III, ch. 7 (Binet at his lathe); and Barthes, *Le plaisir du texte* (Paris: Editions du Seuil, 1973) pp. 82–3.

22 See Merleau-Ponty, *Phenomenology of Perception* (trans. C. Smith; London: Routledge and Kegan Paul, 1962) pp. 3–66; and Husserl, *Formal and Transcendental Logic* (trans. D. Cairns; The Hague: Martinus Nijhoff, 1978) pp. 202–66.

23 Popper, *The Growth of Scientific Knowledge* (1963; rpt Routledge and Kegan Paul, 1978) pp. 46–7.

24 Gombrich, *Art and Illusion*, pp. 76, 90.

25 B. Magee, *Popper* (Glasgow: Fontana/Collins, 1973) p. 65; see also Popper, 'On the Sources of Knowledge and of Ignorance', *Proceedings of the British Academy*, XLVI (1960) 39–71.

26 See T. Kuhn, *The Structure of Scientific Revolutions, International Encyclopedia of Unified Science*, II, no. 2; and I. Lakatos, 'Changes in the Problem of Inductive Logic', *Proceedings of the International Colloquium in the Philosophy of Science, London, 1965* (Amsterdam, 1968) pp. 315–417. Art History has yet to experience its Kuhnian Revolution.

CHAPTER THREE: PERCEPTUALISM

1 See, in particular, G. Rousseau, 'Traditional and Heuristic Categories: A Critique of Contemporary Art History', *Studies in Burke and His Time*, XV, no. I (Fall, 1973) 51–96.

2 See N. Bryson, 'Watteau and Reverie: a Test Case in "Combined Analysis"', *The Eighteenth Century: Theory and Interpretation*, vol. 22, no. 2, 1981, pp. 97–126.

3 On the 'universalism' of perception, see C. Tolman and E. Brunswick, 'The Organism and the Causal Texture of Environment', *Psychological Review*, XLII (1935) 43–77; D. O. Hebb, *The Organisation of Behaviour* (New York: John Wiley and Sons; London: Chapman and Hall, 1949); F. H. Allport, *Theories of Perception and the Concept of Structure* (New York: John Wiley and Sons; London: Chapman and Hall, 1955) and, crucially, F. A. von Hayek, *The Sensory Order* (London: Routledge and Kegan Paul, 1952). I hope it is apparent that the present argument belongs more to the context of Cambridge, than of Vienna: see G. E. Moore, 'A Defence of Common Sense', in *Contemporary British Philosophy, Second Series* (ed. J. H. Muirhead; London, 1925); 'Proof of an External World', *Proceedings of the British Academy*, XXV (1939) 273–300; and Wittgenstein's internal dialogue with Moore, *On Certainty* (*Über Gewissheit*) (trans. D. Paul and G. E. M. Anscombe; Oxford: Basil Blackwell, 1977) pp. 2–38e.

4 See N. Malcolm, 'Wittgenstein's *Philosophical Investigations*', in *The Philosophy of Mind* (ed. V. C. Chappell; Englewood Cliffs, N.J.: Prentice-Hall, 1962) pp. 74–100; and 'Knowledge of Other Minds', *The Philosophy of Mind*, pp. 151–9.

5 My exposition here follows closely that of John Casey in his excellent work *The Language of Criticism* (London: Methuen, 1966) chs I and II.

6 Wittgenstein, *Philosophical Investigations* (1953; trans. G. E. M. Anscombe; rpt Oxford: Basil Blackwell, 1968) paragraphs 244–341.

7 *Noumenon:* 'An object of purely intellectual intuition, devoid of all phenomenal attributes (*OED*). See Wittgenstein, *On Certainty*, paragraphs 38–65.

8 Wittgenstein, *Philosophical Investigations*, paragraph 155.

9 Ibid., paragraphs 186–90; and Casey, *The Language of Criticism*, pp. 5–7.

10 Wittgenstein, *Philosophical Investigations*, paragraphs 156–71, 375, 493.

11 Gombrich, *Art and Illusion*, pp. 29–34, 320–9.

12 'In the Western tradition, painting has indeed been pursued as a science. All the works of this tradition that we see displayed in our great collections apply discoveries that are the result of ceaseless experimentation'; Gombrich, *Art and Illusion*, p. 29.

13 Constable: cit. ibid., p. 33.

14 Ibid., pp. 272–5.

15 See O. Demus, *Byzantine Art and the West* (London: Weidenfeld and Nicolson, 1970); D. T. Rice, *Art of the Byzantine Era* (London: Thames and Hudson, 1963) esp. pp. 21, 27–8, 93–7, 258–64; W. F. Volbach, *Early Christian Art* (London: Thames and Hudson, 1961); C. R. Morey, *Early Christian Art* (Princeton, N.J.: Princeton University Press, 1953).

16 Bourdieu, *Outline of a Theory of Practice*, pp. 1, 19, 24, 96–7, 116, 117, 203 n.47.

17 On Lukács's political evolution, see M. Löwy, 'Lukacs and Stalinism', in *Western Marxism – A Critical Reader* (London: New Left Books, 1977); *Aesthetics and Politics* (ed. R. Taylor; London: Verso, 1977) pp. 9–15, 60–7, 100–9, 142–50; and F. Antal, *Florentine Painting and its Social Background* (London: Kegan Paul, 1948).

18 N. Malcolm, *Dreaming* (London: Routledge and Kegan Paul; New York: Humanities Press, 1959) pp. 76–81.

19 Vološinov, *Marxism and the Philosophy of Language*, pp. 83–98.

20 See J. White, 'Measurement, Design and Carpentry in Duccio's *Maestà*', I, *Art Bulletin*, LV (1973) 344ff; II, ibid., 547ff; White, 'Carpentry and Design in Duccio's Workshop', *Journal of the Warburg and Courtauld Institutes*, XXXVI (1973) 92ff; White, *Duccio: Tuscan Art and the Medieval Workshop* (London: Thames and Hudson, 1979) pp. 80–136. On the bibliography of Giotto's *Betrayal*, see C. de Benedictis, *Giotto* (Instituto Nazionale d'Archeologia e Storia dell'Arte, Bibliografie e Cataloghi, IV, p. 535).

21 Pierce, 'Logic as Semiotic: The Theory of Signs', in *The Philosophy of Pierce: Selected Writings* (ed. J. Buchler; London: Routledge and Kegan Paul, 1940) pp. 98–119; and Saussure, *Course in General Linguistics*, Part One, Section I.

22 'Ce qui définit le réalisme, ce n'est pas l'origine du modèle, c'est son extériorité à la parole qui l'accomplit'; Barthes, *Essais critiques* (Paris: Editions du Seuil, 1969) p. 199.

23 On 'narrative grammar', see Propp, *Morphology of the Folktale* (Bloomington, Indiana: Indiana Research Center in Anthropology, 1958); 'Fairy Tale Transformations', in *Readings in Russian Poetics* (ed. L. Matejka and K. Pomorska; Cambridge, Mass.: M.I.T. Press, 1971) pp. 94–114; T. Todorov, *Grammaire du Décaméron* (The Hague: Mouton, 1969); J. Kristeva, *Le Texte du roman* (The Hague: Mouton, 1970), esp. pp. 129–30; and A. J. Greimas, *Du Sens* (Paris: Editions du Seuil, 1970) pp. 191–209.

24 See H. W. Haussig, *A History of Byzantine Civilisation* (trans. J. M. Hussey; London: Thames and Hudson, 1971) pp. 35–173.

25 Djuna Barnes, from *Nightwood* (London and Boston: Faber and Faber, 1936; rpt 1979) p. 57: 'Felix now saw the doctor . . . make the movements common to the "dumbfounder", or man of magic; the gestures of one who, in preparing the audience for a miracle, must pretend that there is nothing to hide; the whole purpose that of making the back and elbows move in a series of *honesties*, while in reality the most flagrant part of the hoax is being prepared.'

26 See J. Culler, *Structuralist Poetics* (London: Routledge and Kegan Paul, 1975) pp. 55–76.

27 Barthes, *Mythologies* (Paris: Editions du Seuil, 1957) pp. 193–247; trans. A. Lavers (Paladin, 1973; rpt, 1976) pp. 109–59, esp. pp. 122–5.

28 Barthes, *La Chambre Claire* (Paris: Cahiers du Cinéma, Gallimard, Seuil, 1980) pp. 133–9. This is not the last time I find my argument in conflict with Barthes. But there is something else I must say. During the completion of the manuscript, the news came through of Barthes's death. I never met Barthes: but it is still like the death of a close friend. (No one else, in critical prose, has ever given me so much pleasure; his is a voice that will be greatly missed.)

29 A parenthesis for raconteurs: Edith Wharton tells the following tale of recognition in *A Backward Glance* (New York: Appleton-Century, 1934; rpt New York: Scribner's, 1964) pp. 157–8. 'The young Heir Apparent of a Far Eastern Empire, who was making an official tour of the United States, was taken with his suite to the Metropolitan, and shown about by Robinson and the Museum staff. For two mortal hours Robinson marched the little procession from one work of art to another, pausing before each to give the necessary explanations to the aide-de-camp (the only one of the visitors who spoke English), who transmitted them to his Imperial Master. During the whole of the tour the latter's face remained as immovable as that of the Emperor Constantius entering Rome, in Gibbon's famous description. The Prince never asked a question, or glanced to the right or left, and this slow and awful progress through the endless galleries was beginning to tell on Robinson's nerves when they halted before a fine piece of fifteenth-century sculpture, a Pietà or a Deposition, with a peculiarly moving figure of the dead Christ. Here His Imperial Highness opened his lips to ask, through his aide-de-camp, what the group represented, and Robinson hastened to explain: "It is the figure of our dead God, after His enemies have crucified Him". The Prince listened, stared, and then burst out into loud and prolonged laughter. Peal after peal echoed uncannily through the startled galleries; then his features resumed their imperial rigidity and the melancholy procession moved on through new vistas of silence.'

CHAPTER FOUR: THE IMAGE FROM WITHIN AND WITHOUT

1 See, for example, J.-F. Lyotard, *Discours, Figure* (Paris: Klincksieck, 1974); Leach 'Michelangelo's *Genesis*: Structuralist comments on the Sistine Chapel ceiling', *TLS* March 18, 1977, 311–13; J.-L. Schefer, *Scénographie d'un tableau* (Paris: Editions du Seuil, 1969); Schefer, *Le Déluge, La Peste: Paolo Uccello* (Paris: Galilée, 1976); and M. Serres, *Esthétiques sue Carpaccio* (Paris: Hermann, 1978).

2 See Bourdieu, 'Condition de classe et position de classe'; *Outline of a Theory of Practice*, pp. 1–71; and Sperber, *Rethinking Symbolism*, pp. 17–50.
3 Bourdieu, *Outline*, pp. 140–3 ('Making use of indeterminacy').
4 Cit. Leach, *Lévi-Strauss* (Fontana/Collins, 1970) pp. 71–2. Leach also produces the following diagram or 'reduced model' of Greek mythology:

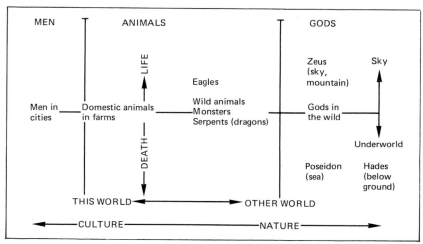

SOURCE: Edmund Leach, *Lévi-Strauss* (Glasgow: Fontana/Collins, 1970) p. 72.

5 See R. Williams, *Marxism and Literature* (Oxford: Oxford University Press, 1977) pp. 35–42.
6 Sperber, *Rethinking Symbolism*, pp. 51–84.
7 Cf. Bourdieu, *Outline*, p. 18.
8 See Lévi-Strauss, *Structural Anthropology* (trans. C. Jacobson and B. G. Schoeps; London: Penguin, 1963) pp. 213–18.
9 Lévi-Strauss, *Le Cru et le cuit* (Paris, 1969) p. 13.
10 Bourdieu, *Outline*, pp. 2, 16–22; and 'Champ intellectuel et projet createur'.
11 See G. Bateson and M. Mead, *Balinese Character: a photographic analysis* (New York: New York Academy of Sciences, Special Publications II, 1942) pp. 13–48.
12 Wittgenstein, *On Certainty*, paragraphs 113–77.
13 See Brecht issue of *Screen*, XVI (Winter 1975–6); and *Brecht on Theatre: the development of an aesthetic* (ed. and trans. J. Willett; London: Methuen, 1964) esp. pp. 1–37.
14 For an extremely interesting exploration of the concept of *doxa* in the literary text, see C. Prendergast, 'Writing and Negativity', *Novel*, VIII, no. 3 (Spring, 1975) 197–213; and 'Flaubert: Quotation, Stupidity and the Problem of the Cretan liar Paradox', King's College, Cambridge, 1980.
15 Reprinted in *Roland Barthes par Roland Barthes* (Paris: Editions du Seuil, 1975) p. 149.

16 S. Timpanaro, *On Materialism* (trans. L. Garner; London: NLB, 1975) pp. 135–220; and L. Hjelmslev, 'Langue et parole' in *Essais linguistiques, Travaux du Cercle Linguistique de Copenhague*, XII, pp. 69–81.

17 Saussure, *Course in General Linguistics* (trans. C. Bally and A. Sechehaye; New York, Toronto, London: McGraw-Hill, 1959) p. 113.

18 On the rich sea-change of Wittgenstein's dictum, see T. Tanner, *City of Words* (London: Cape, 1975) pp. 415–20.

19 See B. L. Whorf, *Language, Thought and Reality* (ed. J. B. Carroll; Cambridge, Mass.: M.I.T. Press, 1956) pp. 51–86, 112–60, 246–70.

20 Barthes, *Mythologies* (trans. A. Lavers) pp. 109–59.

21 Barthes, *Leçon* (Paris: Editions du Seuil, 1978) p. 14.

22 J. Derrida, *L'Ecriture et la différence* (Paris, 1967) English translation, *Writing and Difference* (Chicago, 1978); *La Voix et la phenomène* (Paris: Presses Universitaires de France, 1967) English translation, *Speech and Phenomena* (Evanston, Ill.: Northwestern University Press, 1973); *De la Grammatologie* (Paris: Editions du Seuil, 1967) English translation *Of Grammatology* (Baltimore, Md., and London: The Johns Hopkins University Press, 1977).

23 See F. Kermode, *The Genesis of Secrecy* (Cambridge, Mass. and London, England: Harvard University Press, 1979) pp. 23–47, esp. 39–41; and P. Ricoeur, 'What is a Text?', in *Mythic-Symbolic Language and Philosophical Anthropology* (ed. D. M. Rasmussen; The Hague: Martinus Nijhoff, 1971).

24 Saussure, *Course*, pp. 14–15, 19.

25 Ibid., pp. 7–22.

26 See, for example, G. Bateson, 'Redundancy and Coding', in *Steps to an Ecology of Mind* (London: Paladin, 1973) pp. 387–401.

27 For Jakobson, the subject's speech is constrained only in the 'lower' levels of language: as the subject ascends up to and beyond the level of the sentence, constraint disappears. 'There is an ascending scale of liberty in the combination of linguistic units. In the combination of distinctive traits into phonemes the user's liberty is nil; the code has already established all the possibilities that can be used in the language in question. In the combination of phonemes into words his liberty is heavily circumscribed; it is limited to the marginal situation of the creation of new words. The constraints upon the speaker are less when it comes to the combination of words into sentences. But finally in the combination of sentences into statements the action on the constraining rules of syntax stops and the liberty of each speaker grows substantially'; *Essais de linguistique générale* (Paris: Minuit, 1963) p. 47.

28 Dostoievsky, *Polnoe socinenij F.M. Dostoevskogo* (Petrograd, 1906) vol. IX, pp. 274–5; cit. in Vološinov, *Marxism and the Philosophy of Language*, pp. 103–4. The intricate fate of Dostoievsky's story in critical hands is traced by L. Matejka, 'Prolegomena to Semiotics', in Vološinov, *Marxism . . .* , pp. 170–1.

CHAPTER FIVE: THE GAZE AND THE GLANCE

1 See, for example, the *Encyclopédie* entries on painting practice (esp. *Blanc, Beau, Couleur, Harmonie*); and the 'technical tendency' of Diderot's *Salons*, described

by Seznec in *Salons* (Oxford: Clarendon Press, 1957–1967) vol. I, pp. 8–34, 73–9, 151–7; vol. II, pp. 3–17; vol. III, pp. 3–14; vol. IV, pp. 3–12, 121–6, 231–2, 293–4; and by N. MacGregor, 'Diderot and the Salon of 1769' (Diss. Courtauld Institute, University of London, 1976).

2 E. Benveniste, 'Les relations de temps dans le verbe français', in *Problèmes de linguistique générale* (Paris: Gallimard, 1966) pp. 237–50.

3 Quintilian, *Institutiones*, Book XI, ch. III, articles 65–149.

4 On the Six Canons of Hsieh Ho, see A. Waley, *An Introduction to the Study of Chinese Painting* (London: Benn, 1923) pp. 72–4; O. Sirén, *A History of Early Chinese Painting* (London: Medici Society, 1933) pp. 31–6; S. E. Lee, *A History of Far Eastern Art* (London: Thames and Hudson, 1964) pp. 253–55; W. R. Acker, *Some T'ang and Pre-T'ang Texts on Chinese Painting* (Leiden: Brill, 1954); A. C. Soper, 'The First Two Laws of Hsieh Ho', *Far Eastern Quarterly*, VIII, no. 4 (August 1948) 412–23.

5 For introduction to Chinese painting styles, see A. C. Soper, 'Early Chinese Landscape Painting', *Art Bulletin*, XXIII, no. 2 (June, 1941) 141–64; Soper, 'Life-motion and the Sense of Space in Early Chinese Representational Art', *Art Bulletin*, XXX, no. 3 (September, 1948) 167–86; Soper, 'Some Technical Terms in the Early Literature of Chinese Painting', *Harvard Journal of Asiatic Studies*, XI (June, 1948) 163–73; M. Sullivan, *The Birth of Landscape Painting in China* (London: California Studies in the History of Art, 1962); Sullivan, 'On the Origin of Landscape Representation in Chinese Art', *Archives of the Chinese Art Society of America*, VII (1953) 54–65; and T. Kobayashi, *Man in T'ang and Sung Painting* (Chinese Famous Painting Series I; Tokyo, 1957).

6 On Sesshu, see Lee, *A History of Far Eastern Art*, pp. 376–87; N. Kumatani, *Sesshu* (Japanese Famous Painting Series I; Tokyo, 1956); and M. Oshita (ed.), *Sesshu, Mizue*, vol. XXX (Tokyo, 1961). On T'ung Ch'i-chang, see Lee, pp. 424–41; and on Wen Cheng-ming, see Yu-ho Tseng, 'The Seven Junipers of Wen Cheng-ming', *Archives of the Chinese Art Society of America*, VIII (1954) 22–30.

7 'You see, for me a painting is a dramatic action in the course of which reality finds itself split apart. For me, that dramatic action takes precedence over all other considerations. The pure plastic act is only secondary as far as I'm concerned. What counts is the drama of that plastic act'; Picasso, quoted in F. Gilot and C. Lake, *Life with Picasso* (London: Nelson, 1964) p. 51.

8 Ibid., *Life with Picasso*, pp. 50–2, 64–5.

9 J. Starobinski, *L'Oeil vivant* (Paris: Gallimard, 1961) pp. 11–12.

10 See W. R. Acker, *Some T'ang and Pre-T'ang Texts on Chinese Landscape Painting*, pp. XXVII, XLI–XLIII.

11 See H. Tietze, *Titian* (London: Phaidon, 1950) p. 23.

12 Cit. De Bruyne, *Etudes d'esthetique médiévale*, vol. I (Bruges: De Tempel, 1946) pp. 262–72.

13 See B. Rackham, *The Ancient Glass of Canterbury Cathedral* (London, 1959) pp. 73–80.

14 Cf. Lacan, *The Four Fundamental Concepts of Psycho-Analysis* (ed. J.-A. Miller and trans. A. Sheridan; Penguin Press, 1979) pp. 65–119, esp. p. 113.

15 See A. Smart, *The Assisi Problem and the Art of Giotto* (Oxford: Clarendon Press, 1971) pp. 98–100; and B. Cole, *Giotto and Florentine Painting 1280–1375* (New York, San Francisco, London: Harper and Row, 1976) pp. 63–95.

16 M. Baxandall, *Painting and Experience in Fifteenth Century Italy* (London, Oxford, New York: Oxford University Press, 1972) pp. 48–58.

17 Alberti, *De Pictura*, Book II, 40.

18 See Baxandall, *Giotto and the Orators*, pp. 121–39; and Auerbach, *Mimesis*, ch. 3.

19 Alberti, *De Pictura*, Book I, 12.

20 See M. Pêcheux, *Les Vérités de la Palice* (Paris, 1975).

21 See Baxandall, *Painting and Experience*, pp. 56–103.

22 See K. Clark, 'Leon Battista Alberti On Painting', *Proceedings of the British Academy*, XXX (1944) pp. 2–3.

23 The conflict between embodied and abstracted subject-positions is nowhere more pronounced in Piero's work than in the frescoes illustrating the Legend of the True Cross, at Arezzo. Iconologically, the structure of the fresco cycle is divided between a serial, continuous structure of the Glance (Diagram *A*: the arrows indicate the chronological sequence of the Legend); and a simultaneous, discontinuous structure of the Gaze (Diagram *B*: the arrows indicate the repetitions of 'type' and 'anti-type'). As in Masaccio's *Trinity*, certain figures and areas are torn between the two dispensations: note, in particular, the compositional 'interference patterns' between the serial and the simultaneous; the themes of inverse mirroring and twinning; and the curious transformations of the Queen of Sheba's handmaid.

A

B

24 J. White, *The Birth and Rebirth of Pictorial Space* (London: Faber and Faber, 1957; 3rd edition, 1972) pp. 138–40.

25 John Graham, *System and Dialectics of Art* (New York, 1937); cit. in *Readings in American Art Since 1900* (ed. B. Rose; New York: Praeger, 1968) p. 121.

26 Barthes, *Elements of Semiology*, section III; and Jakobson, 'Two Aspects of Language and Two Types of Aphasic Disturbances', in *Selected Writings of R. J.* (The Hague: Mouton, 1971) vol. II, pp. 239–59.

27 Starobinski, *L'Oeil vivant*, pp. 12–16.

28 J. Pope-Hennessey, *The Portrait in the Renaissance* (Princeton, N.J.: Princeton University Press, 1979) pp. 36–63.

29 Ibid., pp. 60–3.

30 E. and J. de Goncourt, *L'Art au Dix-huitième Siècle* (Paris, 1856–75); trans. R. Ironside as *French Eighteenth Century Painters* (London: Phaidon; 2nd edition, 1958) pp. 301–2.
31 Ibid., p. 116.

CHAPTER SIX: IMAGE, DISCOURSE, POWER

1 Vološinov, *Marxism and the Philosophy of Language*, pp. 9–24; cf., for example, D. Spearman, *The Novel and Society* (London: Routledge and Kegan Paul, 1966) pp. 239–50.
2 See J. Barrell's excellent *The Dark Side of the Landscape: The rural poor in English Painting 1730–1840* (Cambridge: Cambridge University Press, 1980) esp. pp. 89–130.
3 'Surely it must be clear that the "superfluous man" did not appear in the novel in any way independent of and unconnected with other elements of the novel, but that, on the contrary, the whole novel, as single organic unity subject to its own specific laws, underwent restructuring, and that, consequently, all its other elements – its composition, style, etc., – also underwent restructuring. And what is more, this organic restructuring of the novel came about in close connection with changes in the whole field of literature, as well.': Vološinov, *Marxism and the Philosophy of Language*, p. 18.
4 See S. Heath, 'Language, Literature, Materialism', *Sub-Stance*, XVII, no. 17 (1977) 67–74.
5 See L. Matejka, 'Prolegomena to Semiotics', in *Marxism and the Philosophy of Language*, p. 173.
6 Cit. Heath, 'Language, Literature, Materialism', p. 70. (My emphases.)
7 Ibid.
8 Marr, *Through the Stages of Japhetic Theory* (1926) p. 269.
9 Heath, 'Language, Literature . . .' 72–3.
10 The unviability of a theory of dialogue, in Marr's system, provoked Vološinov to produce a model of speech fully committed (and in the late 1920s) to a 'Sr → Sr' theory of meaning: see *Marxism and the Philosophy of Language*, Part III.
11 Wittgenstein, *Philosophical Investigations*, section 2, xi.
12 On the impasse of Soviet linguistics, and its difficulty in recognising the existence of Vološinov's work, see Matejka, *Marxism and the Philosophy of Language*, p. 174.
13 G. Genette, *Figures II*, p. 70.
14 Barthes, *S/Z*, pp. 27–8.
15 Barthes, *Le plaisir du texte*, articles 82–104.
16 Barthes, *La Chambre Claire*, pp. 50–1.
17 J. Kristeva, *Sémiotikè: Recherches pour une sémanalyse* (Paris: Editions du Seuil, 1969) p. 273.
18 Barthes, *Leçon*, p. 18.
19 Ibid., p. 16.

20 Cf. *R. B. par R. B.*, p. 53: 'Fiché: je suis fiché, assigné à un lieu (intellectuel), à une residence de caste (sinon de classe). Contre quoi une seule doctrine intérieure: celle de l'*atopie* (de l'habitacle en dérive). L'atopie est supérieure à l'utopie (l'utopie est tactique, littéraire, elle procède du sens et le fait marcher).'
21 Barthes, *La Chambre Claire*, p. 58.
22 T. J. Clark, 'Preliminaries to a Possible Treatment of "Olympia" in 1865', *Screen*, XXI, no. 1 (Spring, 1980) 37–8.
23 See Clark, 'Preliminaries . . .', pp. 18–42. The present argument is much indebted to Clark's clarifications.
24 On Gros, see N. Bryson, *Word and Image: French Painting of the Ancien Régime* (Cambridge, England: Cambridge University Press) ch. 9.
25 Barthes, *Le plaisir du texte*, p. 49.
26 Cf. M. Foucault, 'On governmentality', *Ideology and Consciousness*, no. 6 (Autumn 1979) 5–22; and *The History of Sexuality, Volume 1: An Introduction* (trans. R. Hurley; London: Allen and Lane, 1979) pp. 92–102.
27 Cf. Clark, 'Preliminaries . . .', p. 38.
28 Barthes, 'Rhetoric of the Image', in *Image, Music, Text* (ed. and trans. S. Heath; London: Fontana/Collins, 1977) p. 41.
29 See Durkheim, *Education et Sociologie* (Paris: PUF, 1968; 1st edn, 1922) pp. 68–9; English translation, *Education and Sociology* (New York: Free Press, 1956) p. 101.
30 See Bourdieu, *Outline of a Theory of Practice*, p. 2.
31 On the *Marat assassiné* and the *LePelletier assassiné*, see D. L. Dowd, *Pageant-master of the Republic: Jacques-Louis David and the French Revolution* (Lincoln, Nebraska: University of Nebraska Studies, 1948).
32 'In the weeks following the conquest of Niš no device was neglected, by which the invader might strike terror into the hearts of a people whose courage had been tried through long and bitter siege. Close to the citadel, and on a patch of high ground, was raised a stone tower, visible from all parts of the city, and covered with long spikes, on which were impaled the heads of the principal defenders of Niš, alongside those of the royal family, placed somewhat higher than the rest: along each battlement of the tower, soon known as Skull Tower, a line of heads looked down on the South, the North, the West and the Silver gates of the city. As the Terror increased, so the heads multiplied: a second row of spikes soon displayed those whose secret opposition to the new rulers was discovered through torture; of those declared agents of the Caliph of Rūm, executed together with their wives and children; of those denounced at the Tribunal and in the Clubs. Every dawn brought a new crop: the heads of those executed during the night. Each citizen, looking up at the tower, would find someone linked to his own life: a relative; a customer; a face remembered from the dark of a brothel; a silk-trader, known to have had enemies; a water-seller; a singer. The threads of life, sundered since the fall of the city, began to draw together around Skull Tower. Where once the sight of the tower had provoked only the sickness of fear, now it came to embody the pattern of everything that had been lost. Ties ignored before became precious; the water-seller, once despised, was venerated; people remembered or invented the music of the

singer. Exactly one year after the fall of Niš, when in a single, glorious day of revolution the people overthrew their masters and established a democracy, it was at Skull Tower that the first disturbances broke out.' From *A History of the Caliphate* (trans. T. N. Ratner; London: Murray, 1968) p. 123.

33 I.e. television.

Index

187